LOS ANGELES

SPORTS MEMORIES

LOS ANGELES
SPORTS MEMORIES

DOUG KRIKORIAN

THE
History
PRESS

Published by The History Press
Charleston, SC 29403
www.historypress.net

Copyright © 2015 by Doug Krikorian
All rights reserved

First published 2015

Manufactured in the United States

ISBN 978.1.62619.989.7

Library of Congress Control Number: 2015941629

Notice: The information in this book is true and complete to the best of our knowledge. It is offered without guarantee on the part of the author or The History Press. The author and The History Press disclaim all liability in connection with the use of this book.

CONTENTS

CONTENTS

CONTENTS

A Writer and the Brit
Who Changed Him

Long Beach Press Telegram, *September 17, 2001*

It was a dark, gloomy, rainy London afternoon in April 1992, and the aging sportswriter was seated on a bench in the small Crystal Palace train station. The commuter he was scheduled to take went zooming by without stopping, and he wondered when the next one would arrive to take him back to the Hyde Park Hilton, where he was staying.

He turned to the person next to him and asked her, "When's the next train coming?"

The young Brit looked up at the schedule and quickly answered in a thick English accent, "Forty-five minutes."

The furthest thing from the aging sportswriter's mind at that moment was starting up a romance, since one of the reasons he was in England in the first place was to get away from one that was unraveling in the United States. But for forty-five minutes, the aging sportswriter and the young Brit engaged in a conversation on a variety of subjects—with him posing most of the questions—before the next train arrived to take each of them to different destinations.

There was nothing flirtatious about the meeting, and it seemed as though the two people would go their separate ways even though they still were seated next to each other as the train began to slow down for a stop at Streatham Hill, where the young Brit with the soft voice and mild personality owned a flat.

DEDICATION

But then the aging sportswriter, perhaps from habit, wondered if the young Brit might be available sometime during the upcoming weekend to meet for dinner. She shyly agreed, but her idea of a first date was slightly different than what he had been accustomed to, and the two would meet again on Sunday in front of the National Gallery and would, at her request, spend the afternoon gazing at famous paintings.

They would get along well and would spend more time together in the upcoming days, but then the aging sportswriter, with Constables, Rubens, Poussins, Turners and Vermeers dancing in his head for the first time in his life, returned to America to resume his trademark lifestyle that didn't include passionate commitment but did include other pursuits not exactly conducive to maintaining a stable relationship.

But the young Brit—so natural, so bereft of artifice, so intelligent, so giving, so kind, so honest, so industrious in her occupation as a physical therapist assisting physically challenged people—remained etched in the aging sportswriter's memory.

They would see each other again during the dawn of the New Year in 1996 in Cannes, in the South of France, and this time the aging sportswriter, perhaps mellowed by the years or perhaps having learned from past mistakes, was struck by an epiphany. Never again would he leave the young Brit's side, either emotionally or spiritually, and for more than a year and a half, they maintained an eight-thousand-mile romance that would climax on September 27, 1997, when they were married.

The skeptics said it wouldn't work because of the age and cultural differences and the fact that the aging sportswriter had been an independent bachelor for so many years, unencumbered by the restraints inherent in matrimony.

But the skeptics were wrong.

There wasn't a time the two ever fell asleep mad at each other, and they did everything together—from jogging to lifting weights to vacationing to attending sporting events to eating out at restaurants on a regular basis.

Oh, Southern California was not an easy adjustment for the young Brit, who was not accustomed to its cultural affectations, not used to its frenetic freeway system, not overjoyed that a person who had been an honor student graduate from the University of Newcastle and had been on the rise in the England healthcare system suddenly had to return to school in order to qualify to do what she had done for ten years in England.

But she never complained and would stoutly persevere, and would receive nothing but A's in her classes at Long Beach State, where she impressed

the professors and the school's president, Dr. Robert Maxson, with her intelligence, resourcefulness and wisdom.

Actually, since she did so well in academia, she even thought about becoming a college professor and was given strong encouragement by Dr. Maxson.

The young Brit and the aging sportswriter lived an idyllic existence in their east Long Beach home, and when he wasn't writing and she wasn't studying, they would fly over to Europe, where they would travel around in trains and visit many historic cities and art galleries.

There had been early heartache in their marriage when she miscarried after five months, but she was still young and strong and healthy, and the doctors told her it was only a matter of time before she would get pregnant again and have the child that she and her husband so badly wanted.

Other couples gripe at each other. Other couples argue and nitpick each other. Other couples harbor lingering resentments. But the young Brit and the aging sportswriter only loved each other and worked to make each other's lives better, and they were so excited when they returned to America after spending the millennium in Damascus and visiting shrines in Syria and Lebanon.

The young Brit was only a few units away from picking up her bachelor of arts degree, and she fully expected that the new century would be kind to her and she soon would become a mother.

She had grown fond of America, and those who knew this proper lady from the northeast England town of Hartlepool had grown fond of her.

There was nothing you could dislike about her. She would never say anything bad about anyone and never was judgmental. She accepted people the way they were, and jealousy and possessiveness weren't part of her reserved nature.

The aging sportswriter often thought to himself that the young Brit was too good to be true and couldn't believe his good fortune to have as his wife someone so sweet, gentle, caring, devoted and attractive.

But tragically, the year 2000 would not be kind to the young Brit. On Easter Sunday, it was discovered in a Torrance hospital that she had a mass in her colon that looked to be cancerous. A biopsy revealed it was.

The mass was surgically removed five days later at the UCLA Medical Center, but a chest X-ray showed that a couple of lesions had formed in her lungs.

The colon cancer had metastasized, and for the next sixteen and a half months she would battle her disease with a quiet resoluteness that was heroic, and she never once cursed her fate and never once expressed sorrow

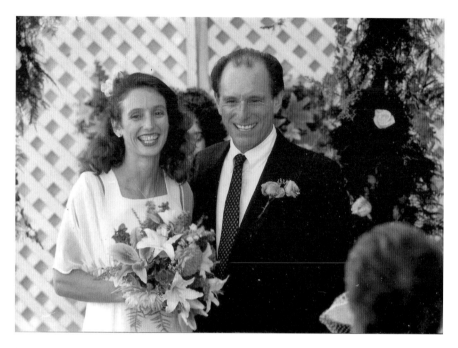

Doug and Gillian. *Author's collection.*

for herself despite the never-ending chemotherapy and radiation treatments and other surgical procedures she had to endure.

She kept planning for the future and couldn't wait for that time to come when the aging sportswriter could retire to write books and she would be able to work and support him in such an endeavor.

"Do you realize how beautiful a gift life is?" she said to her husband. "Just look at all the great things life has to offer. Look at the great places I've been. Look at the great books I've read. Look at the great art I've seen. I feel just so fortunate to have been born into this world. And so fortunate to have met you."

The young Brit, as of two weeks ago, once an extraordinary jogger who easily would leave her husband in her wake, still accompanied him to El Dorado Park and would walk for forty-five minutes as he ran. She even managed to walk around her neighborhood, stopping and talking to the people on her block who liked her so much.

But on Tuesday morning at 3:00 a.m., only hours before terrorists brought so much pain to America, the young Brit herself found herself in even more pain than usual.

DEDICATION

The hospice nurse would come over and relieve it, and the young Brit would spend the rest of the week in a sedated state, emerging in and out of consciousness, seldom able to react to the people who constantly were near her.

On Saturday afternoon at 3:59 p.m., as she was gasping her final breaths, she somehow summoned enough strength to whisper to her husband, "I love you…I love you…I love you…"

"I love you, too," said the aging sportswriter, weeping.

At 4:00 p.m., she stopped breathing, and finally her long agony had come to an end without so many of her dreams being realized. She was a mere thirty-five years old.

The agony of the aging sportswriter had only intensified, although he knows there are few human beings who experienced the euphoria he did during the five glad years he was with the young Brit.

ACKNOWLEDGMENTS

I would like to thank two stalwarts who taught me the journalistic trade as a youngster at the *Los Angeles Herald Examiner*, the great columnist Melvin Durslag and the great sports editor Bud Furillo. Also, the impact a couple of stellar *Long Beach Press Telegram* editors, Rich Archbold and Jim McCormack, had on me was invaluable. And my kindly, supportive sister, Ginny Clements of Tucson, has throughout my life always been an encouraging force. And of course, the continuing support of Olympic swimmer Kathy Heddy, my fiancée, has been a godsend.

1

FOOTBALL

THE DAY ANTHONY DAVIS HEARD NO CHEERS

Los Angeles Herald Examiner, *November 17, 1978*

The legs were churning and the heart was willing, but there were no cheers for Anthony Davis yesterday in Long Beach. He was just another guy being given a one-day tryout with the Rams—another released, rejected football player seeking employment in a tight market.

He ran some wind sprints, retrieved some Frank Corral field goal kicks and took some Pat Haden handoffs, but at no time did he remind anyone of the quick, shifty, elusive runner who scored six of his fifty-two USC touchdowns on one golden afternoon against Notre Dame.

It was as though some imposter playing a wicked joke had showed up at Blair Field, passing himself off as Anthony Davis—looking like A.D., walking like A.D. but displaying only a parody of A.D.'s skills.

This wasn't the man who had broken all those records at San Fernando High, made all those dazzling runs at USC, was given all that money to play with the Southern California Sun of the World Football League and then with the Toronto Argonauts of the Canadian Football League before entering the National Football League and his lost Eden.

This man was too heavy around the middle, too slow around the corners, too often resembling a player who had suffered two hairline fractures of his left leg, as he had this past season with the Houston Oilers.

Anthony Davis scoring a touchdown against Ohio State in the 1973 Rose Bowl. It climaxed a twenty-yard run. *Courtesy of the University of Southern California.*

He was trying to make an impression on the Rams coaches and the Rams hierarchy—Steve Rosenbloom, Don Klosterman, Jack Teele, Harold Guiver—and they silently watched him with practiced skepticism, waiting for him to flash his thrilling form.

But he never did, and the Rams decided to pass on the youngster, who only a few years ago had heard the applause of 100,000 Rose Bowl fans, signed million-dollar contracts, driven a Rolls Royce and walked jauntily down streets covered with gold and lined with bright flowers.

He decided to go through the workout because recently the Oilers had put him on waivers and because it had been his desire since childhood to play for the Los Angeles Rams.

"I can help the Rams...really I can," he insisted after it was over, after the first time in his twenty-five years that he had put on a Ram uniform. "I feel 100 percent. The leg is fine. They weren't bad fractures I suffered. Just unlucky ones."

"How did they happen?" he was asked.

He shook his head sadly, and his eyes seemed as lifeless as his legs had been.

"You wouldn't believe it," he said. "On the first running drill in training camp, I broke the leg. No one even touched me. It just happened.

"I made it back for the first Oiler regular season game and returned a couple of kickoffs. I felt great, even returned one kickoff thirty-one yards. But on the second kickoff I returned in the second game, I broke the leg in exactly the same place again. This is the way my pro career has gone. One bad break after another."

He bowed his head and pondered thoughtfully for a moment.

"I can still run as well as ever," he resumed. "I tell you, I can. I could be a good special team player for the Rams. You know, return punts and kickoffs. I just hope they give me a chance."

"Your NFL career hasn't gone so well," someone pointed out.

Anthony Davis nodded in agreement

"You're right…like I said, one bad break after another," he lamented. "I don't know what it is. I did have some personal problems, but I think I've cleared them up.

"Look, I can handle what's happened to me. I've known the good times, and I can accept the bad times."

Oh yes, Anthony Davis has known the good times, but this wasn't one of them in a career that has turned into a sad opera.

ALL'S NOT LOST RAM FANS…GEORGIA WAS FOUND

Los Angeles Herald Examiner, *September 12, 1980*

So what if the Rams are now the only football team in America—high school, college, pro, semipro and even Pop Warner—to lose two games.

So what if the Rams lost to a quarterback named Williams, first name Doug.

So what if the Rams blew a game they had no business blowing to an outmanned Tampa Bay team whose most valuable performer was Ivory Sully, a Ram defensive back who set up the Bucs' last-gasp touchdown by being charged with a decisive pass interference penalty.

So what if the Rams are still 0-for-1980 because, after all, Green Bay will be next, and the rest of Pete Rozelle's schedule isn't much more taxing. And anyway, their membership in mankind's most oppressed fraternity, the NFC Western Division, already guarantees them a playoff spot.

Just forget the unfortunate events that befell the Rams on the Tampa Stadium field because they are meaningless compared to the historic happening that transpired at halftime in the ABC booth in the press box.

You see, Georgia Frontiere, who has been missing in action since taking on Hubby VII, allowed herself to be interviewed on national television by Howard Cosell. This has to be the journalistic coup of Mr. Cosell's career because the whereabouts of Georgia in recent months has been a great mystery to deposition-serving lawyers, interview-seeking reporters, contract-squabbling players, cliché-spewing front office personnel and double martini–drinking coaches.

There even had been speculation that Georgia was giving serious consideration to becoming a recluse in the mold of the late Howard Hughes, although we refused to give any credence to such a bizarre fable.

Georgia Hayes-Rosenbloom-Frontiere-Et-Cetera is a born entertainer who savors the spotlight so much that she wouldn't dare pass up a chance to appear on a national telecast viewed by maybe fifty million people.

The most shocking part of the interview is not what Georgia said—she said absolutely nothing worth repeating, and therefore we shall repeat some of her most startling statements—but the fact that she showed up for it on time.

Georgia's tardiness is legendary—she once showed up an hour late for a party in her own home honoring her late husband Carroll Rosenbloom—and to be punctual for Cosell was quite out of character.

Georgia didn't say, "Hi Mom," but she did start off by saying to Cosell, "I think owners get too much credit when a team wins and get blamed too much when it loses. We are a lot like quarterbacks…"

Huh?

Don't worry, Georgia. We won't give you credit for any Ram victories this season—and there will be some despite your efforts in the past month to alienate at least one-fourth of the players on the team with your let-the-holdouts-fish-in-Florida-tend-bar-in-Long Beach stance.

When Cosell asked Georgia if the Rams would be willing to renegotiate the contracts of players not in their option year, she smiled nervously and said, "I'm always willing to listen. I have an open mind. I know there are always two sides to a story."

Is that Jack Youngblood's famed cackle we hear out there? Or is it Dennis Harrah's shrill guffaw?

Georgia looked great. She seems to get younger with age. We tend to believe that memorable 1979 Ram press book that listed her age as twenty-

St. Louis Rams owner Georgia Frontiere surrounded by reporters before the team played the 2000 Super Bowl in Atlanta against the Tennessee Titans. To Frontiere's glee, the Rams emerged victorious, 23–17. *Photo by Sean Daly.*

five, or somewhere in that area. She preened her lush blond hair as though she were a teenager on the way to the prom.

If the Rams could only play as good as their owner looks, they would be undefeated today instead of having to wait until September 21 to pick up their first win (Bart Starr should forfeit that one now and spare himself further agony).

Actually, the Rams didn't play poorly against the Bucs. But they didn't play well, either. They made their usual quota of mistakes in a boring, forgettable match of Frank Corral field goals and Garo Yepremian field goals.

The numbers show that Vince Ferragamo threw four interceptions. Two were his fault, but two weren't—one bouncing off Terry Nelson's hands and the other off Billy Waddy's.

Ferragamo performed exceptionally for a fellow who hadn't seen action for three weeks, who lost his starting job for reasons that no one can quite understand except Ray Malvasi, who boycotted the Rams' Monday practice and understandably doesn't believe certain people on the Ram coaching staff have confidence in him.

He was betrayed by his receivers, who were credited with six drops.

"I think Vince's bargaining position is stronger than ever," said Paul Caruso from his Hancock Park estate. "Don't forget the kid was facing one of the toughest defenses in the league. And this was only his sixth regular season start."

"What do you think about Malavasi calling you stupid for holding Ferragamo out for a day?" Caruso was asked.

"Ray Malavasi is well versed on the subject of stupidity," he cracked.

Another fellow well versed on the subject, Howard Cosell, was in mid-season form.

He called Jack Faulkner a "Ram scout," a social faux pas of staggering magnitude since Faulkner is now listed as the Rams' assistant general manager.

He said he didn't want to talk about the Oakland Raiders' attempted move to Los Angeles because it is such a "complex" issue.

It is, of course, complex only in the eye of Pete Rozelle and the other stooges he has lined up behind him to fight against Al Davis and the free enterprise system.

When the Rams were driving through the Tampa Bay defense with ease, Cosell said, "It's amazing the way the Ram offensive line is getting off against the Tampa Bay defense."

It really wasn't that amazing, considering it was last January 6 that the Rams rushed for 216 yards against the same Buccaneer defense.

We're not sure who is more amazing, Cosell or Georgia.

RAM WORLD TURNS—FOR THE WORSE: IT'S FRED DRYER APPRECIATION DAY

Los Angeles Herald Examiner, *September 7, 1981*

The man without a franchise, Fred Dryer, is taking over the Los Angeles Rams franchise.

Forget Georgia Frontiere, who owns the Rams. Forget Dominic Frontiere, who is Georgia's better half. Forget Duke Klosterman, who makes Rams trades and is a peerless raconteur. Forget Ray Malavasi, who coaches the team.

Fred Dryer proved yesterday afternoon at Anaheim Stadium that it is he who is the most influential individual on the Rams, even though he didn't do anything more strenuous than lead cheers for himself.

"We want Dryer…We want Dryer…We want Dryer!" the 63,198 fans began chanting with 5:39 left in the third quarter when it was becoming apparent their beloved heroes could actually lose to the Houston Oilers.

Standing alone at the end of the Ram bench, Dryer turned to the crowd and began waving his hands wildly. And then he began blowing kisses to his adoring supporters.

He repeated the act a few minutes later in what has to rank among the most bizarre scenarios in Rams history, a defrocked player taking command of a game he wasn't playing in.

"Why did you instigate the fans?" Fred Dryer was asked in the solemn Rams dressing room after his team's 27–20 loss.

"It was they who instigated me," replied Dryer. "It was they who started cheering for me. It was the greatest show of appreciation I've received during my thirteen years in the NFL.

"If fans are going to cheer me like that, I'm going to cheer them back. This is the way it's going to be for the next fifteen games. What are you supposed to do when 60,000 fans are cheering you?

"I wasn't going to ignore them. No way. They showed they had great appreciation for me—something the Rams haven't showed me. And I just showed the fans I had great appreciation for them."

The Great Fred Dryer Fiasco has deteriorated to such a dangerous level that Dryer had more reporters surrounding him afterward than Pat Haden and Ray Malavasi put together.

He has become a rallying force for Ram fans, a cause célèbre who has received more publicity in two weeks for not playing than he did the previous thirteen years for playing.

During pregame warmups, the fans gave him a thunderous ovation as he jogged around the field. They displayed a banner that read, "Malavasi Is All Wet, He Needs a Dryer."

"When I was running onto the field before the start of the game, I heard cheers," said Dryer. "Then suddenly I heard boos. I looked around, and there was Ray Malavasi right behind me."

"Don't you think you've become a distracting element to the Rams?" Dryer was asked.

"I'm sure all this commotion doesn't help the team," he replied. "I'm sure it all adds up. But don't blame me. I didn't cause it.

"Look, I told the Rams during those five days I was gone that our relationship was irreparably ruptured. I told them not to make me come back, that it was a classless act.

Doug cuts it up with Fred Dryer, a star defensive end who played for the New York Giants and Rams and went on to become a TV star in the cop drama *Hunter*. *Author's collection.*

"But they didn't care. The Rams suffer from impotent rage. So I'm back with the team, and I'll honor my contract. I'll do anything they want me to do. I want to play. I want to contribute.

"They're obviously not going to allow me to contribute. I think it's going to go on like this for the rest of the season. The Rams aren't going to give in. And believe me, I'm not going to give in, either."

The attorneys for both warring parties also aren't giving in, each accusing the other of telling tall tales.

In an impromptu halftime press conference, the Rams' Joseph Cotchett said, "Contrary to what Fred Dryer's legal counsel [John Thomas] has been saying, the Rams have made Dryer a settlement offer."

In an impromptu postgame press conference, John Thomas said, "What Cotchett said was absolutely false. The Rams made no firm offer whatsoever. To say they did is a complete fabrication. The situation with Fred Dryer right now is zero."

I can't imagine the Rams enduring Dryer's theatrics for the next four months, but I couldn't imagine the team losing Vince Ferragamo, Bob Brudzinski and Jack Reynolds.

Obviously, Fred Dryer is becoming a distraction to his teammates. How else can you explain their endless mental blunders against the Oilers? What other reason can you offer for Pat Haden playing like a dropout from a mud-wrestling contest? What possible excuse can you dredge up for the Rams special teams specializing in embarrassing themselves?

And the Fred Dryer Phenomenon figures to get even more heated.

"Free Fred Dryer" bumper stickers are now being distributed. Dryer himself is keeping a daily log of his thrilling adventures.

"I've been contacted by a few people to write a book on this whole thing," said Dryer to a swarm of reporters. "Look what this whole thing has turned in to. Here we just lost a game we shouldn't have lost. And I didn't even play. And all you guys want to talk to me. It's ridiculous."

When Ray (Rip Van Winkle) Malavasi was asked what he thought about the chants for Dryer, he said, "I didn't hear it. I don't hear anything during a game."

But before the game, Malavasi made sure his players heard an earful. He read to them a love letter from Georgia Frontiere. She wished everyone luck and also wanted everyone to know how badly she felt about having to miss the regular season opener.

I wonder if she felt worse than Fred Dryer.

RAMS DID GREAT CONSIDERING THEY DON'T HAVE A QB

Los Angeles Herald Examiner, *January 13, 1986*

Even though the Los Angeles Rams yesterday were beaten by twenty-four points and did nothing on offense except probably make funny faces at their "quarterback," they need not bow their heads in shame.

Indeed, the Rams still can be quite proud of pulling off a modern miracle: making it to the NFC championship game against the Chicago Bears without an NFL quarterback.

And anyone who dares claim Dieter Brock is a legitimate NFL quarterback shall hereby be sentenced to spend the next few weekends in John Robinson's private audio-visual room watching what certainly will be the comedy hit of the year: "Dieter Brock's Funniest Ram Moments."

I thought Brock's incredibly zany performance several weeks ago against New Orleans was destined to be the film's most hilarious highlight—until

he easily surpassed himself last week with his six-for-twenty-two, fifty-yard abomination against the Dallas Cowboys.

But Dieter—like a true entertainer with a flair for the dramatic—saved his worst for last against the Bears by putting on perhaps the most horrendous show ever dispensed by a professional quarterback in a championship game.

If the Rams would have been fortunate enough to have the Bears' quarterback, Jim McMahon, on their side and the Bears unfortunate enough to have Dieter Brock on theirs, this one-sided match might have wound up in a tense overtime session.

The Rams' defenders played just as well as their more celebrated counterparts, but they played under a serious handicap: they had to face the talented McMahon.

Richard Dent, Mike Singletary, William (The Refrigerator) Perry, Dan Hampton, Otis Wilson, Steve McMichael, Dave Duerson and the rest of the mighty Bears had it much easier: they were fed Brock.

If ever there was any doubt that Dieter Brock is over his helmet in the NFL—and the only doubt raised the entire season has been by John Robinson—Brock erased it for good with his sorry work at Soldier Field.

Ol' Dieter couldn't pass (he was ten for thirty-one for sixty-six yards), he couldn't scramble, he couldn't sustain as much as one Rams scoring drive, he couldn't throw over the Bears, he couldn't throw around the Bears, he couldn't do anything but make people wonder why in tarnation John Robinson ever gave him $2 million to depart the Yukon and gave up on Vince Ferragamo and Jeff Kemp.

Kemp actually did a better job as an emergency fill-in for Ferragamo in 1984, when he was just a rookie.

He deserved a greater chance this season to show what he could do, but Robinson never gave it to him—and I'm certain Robinson has to be second-guessing such a decision.

Of course, Robinson will passionately defend Brock by pointing to his high completion percentage and the Rams' 11-5 NFC Western Division-winning record.

But what Robinson cleverly never will point out is that many of Brock's completions were low-risk dinkers even a high school quarterback could have completed and that the Rams won many of their games *despite* Brock's presence.

In retrospect, it was inevitable that the Rams would go scoreless against the Bears.

Robinson always was an animated figure on the sidelines. *Courtesy of the University of Southern California.*

I mean, if the New York Giants didn't manage a touchdown the previous week with Phil Simms at quarterback, then how would the Rams manage one with Dieter Brock?

They didn't, although they certainly should have lit up the scoreboard in the final forty seconds of the first half after recovering a tipped punt on the Bears' twenty-yard line.

Incredibly, the Rams managed to get off only two plays in that time, even though they had one timeout remaining.

Apparently, both Brock and Robinson suffered severe seizures of amnesia.

For reasons that defy all logic, the Rams, trailing 10–0 and desperately needing a break, never put the ball in the end zone, which was bad enough. But even worse, both Brock and Robinson never called a timeout, letting the clock run out in a scandalous display of strategic mismanagement.

Even had the Rams scored at that juncture, it's doubtful the outcome would have been any different. Everyone, with the possible exception of John Robinson, knew going into this one that Dieter Brock wouldn't be a factor—and he wasn't.

But the Rams felt that Eric Dickerson would be a factor. He wasn't, either.

With the Rams' passing game posing no threat whatsoever, the Bears concentrated on stopping Dickerson—and they did so with ease by often bunching as many as nine defensive players at the line of scrimmage.

Buddy Ryan predicted Dickerson would fumble three times. For once this season, Ryan miscalculated; Dickerson fumbled twice.

But Eric Dickerson isn't to blame for the 24–0 grief that beset the Rams in the Windy City. Neither is the Rams' defense, nor their offensive linemen, nor their special teams.

The poor Rams simply were overmatched, as they reminded one of a gunfighter facing a feared adversary without his six-shooter.

For four months, John Robinson has won and won and won and done it without an NFL quarterback, a remarkable feat deserving of coach-of-the-century honors.

But John Robinson couldn't hide Dieter Brock against the Chicago Bears.

After the Rams' recent upset of the San Francisco 49ers on the strength of several late-game breaks, Robinson went out of his way to praise his quarterback and even mock long-critical reporters.

"He spells his name B-R-O-C-K," said Robinson, dripping with sarcasm.

Funny, I thought he spelled it B-A-D.

FOOTBALL

Dear John: You Do Your Job, We'll Do Ours

Los Angeles Herald Examiner, *June 3, 1986*

Over the weekend, that well-known newspaper ombudsman John Robinson continued his relentless critique of the flower of American journalism: sportswriters.

During a speech in Irvine to two hundred members of the California Society of Newspaper Editors, Robinson once again accused sporting authors of being too negative in their coverage of, among other things, the Los Angeles Rams and their celebrated quarterback, Dieter Brock.

Now, since Mr. Robinson happens to coach the Rams, since it was he who arranged for Mr. Brock to move from the Yukon to Anaheim and since Mr. Brock wound up providing more material to comedians than he did accurate passes to receivers, one's reflex action is to snicker and put an asterisk next to Robinson's remarks.

But in retrospect, some of us in the press may have been too hard on Brock, a nice, civilized family man who just doesn't happen to be a legitimate NFL quarterback—certainly no crime against society.

I mean, a guy shouldn't be strung up and hanged for not being another Joe Montana or Dan Marino—or, in Brock's case, even another Vince Ferragamo.

Maybe, as Robinson angrily contends, some of us overreacted to Brock's glaring deficiencies and created a climate among football fans so negative toward Brock that, Robinson says, "Dieter Brock is a hated man in Orange County."

(I'm sure Robinson is right—Dieter wouldn't win any popularity contest out in Disneyland—but you'd be hard-pressed to find a Chicago Bears fan who has any hate for Brock.)

Still, you can't help but question the motives behind Robinson's campaign to cleanse this country of reporting excesses.

John Robinson is a cunning man, a charismatic, forceful speaker skilled in the hyperbolic utterances and euphemistic disclaimers of award-winning car salesmen. There is a Machiavellian quality to Robinson's nature—as there is in all people in the corporate world who soar to great artistic and financial heights.

By continuing to hammer out publicly his the-press-has-gone-overboard-in-its-dissection-of-Dieter-Brock theme, Robinson is, in essence, attempting to manipulate the editorial content of future stories concerning the Rams.

If Tommy Heinsohn keeps being told he has a Boston Celtics bias, then he subconsciously will tilt his television commentary toward Celtics opponents to prove his fairness—which has been the case this spring.

With cool calculation, Robinson is attempting the same tack with sportswriters, criticizing them to the point where he hopes they feel guilty about their prose and then subconsciously begin tilting it in favor of the Rams, Brock and John Robinson himself.

Robinson claims the press's assessment of Brock has been tinged with wild exaggerations and downright falsehoods—I have tapes of Brock's most memorable pratfalls to prove otherwise—but he clearly dismisses the liberties his own organization has taken with the truth concerning Brock.

When the Rams first signed Brock, amid the blaring he's-going-to-set-the-NFL-on-its-helmet rhetoric of Robinson, they claimed his annual salary was in the $250,000 range.

There is, of course, one other reason for John Robinson's impassioned crusade for journalistic purity: the tenderness of his skin. Considering how he's reacted to criticism of Brock, I have serious doubts if Robinson can stay out in the sun longer than ten minutes. His skin is that thin.

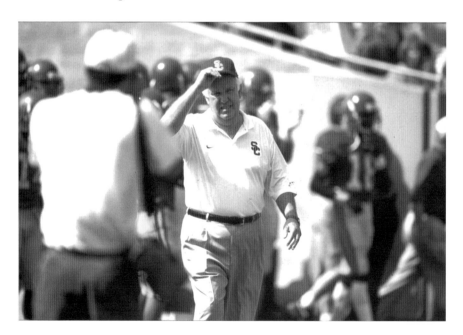

John Robinson not only coached the Los Angeles Rams for nine seasons (1983–91) but also spent twelve (1976–82 and 1993–97) in charge of the USC Trojans. *Courtesy of the University of Southern California.*

Until Brock arrived, Robinson somehow had gone through his entire football-coaching career avoiding any prolonged second-guessing by the press.

Until Brock arrived, Robinson had maintained a favorable relationship with the press because of his charm, friendliness and unique abilities as a dissembler. Robinson tried valiantly for seven months to sell the press on the virtues of Brock—one week he went so far as to say that Brock was playing better that Montana and Marino—but he failed to change its perceptions.

Much to Robinson's dissatisfaction, the press stubbornly kept reporting what Dieter Brock is—an aging, short, immobile Canadian Football League quarterback who was over his head (literally) in the National Football League.

I think Robinson has perceived every knock on Dieter Brock as a knock on him, since it was indeed he who emptied a portion of Georgia Frontiere's coffers to secure a fellow who turned out to be nothing more than fodder for Rickles's jock jokes.

It is still my feeling that we in the press have risked back spasms trying to bend over to be fair to John Robinson. I haven't read one story of anyone savagely underscoring Robinson for his miscalculation of Brock or for the final-minute-first-half amnesia that afflicted Robinson and cost the team either a touchdown or a field goal in the NFC championship game with the Chicago Bears.

Referring to Rams fans' dislike of Dieter Brock, Robinson said, "People should be treated with respect…The reader can no longer separate the man from the quarterback."

This may be true, but I think if John Robinson gets his way with the press, the reader soon won't be able to separate fact from fiction.

AL COULD SETTLE THIS THING

Los Angeles Herald Examiner, *September 24, 1987*

As he gets out of his black Cadillac, a picture of sartorial elegance in his terrycloth white sweater and his glistening Super Bowl rings and diamond bracelet, Al Davis casts a sidelong glance toward a group of players carrying picket signs. An amused look covers his tanned face as he heads for his second-story office at his team's headquarters in El Segundo trailed by three reporters.

"Look, fellows, I have nothing to say," says a man many observers believe could settle the football strike instantly because of his long friendship with players' union executive director Gene Upshaw, because he had the NFL desperately pleading for peace during his brief tenure as commissioner of the old American Football League, because of his negotiating beefs with the Oakland Coliseum and the Los Angeles Memorial Coliseum, because he's long been one of the few owners in the league willing to share a reasonable portion of his franchise's profits with his players and because he just might be the most enlightened figure in professional football.

Al Davis's players long have ranked among the highest-paid in the NFL—definitely the most coddled with their fancy hotel–style training camp facilities and DC-10 flying accommodations—and it had to be a most curious sight for Davis to witness his pampered jocks manning picket lines as though they were exploited laborers protesting sweatshop conditions.

Later, as he munches on an egg-salad sandwich and French fries in his office, Al Davis is asked about his feelings toward the strike.

"I told you already I have nothing to say about it," he says. "Obviously, I hope it's settled soon. No one will benefit from a lengthy strike."

"Have you been asked by anyone to mediate?" the reporter asks.

"Are you kidding?" replies Davis incredulously. "I'd be the last guy in the league they'd want working out a settlement."

This is true, of course.

Peter O'Malley will sign Tim Raines, Wilt Chamberlain will get married, Tommy Lasorda will go on a diet and the sun will set in the east before NFL commissioner Pete Rozelle seeks help from his eternal nemesis from the Raiders.

Rozelle and his minions would be ashen-faced with embarrassment if Davis became actively involved in the strike talks—and it's frightening to contemplate what harm they might do to themselves if Davis actually were the one credited with hammering out an agreement.

I have a feeling when this strike is resolved that Rozelle will be exulted by his propaganda machinery as some sort of knight in shining armor, swooping down from his Park Avenue enclave to save professional football from extinction and thereby ensuring for hundreds of players and twenty-eight football owners continuing riches and also ensuring for millions of football and gambling aficionados continuing sanity.

Could any of you fans out there even imagine the horrifying spectacle of being deprived for the rest of the year the sacred privilege of watching Dennis Harrah camping a full Nelson on a defensive lineman, or Jesse Hester dropping a pass or Marcus Allen and Eric Dickerson fumbling the football?

I know I would be seized with a depressed emptiness if I had to go through the autumn without being able to watch my favorite zebra, Jerry Markbreit, mugging shamelessly for the TV cameras or another posturing SAG member zebra, Jim Tunney, giving his theatrical hand signals. Really, how bearable would life be without a Red Marion or Fred Silva around to blow a big call?

"Are you going to field the best substitute team possible, one with a 'just win, baby' attitude?" the reporter joshes Al Davis.

Davis sips on a Diet Pepsi—a surprising staple for a fitness fanatic who lifts weights an hour each day—and smiles wryly.

"Look, there are a ton of players out there who can play in this league who aren't playing," he says. "I still think we should have a spring football league to develop players. It would work. There are so many examples of guys nobody wanted who have become big stars.

"Nobody wanted Rod Martin when we got him—and look what he's done. The same goes for Todd Christensen. And Jim Plunkett, too. Every team passed on Plunkett after he got hurt in New England. And he winds up leading us to two Super Bowl titles."

Davis's longtime secretary, Beverly Swanson, enters the silver-and-black-themed room and informs Davis that Bill Walsh is on the line.

Despite his long being an NFL outcast, a renegade who successfully challenged Rozelle's power, a nonconformist who blithely has defied the establishment, a rebel with endless causes, Al Davis has maintained close ties with various high-profile people in the athletic community. He speaks regularly to such diverse personalities as Walsh, Jimmy (The Greek) Snyder, John Madden, Howard Cosell, George Allen, Bill Parcells and many others. In fact, in his recently published book, Parcells devotes an entire chapter to Davis, saying, among other glowing things, how he respects the Raiders' managing general partner more than any person in football.

"I have a lot of friends—a lot of loyal friends," says Davis.

"What do you think of your football team so far?" the reporter asks.

"We're 2-0, but you'd never know it from some accounts," he says. "I find it very challenging to build a team—and still keep winning. This is what we're trying to do. What do you think of the team?"

"You've beaten Green Bay and Detroit and proved only that you still have a good defense," the reporters replies.

"We still have to get used to the culture around here," says Davis. "This is so different than it was in Oakland."

"What about Irwindale?"

"We're set to build a stadium there. I'm looking forward to playing there."

"How long is this strike going to last?"

"I don't know. Anyway, I really don't have anything to say about that. We just have to see what happens."

HERE'S TO YOU, MR. ROBINSON: YOU BLEW IT

Los Angeles Herald Examiner, *November 3, 1987*

In the aftermath of the most moronic athletic personnel decision since the Boston Red Sox gave Babe Ruth to the New York Yankees sixty-seven years ago, you still pinch yourself to make sure you aren't dreaming that the Los Angeles Rams actually dealt Eric Dickerson to the Indianapolis Colts.

In fact, you would expect the Rams' illustrious owner, Georgia Frontiere, to desist with her gauche pregame kissing antics before you would expect such a nonsensical move.

The next piece of fantasy you expect to assault your senses is that the Los Angeles Lakers have rid themselves of Magic Johnson, or that the Boston Celtics have sent Larry Bird packing, or that the Edmonton Oilers have issued discharge papers to Wayne Gretzky or that the New York Yankees have detached Don Mattingly.

A running back of Dickerson's staggering magnitude comes along once or twice a century—Jim Brown and O.J. Simpson are the only ones I can think of who can be compared to him without inspiring laughter—and it defies sane logic to remove such a rare jewel no matter what the circumstances.

And the most incredible part of this totally surrealistic scenario is that, according to reliable Rams sources, the person who played the decisive role in Dickerson's banishment was John Robinson, the same person who just happened to benefit most from his feats.

It had been presumed by most observers that Ms. Frontiere and her baby-faced financial hit man, John Shaw, were the ones primarily responsible for the latest Rams charade, although they certainly instigated it with their curious penny-pinching posture toward Dickerson.

Apparently, Robinson, whom I'm sure uses suntan lotion year round because his skin is so sensitive, became enraged when Dickerson had the temerity to suggest to reporters that, since the Rams coach was earning

The great NFL running back Eric Dickerson (second from right) poses with Doug, one-time Los Angeles Clipper owner Donald Sterling (left) and former Pepperdine University chancellor Norvell Young. *Author's collection.*

more money than he was, Robinson himself should carry the football in a running play called 47 Gap.

Infuriated with his financial status and frustrated at what he perceived to be another contract offer from the Rams, Eric Dickerson was in an angry mood when he returned after the strike, and he made a number of off-hand, flippant remarks not to be taken seriously considering his frame of mind.

John Robinson should have ignored Dickerson's frenzied statements, should have understood they were nothing but the ravings of a twenty-seven-year-old man who had become disillusioned at being the most underpaid superstar in sports.

Indeed, what John Robinson should have done was use every persuasive pearl in his vast rhetorical arsenal to convince Frontiere and Shaw what folly it was keeping the cornerstone of the Rams franchise in a dangerously despondent state.

Certainly, John Robinson had the leverage to stick up for a player who had gained more than seven thousand yards rushing for him and led his team to four

straight playoff appearances and was as responsible for his fat new four-year, $3 million contract as his agent, E. Gregory Hookstratten.

"Look, either give Eric what he's worth or I'm going to go public with your shabby treatment," John Robinson could have threatened, and Frontiere and Shaw surely would have caved in and brought Dickerson's contract up to modern-day standards.

With brushfires erupting throughout her organization, Georgia Frontiere didn't need the public-relations nightmare of an unhappy coach censuring her in public.

But John Robinson, in conduct that was right out of Disneyland, in behavior peculiar to a nouveau riche person anxious to flex muscle, in deportment that seemed calculated to win Brownie points with ownership, instead turned against Dickerson with a passion that was as stunning as it was misguided.

"It was Robinson who forced the issue with Georgia and Shaw about trading Dickerson," said one Rams source. "They were hesitant about doing it. But Robinson convinced them it had to be done."

There is a hoary saying that one doesn't cut off his nose to spite his face. In the case of Eric Dickerson, the Rams not only cut off their nose but also their arms, head, legs and heart to spite Dickerson and, in one wicked stroke, turn their franchise into the Atlanta Falcons.

This whole sorry mess easily could have been avoided had the Rams only done what the Denver Broncos did with John Elway and the Miami Dolphins did with Dan Marino and the San Francisco 49ers did with Joe Montana: given their prized commodity a contract commensurate with his unique skills.

As you might know, the Rams made Dickerson a take-it-or-leave-it proposition that would have maintained his lavish lifestyle—and also maintained the team's record of never paying Dickerson honorably.

The offer—worth about $950,000 a year—was ludicrous when you consider Dickerson wound up making $450,000 more a year from the Colts with his long-term $5.6 million deal.

Having already shorted Dickerson an estimated $2 million with below-market contracts in his first four years with the team, the Rams should have relented and finally given Dickerson what he was worth, but true to hallowed custom, they didn't.

And now their fans must suffer for such a sinful miscalculation, having to endure the woefulness of a 1-6 team that was considered a Super Bowl prospect as recently as early September.

John Robinson does possess a slew of high draft choices in the next few years to rebuild his crumbling team, and he also has a bottomless reservoir of excuses to keep the press—and Georgia, too—from critiquing his work too harshly for what probably will be troubling times.

He will survive nicely because he has a guaranteed contract that will ensure his security, but such security won't lessen the pain of losing Erick Dickerson.

You don't lose a player of such caliber without devastating effects, and the Rams already have discovered how miserable life can be without Dickerson against the San Francisco 49ers.

Maybe one day John Robinson, sporting gentleman that he is, will forget old feuds, throw away his rabbit ears and condescend to speak to the athlete principally responsible for his NFL success.

Astonishingly, Eric Dickerson left town without hearing a peep from Robinson.

It was said in this space recently that the Rams were about as likely to trade Eric Dickerson as John Robinson and I were of being selected to fly in the next space shuttle. Well, despite the insanity that has ensued, I seriously doubt my old pal and I will be chosen for such an honor, but it's a certainty that Mr. Robinson has now embarked on the most ominous odyssey of his coaching career.

Suggestion for New Raider Motto: Just Cry, Baby

Long Beach Press Telegram, *January 21, 1991*

ORCHARD PARK, NY—In the aftermath of the darkest hour in Los Angeles Raiders history, it turns out that Bo Jackson was the only Raiders player who did anything right on Sunday. He chose not to play against the Buffalo Bills. Alas, forty-five of his teammates did the same.

Oh, they showed up at Rich Stadium wearing uniforms, but not one of them contributed anything more to the hapless Raiders cause than Bo, who stood silently on the sidelines bundled up in an overcoat, gloves and ski mask watching in horror the unpleasant proceedings.

Giving a rousing impersonation of the New England Patriots, or at least the New Mexico State Aggies, the Raiders went down with a whimper against the Bills, 51–3, in a match not nearly as close as the final score insists.

"Who Knows What Bo Knows—He Ain't Playing," said one of the many unflattering signs festooning the premises in reference to the sidelined Raiders running back.

Well, who knows what Bo's teammates know—they weren't playing, either, during a laugher when the team didn't come faintly close to living up to its hallowed traditions.

Raiders football? Big, tough linemen. Batter your opponents. Run them into submission. Hit them with long passes. Don't try to be fancy. Just win, baby. Huh?

This approach might have worked in the glorious 1960s, '70s and early '80s for the Raiders. But this is the era of the run-and-shoot, no-huddle, shotgun formation when good teams aren't stuck in a time warp.

Just cry, baby. The Bills made a mockery out of the Raiders and their mystique. They exposed their offense as being too outdated, they exposed their defense as being too slow-witted and slow-footed and they exposed their coaching staff as being too unimaginative.

Listen, the Bills are good—very good—have a great quarterback in Jim Kelly, have a great running back in Thurman Thomas, have a great defensive lineman in Bruce Smith and have a roster full of other talented personnel. But there is no physical, mental or spiritual way they should have had such a scandalously easy time against a Raiders team that had no idea what it was doing on either side of the line of scrimmage from the first play of the game to almost the last.

"We were ready for everything they threw at us, but we just didn't execute well," insisted Raiders nose tackle Bob Golic in what has to be the funniest line of 1991.

Ready for everything? You've got to be kidding me. The only thing the Raiders were ready for on Sunday was raising the white flag and quitting at the first sign of adversity, meaning they meekly surrendered before the first quarter had come to its conclusion.

The Bills scored the first four times they had the football—and they did it with such frightening ease that you figured they might score at least, well, forty-one points by halftime.

And that's precisely what they did.

The Raiders enjoyed quite a moral victory during the final thirty minutes. They were outscored by only ten points.

Poor Jay Schroeder. He had a fine season—if only it had ended last week.

Alas, it didn't, and the dreary five-interception, eighteen-incompletion, no-touchdown performance he dispensed on Sunday will ensure him a

tranquil off-season of having to hear those inevitable Al-Davis-is-looking-desperately-for-a-new-quarterback rumors.

The embarrassing setback, of course, wasn't all Schroeder's fault, although he wasn't exactly a heroic figure when the Raiders desperately needed an emotional lift. Some of his passes wound up in nearby Lake Erie; others wound up in the embrace of Buffalo defenders. None wound up leading the Raiders to as much as one touchdown. What was that someone said about the genius of quarterback coach Mike White?

Still, it wasn't Jay Schroeder who allowed Jim Kelly to complete one pass after another, or allowed Thurman Thomas to run with such impunity throughout a cold, drizzly afternoon, or allowed James Lofton to catch every pass thrown his way.

Where was the fearsome Raiders defense? Where was Greg Townsend? Howie Long? Scott Davis? Bob Golic? What was that someone said about the genius of defensive coordinator Dave Adolph?

Townsend spent more time arguing with the officials than he did chasing Kelly. The Raiders defense seemed hopelessly confused by the creative Bills attack that kept successfully isolating its receivers against the slow-motion Los Angeles linebackers.

When Art Shell was asked afterward if the Raiders weren't properly prepared, he uttered the second funniest statement of 1991 when he replied, "No, I thought we were prepared."

Sure, and Al Davis was in a blissful mood in the press box observing what had to be a most harrowing spectacle to the Raiders' managing general partner.

Davis actually thought his team had the muscle to upset the Bills. And Davis's brawny players might well be able to beat the Bills in a power-lifting contest. And maybe they can teach the Bills players a thing or two about getting lucrative TV commercials or even movie roles.

But the new AFC champion Bills showed convincingly that they know how to play football far better than an overmatched Raiders team that one day might bring its archaic philosophies into the 1990s.

These Days, Just Call Them the Masque Raiders

Long Beach Press Telegram, *November 10, 1992*

I'm not sure who coaches the Los Angeles Raiders these days—Al Davis, Art Shell or Mickey Mouse—although I wouldn't be surprised to find out all three individuals are involved in the process.

The hallmark of the Raiders for years—at least during those long-ago days when they didn't make a mockery out of their commitment-to-excellence theme—was an uncanny ability to out slicker opponents.

Well, as the Raiders bumble through the agony of a 3-6 season, the only consistent part of the team is the fact that its coaching staff hasn't managed even once to come up with a game plan that could be described as enlightened, original or even modern.

After watching the Raiders fall apart miserably against the Philadelphia Eagles on Sunday—and somehow revive the career of a moribund quarterback named Jim McMahon—one was reminded of an old movie about the *Titanic* and a haunting scene when the great cruise ship on its maiden voyage started sinking into the depths of the Atlantic Ocean.

The Raiders sank into a similarly dark abyss during their 31–10 embarrassment against the Eagles, with all facets of the team malfunctioning in a hapless fashion once so alien to a franchise with such a proud legacy.

I'm not sure if the Raiders are the most poorly coached team in the NFL, but they certainly rate strong consideration right there alongside the 0-9 New England Patriots and 1-8 Seattle Seahawks.

"Whatever reason, it's always something," observed Art Shell after his team's implosion in Philadelphia, referring to the weekly breakdowns in the offensive line, the defensive line, the linebacking, the secondary, the quarterbacking, the running, the receiving, the punt coverage, the kick coverage, et cetera, et cetera, et cetera.

As recently as two years ago, ol' Art earned coach-of-the-year honors for the Raiders' 12-4 record, but one wonders now if that was a freak of nature considering what has happened to his team since its 51–3 defeat by Buffalo in the AFC championship game in January 1991.

The Raiders have dropped fourteen of twenty-six decisions, which is bad enough, and appear as though they're stuck in a 1960s time capsule, which is even worse.

Indeed, their only innovative action this season—and it's been a negative one—has been in their media harassment category in which an illustrious

gentleman named Dan Turk, a backup center no less, wiles away his idle time posting unflattering articles around the team's El Segundo headquarters in a juvenile tactic calculated to intimidate newspaper critics into silence.

The media, of course, are responsible for Willie Gault turning out to be a sad impersonator of Cliff Branch and of Todd Marinovich being about as close to becoming another Kenny Stabler as Rusty Hilger was of becoming another Darryl Lamonica.

The media draws up those visionary Raiders game plans that constantly befuddle opponents, leaving them bewildered that a Hall of Fame entrant, Al Davis, would persist in the delusion that the vertical passing game—once so vital to the team's success—has become as outdated as the single wing.

The media also are responsible for the Raiders oftentimes looking so disoriented and dispirited, qualities that were quite in evidence against

Doug and Al Davis are all smiles, but later Davis got mad at Doug for criticizing Raiders coach Art Shell. *Author's collection.*

the Eagles in a match that graphically revealed just how badly the team has deteriorated.

In retrospect, the Raiders made a staggering blunder demoting Jay Schroeder after his extraordinary performance against Cincinnati because Marinovich, a twenty-three-year-old youngster who would now be a senior at USC had he remained in college, has too often shown his inexperience and his lack of arm strength.

I, too, thought the Raiders would be better off with Marinovich directing matters, and maybe in time they will be considering their only alternative is Schroeder, who once again showed his erratic tendencies against the Eagles.

The person who must be suffering most over the plight of the Raiders is Al Davis, whose judgment, ironically, is being widely underscored during a year in which he finally realized a longtime goal and made it into pro football's pantheon in Canton, Ohio.

It is he who pulls the puppet strings on the Raiders, even though he will firmly insist that Art Shell doesn't dutifully dance to all his commands.

Still, the Raiders always have been his creation,. and it is he who is ultimately responsible for this year's team with its excess of high-priced Plan B free agents past their primes and its unimaginative game plans that seem concocted by one of those Disneyland characters.

There was a time when the Raiders were celebrated for their shrewdness, toughness, renegade hijinks and dramatic victories. There was a time when they laughed at their media critics and blithely stood up to the establishment with an élan that appealed to the masses. Now, sadly, the Raiders react to press criticism like an amateur politician and wallow blindly in the muck of their hierarchy's shallow self-justifications for a season hopelessly lost.

BACK ON SPEAKING TERMS WITH MR. ROBINSON

Long Beach Press Telegram, *August 10, 1995*

OK, it's over. Mr. Nice Guy Sports Columnist that I am has chilled the beef with USC football coach John Robinson. Honestly.

No more Robocoach, no more Jolly John, no more sarcastic asides will spew forth from my computer about Robinson—unless, of course, he does something in upcoming times to deserve their resurrection.

I went up to him at the Pacific-10 media conference the other day at the Airport Hilton, tapped him on the shoulder and said, "John, as far as I'm concerned, the feud is over between us."

Predictably, Robinson, ever the political diplomat, feigned surprise.

"What feud?" he asked. "I don't know what you're talking about."

"Oh, cut out the horse manure," I joshed.

John Robinson burst out laughing. So did I. We shook hands.

Somewhere, my old radio partner, Joe (The Big Nasty) McDonnell, a man who still detests Robinson and a man with whom I once was accused by a *Los Angeles Times* radio-TV columnist of treating Robinson on the air worse than a serial killer, had to be overcome by nausea at what had to be the most epic peace offering since Begin shook hands with Sadat.

In case readers of this space weren't aware of it, I had this little falling out with Robinson that dated back to the mid-1980s, when he was the coach of the Los Angeles Rams.

To condense a long and heart-warming account, I started getting on Robinson's nerves when I began ridiculing one of his hand-picked acquisitions, a quarterback named Dieter Brock; and then I blistered him over the departure of Eric Dickerson; and then I demeaned him about the ouster of six Ram assistant coaches; and then I criticized his work habits during his final season with the Rams; and then I never stopped using those nicknames.

And because of all these slights, I became public enemy number one in John Robinson's orbit.

It is one of the occupational hazards of being a sports columnist that you're going to make enemies with some of the people you write about in the newspaper.

Oozing with sensitivity, surfeited with warmth and charity, the classic model of human kindness, I'm a peace-loving individual who's always been stunned when targets of my prose react in a harsh manner or, even worse, decide to no longer speak to me.

I can accept being chased around Blair Field by a Ram linebacker named Isiah Robertson or having former Dodger pitcher Tim Belcher threatening to perform impromptu heart surgery on me, but the hurt becomes intolerable when Wilt Chamberlain, a one-time close friend, no longer deigns to returns my phone calls. Or when Al Davis, whom I championed in print for years when almost everyone else was pillorying him, stops talking to me, or when NFL owner Carroll Rosenbloom, with whom I had been close, refused to utter a word to me during the eight months prior to his drowning on April 1, 1979.

There is no crueler emotion than rejection, and just imagine the unspeakable suffering I've had to endure in recent years no longer being able to listen to Mr. Chamberlain give his insightful views on women or no longer being privy to the paranoid babblings of Al Davis.

I'm a guy with a sacred history of not holding grudges, and my knack for getting mad at a person is exceeded only by my knack for making up with him or her, which is the reason John Robinson and I are speaking again.

It's a little known fact that John Robinson and I once upon a time were actually pals, meeting several times for interviews in restaurants around Long Beach, having a few drinks together, discussing world affairs, sharing observations on various other subjects.

What inspired me to seek reconciliation with Robinson was a look at the calendar and the realization that the years were passing by and nothing was to be gained by either of us stubbornly clinging to such a silly quarrel.

And to be perfectly honest, I'm sure the fact that the Rams and Raiders have lammed it out of town and that the USC Trojans are supposed to be one of college football's top teams this season also might have played a role in my seeking such a rapprochement.

I often took Robinson to task for his rhetorical acrobatics during his press monologues, but in the interest of fairness, does he really sling more blarney than Tom Lasorda or a lot of other persons who have attained lofty positions in the athletic world?

Certainly, John Robinson has his flaws as a human being, but is there any person on this earth who doesn't? Indeed, there are certain individuals in my sordid past who would tell you I myself am a shameless dispenser of blarney, an assertion I passionately dispute.

Well, anyway, the bottom line with John Robinson is that, in just his third season in his second tour of duty at USC, he already has the Trojans ranked among the elite again.

"We're about where I thought we would be at this time," says Robinson, who has had 8-5 and 8-3-1 Trojans teams, with both winding up bowl winners. "But we still have to go out on the field and prove that we belong among the top teams. Being rated high in the preseason ratings is nice. But it really doesn't mean anything."

Robinson says his last two seasons with the Rams were a nightmare as his teams lost twenty-four of thirty-two games.

"It really got ugly for me, and I just lost interest in coaching," he admits. "You can trace the start of the downfall with the Rams when Eric Dickerson

departed. But you can see what has happened since I left, that it's more than just the fault of the coaching staff."

John Robinson was referring to the fact that his successor, Chuck Knox, also was unsuccessful with a Rams team whose bumbling owner, Georgia Frontiere, hasn't exactly created an atmosphere conductive to winning.

"I was very lucky to be able to come back to USC," says Robinson. "This is a great place to be. It has the mystique and history of fielding championship teams. And I'm really enjoying myself."

John Robinson was speaking to a group of reporters, and he suddenly made a lighthearted reference to my hair, which is quite lengthy.

He laughed. I laughed. Buds again.

WATCH OUT, A MURDERER IS ON THE LOOSE

Long Beach Press Telegram, *October 4, 1995*

I'm worried today for the citizens who reside on the west side of Los Angeles because a heinous double murderer still must be on the loose.

Shockingly, those who live in that area never have expressed any concern for their safety even though two people, Nicole Brown Simpson and Ronald Goldman, were savagely knifed to death in Brentwood on the evening of June 12, 1994.

And even more shockingly, law enforcement authorities ceased looking for any suspects shortly after arresting O.J. Simpson for those homicides.

But now that a jury of his peers—or should I say admirers—has cleared Mr. Simpson of all charges in a farcical denouement to the most farcical trial in American jurisprudence history, one wonders if the beleaguered Los Angeles Police Department will reopen its investigation into the case.

After all, O.J. Simpson, under the sacred laws of the land, is now considered an innocent man and free to go about paying off his estimated $10 million legal debt by perhaps doing a pay-per-view special with Larry King, marketing various products linked to his famed initials and writing a tell-all book.

What an Agatha Christie whodunit tale this one suddenly has become now that Simpson is walking the streets again. I mean, if O.J. Simpson had nothing to do with those terrible murders, as the jury has decreed, then who committed them?

Maybe it was a hitman representing one of the Columbian drug cartels, as Simpson's esteemed barrister, Mr. Johnnie Cochran, indicated during the trial. Maybe it was the Unabomber. Lemme see, Manson is still in jail, so maybe it was aliens from outer space.

Maybe O.J. Simpson will now finally come forward with some vital information, since his blood was found at the crime scene and since his whereabouts during the time of the killings is unclear to this day.

For some strange reason, Simpson has remained mysteriously silent on the subject and wasn't even allowed by his attorneys to testify on his own behalf, a curious tack for a guy professing innocence.

I shuddered with distaste when the jury in Simi Valley came back with its innocent verdict against those four cops who battered Rodney King, but fortunately, justice was served in another trial.

I felt a similar discomfiture Wednesday morning when I saw Simpson hugging his attorneys in glee after it became official that he no longer was being held responsible for taking the lives of his former wife and her male friend.

Even though there was an overwhelming preponderance of evidence pointing to Simpson's culpability, for nine months Cochran and his similarly unctuous cohorts masterfully clouded the issues, nitpicked the prosecution witnesses, raised the art of dissembling to dizzying new heights and continually injected racial polemics.

Seizing on the bigoted tape-recorded ravings of a cop named Mark Fuhrman, Cochran, in essence, wound up putting the entire LAPD on trial, saying that Fuhrman planted the bloody glove he found at Simpson's home and that there was a massive police conspiracy to frame Simpson.

In his closing argument, Cochran even went so far as to say a not-guilty rendering for Simpson would be a triumph against racism, a bit of shamelessly twisted logic calculated to appeal to the racial sensitivities of the jurors, nine of whom were of African American descent.

It's quite obvious the fanciful ploys of Cochran and the other defense attorneys worked, since the jury took less than three and a half hours to decide Simpson's fate. But I'm not sure the justice system worked.

O.J. Simpson might no longer be a double-murder suspect in the eyes of the law, but in my eyes there forever will be a lot more than reasonable doubt about his innocence.

One would hate to think that the storied running back for USC and the Buffalo Bills is free today only because he was financially solvent enough to be able to employ a crafty group of criminal lawyers.

One would hate to think that a one-time commercial superstar with an appealing smile and widespread popularity is free today because of the increasing racial divisiveness that now convulses the country.

One would hate to think that a one-time well-known film actor and sportscaster is free today because of the LAPD's past history of intolerance toward African Americans and also because of the shoddy work of its forensic experts and criminalists.

O.J. Simpson eluded a lot of tacklers across the seasons on a lot of sporting fields, but his greatest escape came Wednesday when he eluded a lifetime prison term.

There were gasps of astonishment and eruptions of cheers when the announcement finally came—and it's a sad commentary of these bitter times that some numskulls reacted along racial lines.

All I hope now is that the police go out and are able to find the culprit who killed Nicole Brown Simpson and Ronald Goldman.

That will never happen, of course, because the police had the culprit in custody ever since they arrested O.J. Simpson after his freeway joy ride with Al Cowlings.

IF AL DAVIS ONLY KNEW THAT HE DOESN'T KNOW

Long Beach Press Telegram, *November 11, 1997*

In assessing the incompetence of those rivals for whom he had disdain, the late coach George Allen often used to say, "They don't know that they don't know."

Oh, does such a description fit the besieged leader of the Oakland Raiders, Mr. Al Davis, who, indeed, doesn't know that he doesn't know.

It now can be said, without a threat of libel, that this doddering fool doesn't know how to produce winning football teams; doesn't know he made a mistake returning his franchise to Oakland; doesn't know that he is the most despised, most laughed at, most parodied and most pathetic figure now polluting the National Football League scene.

In the wake of the Raiders' latest humiliation—their 13–10 loss on Sunday to the abominable New Orleans Saints—Al Davis has only one viable recourse left for him to retain even the faintest vestige of his gridiron dignity.

Doug (center) shown listening intently during an Al Davis interview. *Author's collection.*

Ol' Al should fire himself.

At least such a noble act of administrative self-immolation would ensure Davis of hearing a sound—loud applause—that hasn't greeted his presence in several seasons.

If there was a Hall of Shame for professional athletic owners, Al Davis would be a charter member of it for causing what once was a proud, successful organization with a commitment to excellence to become one of the NFL's perennial mediocrities as the 3-7 Raiders will miss the playoffs for the fourth-straight season.

Once known as "The Genius" in those long-ago days when the Raiders actually made Super Bowl appearances, Davis is now a genius only for perfecting a unique knack for being able to make one bumbling decision after another and still remain in power.

But Al Davis's greatest felony is not the roster of underachieving, listless, well-salaried jocks—the Raiders have one of the highest payrolls in the NFL at around $52 million—he has brought to the Raiders.

Nor is it the lousy head coach Davis hired to direct this lamentable group, Joe Bugel, whose NFL record now stands at an embarrassing 23-51.

Nor is it the millions of dollars Davis squandered a couple years ago on a couple free-agent busts named Larry Brown and Russell Maryland.

Nor is it his firing of Mike Shanahan, who has become one of the NFL's most respected coaches with the Denver Broncos.

Nor is it the hiring of Art Shell, who couldn't coach, or Mike White, who couldn't coach.

Nor is it the belief that Marc Wilson would be a great quarterback, or that Rusty Hilger would be a great quarterback, or that Jay Schroeder would be a great quarterback or that Todd Marinovich would be a great quarterback.

Nor is it the belief that Jeff George would be a winning quarterback.

Nor, even, is it the outmoded white bell-bottom trousers in which Davis shambles arrogantly around, nor is it his goofy *American Graffiti* hairstyle, nor is it the rambling stream-of-consciousness speeches he occasionally gives these days when he prattles on about "the greatness of the Raiders" even though such greatness ended about halfway through Teddy Roosevelt's final term in the White House in the early part of this century.

No, these are all minor transgressions for Al Davis, who honestly reminds me of one of those classic South American tin pot dictators sans a garish general hat and uniform overflowing with brass medals.

Actually, I've long been surprised that Davis hasn't been brought down by an in-house coup d'état by other Raiders owners—Davis now possesses an estimated 33 percent of the team's stock—in the aftermath of the silly man's most grievous misjudgment.

And that, of course, is his disastrous 1995 decision to yank the Raiders out of Los Angeles and stick them back in Oakland, a financially strapped city that forever lives in the suffocating shadow of San Francisco.

And Al Davis decided to take such an inappropriate course even though his equally addle-brained counterpart, Georgia Frontiere, decided to transplant the Los Angeles Rams to St. Louis the same year.

Al Davis could have had the entire Southern California basin to himself but instead found Oakland—and the $30 million relocation fee disguised as a long-term, low-interest loan it was bestowing on him—an irresistible allure.

But now, suddenly, with fans staying away by the droves from Raiders home games and with the 49ers still the dominant NFL attraction in the Bay Area, and with Oakland bringing a lawsuit against Davis and Davis bringing a lawsuit against Oakland, Al Davis's kingdom has deteriorated into shambles.

But I doubt Al Davis is aware of such a calamity because this is a bewildered guy who seems to be in a perpetual state of denial and totally oblivious to the chaos that now engulfs his sphere.

Pure and simple, Al Davis doesn't know that he doesn't know.

If Al Davis doesn't soon do himself—and the Raiders—a laudatory public service by voluntarily departing the premises, then he should be held by his heels and shaken until his brains run out his ears and more useful innards slide down and fill his empty head.

WAKE HIM WHEN SOMETHING BIG BREAKS

Long Beach Press Telegram, *September 19, 2006*

Pardon me a moment while I yawn, since the subject I want to address today is the impurity of college football.

As you just might have heard, a report from Yahoo—the Internet service and not someone in Jonathan Swift's *Gulliver's Travels*—is alleging the great running back Reggie Bush and family members were advanced money from competing agents when Bush was dispensing heroics at USC.

Now this, of course, if true, is a serious violation of the rules of that stirring caretaker of major collegiate athletics, the NCAA, which also across the years has nailed its student-athletes for illegal dinners, phone calls, airplane trips, car rides and many other such heinous indiscretions.

Shockingly, Reggie Bush denies the allegations, and sadly, the real truth might never be known since Mr. Bush now draws a paycheck from the NFL and doesn't have to answer questions from the NCAA sleuths if he doesn't want to, which he hasn't been inclined to do other than to offer public denials.

I'm not sure I'll ever have a sound night of sleep again not knowing for certain if Reggie Bush accepted a handout from Mike Ornstein or another agent, a crime against nature that no other person in the history of amateur sports ever has committed.

Eh, these kind of stories have been a recurring part of college football, oh, for seventy-five years and figure to continue unabated because of the nature of the sport, which happens to be a multimillion-dollar business in which the schools are in fierce competition with one another for the top prospects and in which the agents are too.

What I find laughable is the reaction of my journalistic brethren, many of whom evince such a posture of outraged piety when only the most naïve don't realize that violations of NCAA edicts on college campuses are as commonplace as Friday afternoon frat parties.

If Reggie Bush were being accused of shaving points, or some other similarly frightful offense, then I'd take serious notice, just as I would if someone were putting the finger on the NCAA for something untoward.

I doubt if there is any major football program in America that can meet all the stringent standards set forth by the NCAA, and no one knows that more than the college administrators and the NCAA.

It's an impossibility, what with booster clubs flush with cash set to do what they can to strengthen their athletic teams and agents flush with cash in pursuit of top jocks who will earn millions of dollars when they turn professional, a percentage of which the agents seek for themselves.

Purity in major athletic programs is a quixotic ideal, and anyone who thinks otherwise is engaging in staggering heights of self-deception.

The NCAA, which stuffs its overflowing coffers from the proceeds of lucrative TV contracts built on the exploits of people like Reggie Bush and other extraordinary athletes, always has been hypocritical in dealing out punishment, usually going after second-tier athletic schools and staying safely away from major institutions that provide too much income to endanger.

You might recall back in the early 1970s when Long Beach State ran afoul of the NCAA for some trivial matter—and Lute Olson's terrific 1973–74, 24-2 team was made ineligible for the NCAA tournament.

At the same time, up the 405 Freeway in Westwood, John Wooden's mighty UCLA dynasty was being not so clandestinely aided and abetted by a wealthy booster named Sam Gilbert, who provided Bruins players with all sorts of goodies that violated the NCAA rule book.

John Wooden has said he had no idea such shenanigans were going on behind the scenes, and I believe him because this is a man of integrity never known to shade the truth.

But the fact is it was going on, and the fact is certain UCLA players of stature were driving expensive cars far beyond their financial worth at the time.

And the fact is that NCAA investigators chose not to snoop around UCLA in those days even though it had been advised of Gilbert's illegal activities. Instead, it brought the hammer down on Long Beach State, a far safer, less controversial tack to take.

Shhh, let's keep this a secret from the gendarmes of the NCAA, but I'll guarantee those star football players at every major school in America who will be eligible for the NFL draft next spring are now being seriously lured by agents, and I'm sure some are being advanced money by those seeking them as clients, much as those agents allegedly did in wooing Bush.

If the NCAA wants to bring quintessential purity to its major football programs and keep them forever detached from the taint of scandal, it should do what Oxford University does in England.

I once saw a sign posted on a bulletin board on one of its campuses that read, "Applications are now being accepted for a place on the cricket team. No experience required. Petrol costs will be shared for away games."

I doubt schools like USC, Notre Dame, Michigan and Ohio State and all the others who sell out all their home games and generate huge amounts of revenue would favor such a policy.

Please, wake me up when a reporter vying for a Pulitzer nabs a football player who has altered the outcome of a game. That will grab my attention—and my outrage.

UNREAL! BRUINS UPSET TROJANS, 13–9

Long Beach Press Telegram, *December 3, 2006*

Well, the unfathomable, the unusual, the unimaginable and the unexpected transpired Saturday afternoon between UCLA and USC before 90,622 unsuspecting witnesses in a field of surrealistic drama called the Rose Bowl.

No way would Karl Dorrell, under duress since becoming field commander of UCLA, would out-coach Pete Carroll—but he did.

No way would Patrick Cowan, not even named the Bruins' starting quarterback until Wednesday, out-play his more celebrated counterpart, John David Booty—but he did.

No way would the UCLA defensive unit out-hit its more renowned USC opponents—but it did.

And no way would, according to the odds makers, according to the national football pundits, according to the BCS bureaucrats, according to almost everybody who ventures opinions on such matters, the unranked UCLA Bruins outscore the mighty number two–ranked USC Trojans—but they did.

Oh yes, in a stunning development that reverberated loudly around the country—especially in the sovereign state of Michigan—the Bruins emerged with a 13–9 victory that a) ended their seven-game losing streak against USC, b) knocked the Trojans out of the BCS title game against Ohio State, c) sent Carroll's troops wobbling into the Rose Bowl probably against LSU

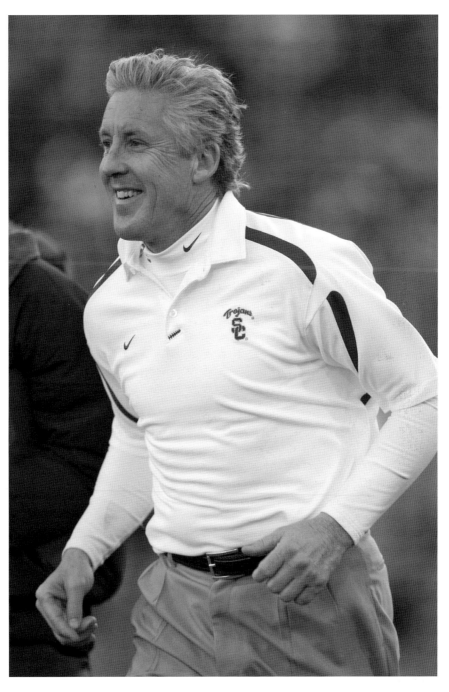

Pete Carroll celebrating a USC touchdown. *Courtesy of the University of Southern California.*

and d) gained UCLA bragging rights for at least a year, much to the horror of cardinal-and-gold fanatics in the area.

"We had a great game plan and did things a little differently than we have throughout the year," said Dorrell afterward.

Indeed, for one thing, the Bruins didn't unravel at the finish against a heavily favored opponent—as they did against Notre Dame. And for another, the Bruins, so conservative and predictable during Dorrell's uneven four-year regime, continually kept the Trojans off balance with their play calling on both sides of the ball.

UCLA kept making all the right calls, especially on defense, where DeWayne Walker's aggressive lads kept shutting down the Trojans on vital third- and fourth-down situations throughout the game, stirringly atoning for the sixty-six points they had yielded a year ago to USC.

People like Christian Taylor, Dennis Keyes, Rodney Van, Chris Horton, Justin Hickman, Eric McNeal, Bruce Davis and others restricted the Trojans to only fifty-five yards rushing and one touchdown, with McNeal's interception at the UCLA eighteen with 1:10 left bringing an end to the Bruins' long torment against their hated crosstown adversaries.

Still, this implausible but well-deserved triumph would not have been achieved without the steady work of Patrick Cowan, who led the Bruins to their first-quarter touchdown with his legs—he had scrambles of twenty-nine and sixteen yards on their twelve-play, ninety-one-yard drive—and to their two final-half field goals with his arm with clutch third-down completions.

He didn't make any major mistakes against a Trojans defense that had caused havoc in recent weeks against teams like Oregon, California and Notre Dame.

Not bad for a guy who only a few days ago didn't know if he would be sitting the bench on Saturday behind the Bruins' opening-game starter Ben Olson, healthy again after being sidelined seven weeks earlier with a knee injury.

Karl Dorrell considered giving Olson back his job, but he decided to stick with Cowan, perhaps the smartest decision Dorrell has made since UCLA athletic director Dan Guerrero hired him to succeed Bob Toledo in December 2002.

Ben Olson might now become UCLA's Wally Pip, a New York Yankees first baseman who once took a day off to give a youngster named Lou Gehrig a chance to become immortal.

Naturally, Dorrell didn't want to discuss Cowan's future status in the afterglow of his team's heroic victory, but it would be difficult for Dorrell

now to dislodge the St. John Bosco High graduate from his current station in the wake of orchestrating one of the more memorable upsets in UCLA athletic history.

His numbers weren't spectacular—he wound up twelve of twenty-one for 114 yards—and weren't nearly as overwhelming as those of Booty (twenty-three of thirty-nine for 274). But he made the big plays when they counted most—and Booty didn't.

Actually, it was apparent from the Trojans' first possession that they might be destined for a difficult afternoon, as the Bruins' defense halted Chauncey Washington for no gain on a fourth-and-one at the UCLA thirty-one-yard line.

This would become a trend throughout the proceedings, as the Trojans would move the ball into UCLA territory—only to be stifled on important downs by a swarming Bruin defense that didn't vaguely resemble the group that was violated so often the previous season, most notably by USC.

The Trojans were out of sync throughout the match, as they committed too many penalties, as they yielded too many long third-down completions to Cowan, as they allowed Cowan to escape their grasps too often (he gained fifty-five yards on ten carries).

They were a listless imitation of the emotional team that had torn apart Notre Dame a week earlier, as they had the look of a team lulled into complacency by their recent spate of glowing press reviews.

In fact, they didn't demonstrate any serious passion until there was a timeout with 5:52 left, when the entire team charged out on the field shrieking and pumping their hands up and down in a show of supportive camaraderie.

The Bruins, not to be outdone, did the same—and both teams were assessed nullifying unsportsmanlike penalties.

But it was too little, too late, too bad for the Trojans, who were unable to avoid their second 2006 disaster at the Rose Bowl.

This one cost them a chance to face Ohio State for the national championship on January 8. The other one last January, a loss to Texas, cost them a chance at their third-straight national title.

And no one is happier about this than Karl Dorrell, the long-beleaguered fellow who finally heard the vocal cheers of the Bruin faithful after so many years of jeers.

"It's going to be nice being back on top in Los Angeles for a year," he sighed, echoing the glad sentiments of a lot of UCLA boosters these hours.

2
BASKETBALL

WILT EXPLODES FOR SIXTY-SIX AGAINST SUNS

Los Angeles Herald Examiner, *February 10, 1969*

You never know what he will do, or where he will go, or whom he will be with or what he will say. Wilt Chamberlain leads a life of intrigue, suspense and thrills—and there is never a dull moment for a person always in the spotlight.

There is no other human being in the world who has done the things he has—like, well, average 50.4 points a game for an entire NBA regular season. He is the envy of every unmarried man who has ambitions that only a large amount of money can accomplish.

Wilt is the only athlete around who one minute might decide to phone his good friend in Washington, D.C., President Richard Nixon, to discuss world events and the next be seen flashing down Sunset Boulevard in his $25,000 Maserati with a beautiful starlet.

He's been around the world twelve times. He's been involved in countless business dealings. He's the most adept seven-foot-one water skier and snow skier who ever lived. And, oh yes, he's also the greatest scorer in basketball history.

His career has been marked by endless controversies. He has on occasion berated coaches, teammates, referees, reporters, fans and the entire NBA structure.

Wilt Chamberlain is the most colorful athlete to land in Los Angeles since a wacky left-handed pitcher named Bo Belinsky arrived in 1962. His unpredictable

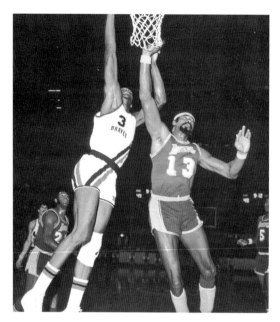

Chamberlain and Elmore Smith battle in the paint, 1971–72. *Buffalo Braves program.*

antics on and off the court his first season with the Lakers has resulted in his becoming a huge favorite among Laker patrons, perhaps already exceeding in popularity a couple old standbys, Elgin Baylor and Jerry West.

No one—certainly not his oftentimes frustrated coach, Bill van Breda Kolff—knows for sure what tack Wilt will pursue in a game.

He may take three shots and score two points, like he did in December against Cincinnati, or he may take thirty-five shots and score sixty-six points, like he did last night in the Lakers' 134–116 win over the Phoenix Suns.

There seldom is an in-between with Wilt Chamberlain, but when you reach as high into the stratosphere as he does, this is quite understandable.

This was a remarkable performance by Chamberlain that was inspired by the news earlier in the day that West, the prolific superstar guard, would be inactive for two weeks because of a recurrent hamstring injury.

"I decided to go to the hoop more because West was out of there, and we needed some offensive help," said Chamberlain in explaining his mighty eruption that easily eclipsed the Forum scoring mark of forty-nine set last year by West.

The only negative about Wilt's thirty-third sixty-plus effort was that only 8,840 were there to witness it. Gosh, the Suns certainly aren't the best professional entry around, but they do have Gail Goodrich, not to mention that Pepperdine favorite Bob Warlick.

Chamberlain, who now has scored more than sixty-five points fifteen times in his career, warmed up against the Suns' two perplexed centers, Jim Fox and David (Big Daddy) Latin, by scoring seventeen points in each of the first two quarters.

But despite his thirty-four points and his backboard dominance—he would wind up with twenty-seven rebounds—the Lakers found themselves still trailing by a 67–61 margin at halftime.

Clearly, this infuriated Chamberlain. Clearly, he didn't want to see his monumental expenditure of energy squandered. Clearly, he was on an obsessed mission last night.

He took total command of the proceedings in the third period. He sank nine of eleven shots, converted four free throws, grabbed eight rebounds and blocked four shots as the small crowd roared its approval of his passionate work.

The Lakers assumed a fifteen-point advantage going into the final round (100–85), and the only drama remaining was how many points Wilt would accumulate.

He easily could have pushed his scoring total into the seventies or even eighties—Latin fouled out midway through the third quarter—but he pulled up in the final twelve minutes when he had only ten points.

"No need to pour it on," said Wilt, ever the milk of human kindness.

Wilt didn't pour it on, but he graphically demonstrated to the adoring LA fans the reason he long has been one of the planet's most fascinating athletes.

The Lament Goes On for West, Wilt, Elg

Los Angeles Herald Examiner, *May 6, 1969*

Their faces were wreathed in agony, their words were solemn and their bearing was somber. Always, the outcome is the same for Wilt Chamberlain, Elgin Baylor and Jerry West.

This was a different season, and they played on a team with superior talent, but again they came up losers against the Boston Celtics.

This time, the Lakers lost the world title by two points (108–106) in their own venue, the Forum, before 17,568 disheartened fans, and afterward Chamberlain, Baylor and West acted like men listening to a dirge in the quietness of the team's dressing room.

West sat there on a bench, answering reporters' questions in hushed tones while his eyes reddened with tears.

Next to his locker was Baylor, twitching nervously and wondering whether he would ever get another chance against the dreaded Celtics, to whom he had now lost on seven occasions going back to when the Lakers were located in Minneapolis.

And limping slowly around the room muttering inaudibly to himself was Chamberlain.

The rest of the players were dressing hurriedly and bidding farewells to one another. A lot of them didn't figure to be back next season.

"It's just hard for me to believe they beat us," said West, deprived of a world title for the sixth time in the past eight seasons by the Celtics. "What makes it so hard is that I know we have the better team. In other years, I could rationalize our setback, but this time I can't."

West again was hampered by his hamstring injury but still ignited the Lakers offense with forty-two points, along with twelve assists. He was named the NBA Finals MVP and earned a car for such an honor.

Small consolation.

"What significance is the car?" he said testily. "You try so hard, you think you finally got them where you want them when you're ahead in the series 3-2, and they still somehow win. I'll give them credit. They have players who know how to win."

He reflected on the Lakers' valiant final-quarter rally and on the squandered opportunities to go ahead.

"We just couldn't make the big plays when it counted," he said, rubbing his left leg, the one that had betrayed him since injuring it late in Game 5 when the Lakers had a big lead and when he should have been resting on the bench.

"It's just one of those things. What can you say? It's done and over with now. Actually, what beat us was when we fell so far behind in that third quarter. It's so tough to make up a seventeen-point deficit.

"You have to play nearly perfect basketball, and against a club like the Celtics this is nearly impossible. We made some mistakes in our comeback, and that's what beat us."

This was Jerry West's darkest hour, and the inquisitors pressed on, and West continued to politely answer the same queries again and again.

It wasn't easy for him, but this is a man who always has reacted to failure with the same dignity that he does success.

Wilt Chamberlain doubtless was as dejected as he's ever been during his thirty-two years on the planet. He stood in front of a mirror and furiously brushed his hair as the lone reporter vainly attempted to console him.

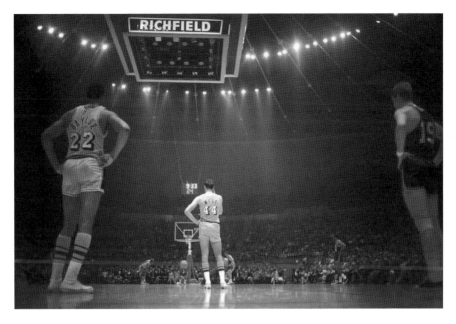

Elgin Baylor (left) and Jerry West wait in the backcourt late in a game at the Forum as a teammate attempts a free throw at the other end. *Courtesy of Karen West.*

He kept shaking his head sadly and saying, "How could it happen…How could it happen?"

Chamberlain played well with twenty-seven rebounds and eighteen points but came out with 5:19 left after spraining his knee. He never reappeared even though he wanted to.

"I asked the coach five times to let me come back in," he said, and his voice quivered with anger. "He makes the decisions, so what can I do?"

The Lakers' coach, Bill van Breda Kolff, explained that he kept basketball's most dominant force out because "we were doing very well with Mel Counts in the lineup.

Clearly, Wilt Chamberlain was hurt by such an indignity from a coach he feuded with throughout the season. This is a sensitive man who is given to moodiness and temperamental outburst but will do anything for a person he respects—and he never has respected Bill van Breda Kolff.

"We lacked the proper direction," said Wilt, obviously referring to van Breda Kolff. "When the Celtics went on their third-quarter spree, we weren't doing anything correctly. This was when someone should have called time out and made the proper moves."

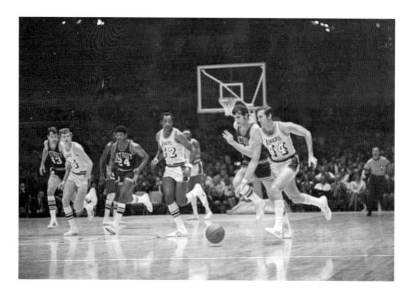

West dribbling the ball up the court. He was as adept a ball handler as he was a shooter and defender. *Courtesy of Karen West.*

He was asked about next season, and Wilt Chamberlain paused momentarily and said, "I don't have any plans. Everything is up in the air."

The pain of seven losses in eight playoff meetings against Bill Russell's Celtics was etched across his face. He flung the comb he had been using to the floor and doubled up his fists. He realized he must endure at least another year with the stigma of being a guy who couldn't win the big one at the end, a stigma that clearly gnawed at him.

"I can just read it now how everyone is going to blame me for this loss," he said. "That's inevitable. I could say a lot of things now, but I'm not going to because then everyone would accuse me of sour grapes.

"There's nothing more that I can say. We were beaten, and that's all."

He strode away, and some reporters gathered around him, and he would have to repeat the routine once again. It seems an injustice for a man of his immense accomplishments, but fate always seems to decree him to finish behind Bill Russell and the Celtics.

In another part of the room, Elgin Baylor was telling people how this was the "bitterest defeat I've ever been in."

"We had the home court advantage and the better team and still lost," said the Lakers captain. "They just got us in that third quarter."

Baylor went on to talk about the game and his frustrations, and one felt a sense of sorrow for him, as one did for Chamberlain and West.

These three men rank among the greatest ever to perform in their sport, but all have spent their careers being tormented by the Boston Celtics.

(The Lakers wound up firing Bill van Breda Kolff a few weeks later.)

SHOT HEARD AROUND THE WORLD (GAME 3 OF NBA FINALS)

Los Angeles Herald Examiner, *April 30, 1970*

He sat there on a stool, a picture of despair, his head bowed, his left hand fondling an ice pack, his eyes red with emotion. He spoke slowly and quietly, and you never would have guessed that only minutes before this man had made a shot that caused the noisiest reaction in the history of the Forum.

Yet to Jerry West, his sixty-three-foot miracle that sent the Los Angeles Lakers into overtime against the Knicks, was meaningless, something that still failed to keep his team from avoiding defeat.

"That shot didn't make any difference," said West, and his head moved back and forth in a nervous show of frustration.

"We got beat, and that's the only thing that mattered. As it turned out, it would have been just as well if I would have missed it."

The Lakers dressing room was eerily quiet as West grew silent and stared emptily at the floor.

The 111–108 setback was gnawing at him, and he wanted to be left alone, but this is a man of class, a man who doesn't run to the sanctuary of the shower to avoid the probings of newspapermen.

"Did you think the shot was going in?" someone asked.

"I had no idea I would make it," answered West. "I just heaved it as far as I could and hoped for the best."

Jerry West was at his best in this memorable Game 3 match that will become part of sacred NBA lore.

He wound up scoring thirty-four points on eleven field goals and fourteen free throws, but it was just one of those field goals that will never be forgotten by the 17,500 in attendance or the millions watching on the national telecast.

After the Knicks' Dave DeBusschere had drilled a contested fifteen-foot jumper to give his team a 102–100 edge with three seconds remaining, Wilt Chamberlain hurriedly took the ball out of bounds and passed it to West.

West dribbled frantically, and just before he reached mid-court, he unleashed his epic high, arching shot that dropped cleanly through the hoop.

Jerry West sets up play during the 1971–72 Lakers season when his team put together a historic thirty-three-game winning streak on the way to a 69-13 record and its first world title in Los Angeles. *Courtesy of Karen West.*

It seemed that the Lakers had the overwhelming emotional momentum and were destined to emerge victorious.

But these Knicks of Willis Reed, Walt Frazier, Dick Barnett, Bill Bradley and DeBusschere are a resilient team undaunted by adversity and would go on to outscore the Lakers by a nine-to-six margin in the five-minute extra period, assuming a two-to-one edge in this best-of-seven NBA championship series.

"All I know is the Knicks beat us," West kept repeating to reporters. "I think their outside shooting killed us, especially in the second half. We took that big halftime lead [56–42] and let it get away from us. We never should have lost this game, but unfortunately we did."

Wilt Chamberlain was asked if the loss would have any lasting psychological effect on the Lakers.

"I can only hope it won't," said Chamberlain, who scored twenty-one points but missed six of thirteen free throws. "We still have a chance. We're not out of it yet. Until they win the necessary four games, I won't concede anything."

Neither will Elgin Baylor, who fouled out for one of the few times in his playoff career—late in overtime.

"We will come back," vowed Elgin, who had twelve points and twelve rebounds but was unable to avoid the whistle of referee Mendy Rudolph, who called five of the six fouls against him.

You might not know that Baylor has a private theory about Rudolph, he of the theatrical movements.

It's Baylor's contention that, for some strange reason, he never winds up with many free throw attempts when Rudolph officiates.

"I thought three of the fouls were very questionable," said the Lakers captain. "Especially the last one. I had my hand on the ball. I didn't even touch Willis Reed's hand. Willis seemed as surprised at the call as I was."

Joe Mullaney, the Lakers coach, was as downcast afterward as his players.

"I guess you can say we're now in a tough predicament," he said. "Here we had a nice halftime lead and we're at home in front of a loud crowd—and we're still beaten. It's tough—really tough."

Mullaney, usually a model of calmness, was visibly upset. He spoke in hushed tones and a couple of times pounded his hands together, vainly coping with his team's most important loss of the season.

Like his players, he knew such games are usually won by teams that go on to win world championships.

(Editor's note: The NBA did not adopt the three-point field goal until the 1979–80 season. West's remarkable shot would have been a game-winner under current rules.)

KRIKORIAN WINS NATIONAL TITLE

Los Angeles Herald Examiner, *March 28, 1971*

Herald Examiner *Editor's Note: The Bruins of UCLA carried Doug Krikorian of the* Herald Examiner *along with them to a national championship when they defeated Villanova in the finals of the NCAA Tournament last March.*

Inspired by the 68–62 UCLA victory, Krikorian proved to be tops in the nation, as well, with his account of the game. It seems that our weightlifter tossed around some neat words to write a story judged the best among Sunday morning entries from throughout the fifty states by the Basketball Writers Association.

Along with first place, Krikorian also won honorable mention for his coverage of the UCLA quarterfinal game against Long Beach State. Following is the March 28 story that won the coveted award for Krikorian.

HOUSTON—And so, the UCLA Bruins did it again. They won their fifth-straight national basketball championship here on Saturday afternoon on Steve Patterson's shooting in a victory that transcends sports.

The 68–62 win over Villanova brings back an era that no longer exists in America during the 1970s.

Nobility isn't cherished anymore, only loathed. These are times when kids on campuses burn buildings in protest against Vietnam and the rich, an era when to be on top invites scorn.

The draft stripped the Yankees of dominating baseball, Bill Russell's retirement brought down the Boston Celtics and old age and Vince Lombardi's departure caught up to the Green Bay Packers.

Dynasties are supposed to be relics, but the UCLA Bruins now have perhaps the greatest one in all the years of organized athletics. They have had to win twenty-eight straight games in the sudden death NCAA tournament to capture the five titles—an incredible feat.

How many championships would the Yankees or Celtics have won under such a system? The best the Packers managed was three straight. Yet the Bruins have rolled a magical five against odds so overwhelming that Jimmy (The Greek) Snyder would never dare post them.

They have done it with not only talented players but also ones with poise, disciple and élan. And they have done it with John Wooden, perhaps the greatest man ever to coach basketball, directing them.

"You know why we win so often?" asked the Bruins' terrific forward, Curtis Rowe, on the Astrodome floor afterward. "It comes from coaching. And we have the best coach on any level in John Wooden. He tells us what to do, and we just execute."

John Wooden epitomizes the Bruins. He's from another era. There are no sideburns on his face, or mod clothes on his body or obscene words coming from his mouth. He even attends church every Sunday.

They laugh at his style, but his teams have won 145 of 150 games in the past five years, and only the opposition does the crying.

On Saturday afternoon, before 31,765 spectators, it was Villanova—the gallant little Catholic school from Philadelphia—that did the crying.

The Wildcats thought they had figured out how they'd become the first team since Kentucky in 1958 to win the NCAA title with six regular season losses.

"What we wanted to do," said Howard Porter, the stout Villanova forward, "was to get off to a fast start and make UCLA play our game."

The plan was admirable, but the execution was faulty.

One reason was Steve Patterson, the Bruins' six-foot-nine center, who would wind up with twenty-nine points. The past four months had not been kind to Patterson. He had been erratic, shooting poorly and throwing his niftiest passes to the opposition.

In fact, in a game against Oregon State in Corvallis, Wooden benched Patterson almost the entire game for his lethargic work. And another

time, Wooden didn't even start him because he was tardy for the team dinner.

And here on Thursday night in the semifinal game against Kansas, Patterson looked as though he were in a trance and managed only six points.

A sensitive, prideful person, Patterson showed up inspired against the Wildcats, much to their disgust. This was a match that was decided in the first half, and this is when Patterson performed brilliantly.

Villanova employed a 2-3 zone defense, and the Bruins attacked it, as expected, with quick passing and constant movement. But what the Wildcats didn't expect was a scoring spree from Steve Patterson.

"Man," sighed Villanova's Clarence Smith afterward, "I'd like to know who was impersonating Steve Patterson against Kansas."

Patterson did it all, roaring to the basket for lay-ins and converting jumpers from the top of the key. In those opening twenty minutes, he put in nine of thirteen shots and collected twenty points to provide the Bruins with a 45–37 lead.

UCLA started the match ominously, as Porter shoveled in three straight baskets to put his team ahead 10–7. But the lead didn't last long.

The Bruins went on an 8–0 surge for a 15–10 edge with 13:53 remaining until intermission. But Villanova, a determined team, roared back to assume advantages of 18–17 and 22–21 as Porter, Smith and Hank Siemiontkowski took turns scoring.

With 10:57 left in the half, Patterson drilled a short jumper from the side to put UCLA ahead for good at 23–22.

Isn't there always a Steve Patterson to sustain a dynasty? Didn't Billy Martin make that miraculous Game 7 catch against the Brooklyn Dodgers to save the 1953 World Series for New York Yankees, and didn't Sam Jones make that final-second shot to keep the Boston Celtics alive in Game 4 against the Los Angeles Lakers in the 1969 NBA Finals?

UCLA now had its lead and came out the second half bent on keeping it.

John Wooden despises zone defenses and despises stalling, so naturally you know what he instructed his team to do right out there in front of a national television audience of millions early in the half. He instructed the Bruins to hold the ball.

After a few minutes, the Wildcats reluctantly came out of their zone and even started chipping away at the cautious Bruins' lead.

With Porter scoring six straight points, the Wildcats drew to within three (61–58) with 2:28 remaining.

Would this be like the 1963 NCAA finals when Cincinnati went into a premature stall against Loyola and squandered away its chance for a third-straight title?

No, the Bruins are different from Cincinnati. They have a mystique about them and react to pressure like a Sandy Koufax, or Yogi Berra or Bill Russell.

And so their tough guard, Henry Bibby, coolly took a deft pick-and-roll pass from Patterson and scooted underneath for a layup to make it 63–58.

Then, after Porter again sliced the margin to three with a jumper, Bibby converted a free throw (64–60) with 1:13 left. Moments later, Sidney Wicks rebounded a Porter miss.

The Wildcats frantically pressed all over the court, and suddenly Patterson found himself loose under the basket. He took a pass from Bibby and went up for the easy layup, but it was slapped out of the hoop by the desperate Porter.

The Villanova standout, who scored twenty-five points, was called for goaltending; the Bruins had a six-point lead, and their dynasty was preserved.

A few moments later, it was over, and there was Sidney Wicks, as is his custom, facing the Bruins rooting section and pointing his arms upward signifying the status of his team. He even went over and warmly embraced Wooden.

UCLA's 1971 NCAA basketball champions. *Courtesy of the University of California–Los Angeles.*

His teammates also were celebrating, no one with more animation than Patterson, who had just dispensed the seminal performance of his career on the biggest stage of a sport that now belongs to John Wooden and the UCLA Bruins.

UNHAPPY WOODEN RAPS BRUIN CRITIC

Los Angeles Herald Examiner, *December 7, 1971*

John Wooden—whose teams have been known for keeping their composure—lost his yesterday at the basketball writers' luncheon. The UCLA coach erupted at the recent criticism of the Bruins' weak pre-conference schedule. The newspaper that angered him most was the *Herald Examiner*, and the writer who angered him most was your humble correspondent.

Wooden was caustic when he strode to the podium, and someone asked him after he spoke briefly if he was upset. He glared at me.

"Yes, I'm upset at you, Doug," said John, alluding to last Saturday's article in which I quoted the UCLA guard, Greg Lee, as saying The Citadel, a 105–49 loser to the Bruins, was comparable to a junior college team.

"It's demeaning the way you try to pull away some of my players and ask them loaded questions. I don't like it, and I'm not going to stand for it.

"I guess I have to apologize for my record. No one seems to be pleased that we won the game. I've never spoken like this before, but I felt I had to."

Before berating me, John Wooden spoke about one of the flowers of American journalism.

"I always had a lot of respect for Grantland Rice because of his positive approach to stories," he said.

Wooden also talked about Henry Bibby.

"Henry Bibby's contributions over the weekend included fifty-eight points, thirteen of twenty-eight from the floor, twenty-two of twenty-three from the foul line, thirteen rebounds, fifteen assists and seven steals," he said. "If he were an emotional choice, I find that strange."

Someone had commented earlier that Bibby, instead of Bill Walton, had been an emotional selection by Wooden as the Writers Player of the Week.

Anyway, after Wooden discussed Bibby, he made it a point to say he doesn't make up the UCLA schedule (the culprit in this regard is the beloved UCLA athletic director, J.D. Morgan), that the Bruins have won their share

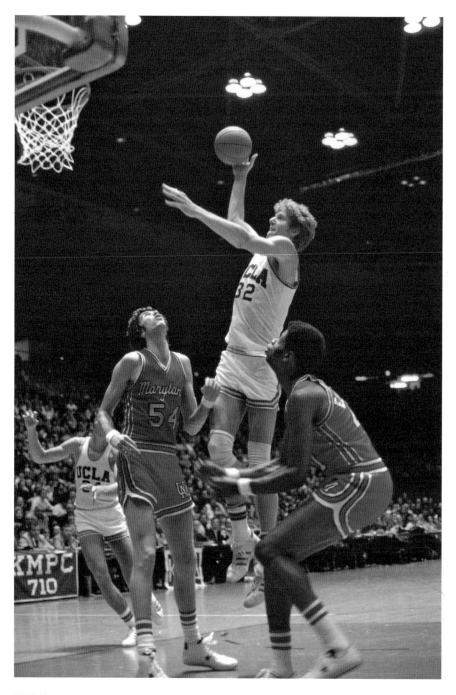

UCLA's dominant center Bill Walton throws one in against Maryland. *Courtesy of the University of California–Los Angeles.*

of games across the seasons against stern competition and that this year's team is "very good and entertaining."

He then signed off with a curt "I'm pleased" when someone inquired about his disposition.

Mike Morrow, the intrepid basketball writers' president, certainly did nothing to enhance Wooden's mood when he had introduced him thusly: "Here's John Wooden to tell you about the Bruins' win over the Crenshaw High JVs."

And earlier, I asked USC coach Bob Boyd about the merits of facing a team such as The Citadel in a home opener compared with starting on the road against Arizona State, which his Trojans did in a 95–78 loss.

Boyd laughed about the question, but John Wooden didn't.

"I'd do anything to be 2-0," said Boyd, whose team is 1-1 after a subsequent 102–82 win over USF. "Everything is based on winning. If you don't win, it doesn't matter who you play.

"If you play tough teams and lose them all, you play before an empty house. You pack the house if you play easy opponents and win them all. There's an obvious message there."

Except for Wooden's eruption, not much else transpired.

Boyd told how the transition of Ron Riley from center to forward has been a success.

"Ronnie showed he still can get those rebounds even if he's not as close to the basket any longer," said Boyd. "He had nineteen against Arizona State and twelve against USF. He's not a great perimeter shooter, but we don't want him to rely on his shooting anyway."

Like Boyd, Jerry Tarkanian, the Long Beach State coach, was in fine spirits, which is understandable. His team opened with easy victories against Nevada Southern and Corpus Christi.

Someone asked Tarkanian if he would rather have opened against a stronger opponent like, say, Kansas—as he did a year ago.

Tarkanian gulped, remembering the 69–52 loss to the Jayhawks in which his team trailed by a 32–8 halftime margin.

"I enjoyed it a lot more this year," he said. "It took us five games to get over that opening-game loss last season."

That certainly wouldn't have been the case had Tarkanian's troops faced The Citadel.

UCLA–Memphis State NCAA Title Game: Bill Walton Scores Forty-four Points on Twenty-one of Twenty-two Shooting in 87–66 Win

Los Angeles Herald Examiner, *March 26, 1973*

St. Louis—Like Napoleon, Caesar, Hannibal and other great conquerors before him, William Theodore Walton—alias William the Conqueror—has no more worlds to subjugate today. At least not in the UCLA world of college basketball.

Although his chances of doing so are about as likely as the Bruins ever losing an NCAA title, Bill Walton might as well forgo his senior year and sign with the Philadelphia 76ers. He would not only add new life to the sagging 76ers but also would add new life to an amateur sport he dominates.

His epic performance here last night, which was responsible for an 87–66 win over Memphis State, was the best in his two varsity seasons with UCLA—if not the best by any player who ever played on the collegiate level.

It was definitely the best by anyone who ever played in this thirty-five-year tournament in which the Bruins have come out the winner seven straight times—and in nine of the past ten years.

Before a crowd of 19,301 at the Arena and a national television audience, Walton—even though in foul trouble most of the game—bounced behind, in front, around and above the Tigers for a career-high forty-four points and also grabbed fourteen rebounds.

But what was even more remarkable was that he missed just one shot in twenty-two attempts. And of course, none of his field goals came on dunks since that shot was outlawed by the NCAA in 1967 after Lew Alcindor's overpowering sophomore season at UCLA.

No wonder the 76ers are reportedly set to offer this twenty-year-old redhead with boundless energy and incredible agility and quickness a $2 million contract to forgo his senior season in Westwood.

He's worth it. Oh, is he worth it!

He took apart aggressive Memphis State last night. He took apart the team that was making threatening gestures of ending the Bruins' winning streak that now has reached seventy-five—and doesn't figure to end until Walton departs.

This was a tight struggle for the Bruins until they broke it open in the late stages—the teams were tied at thirty-nine at halftime—and it was Walton who staved off every challenge from the resilient Tigers.

It was the six-foot-eleven center taking lob passes from guard Greg Lee above the rim and dropping the ball through the hoop, or banking jumpers from the side, or spinning away from defenders in the pivot and freeing himself for easy lay-ins.

He also was a defensive menace, controlling the backboards, blocking shots and forcing Memphis State into an outside shooting game that eventually proved its undoing.

When he sprained an ankle with 2:52 left and retired to the sidelines, the fans, most of whom were rooting for Memphis State, gave him a standing ovation that lasted for more than a minute. They were appreciative of what they had just witnessed, just like those in the past who had witnessed a Koufax no hitter, or a Louis knockout or a Ruth home run.

"Yes, I'd have to say this was Bill's greatest game," said UCLA coach John Wooden. "But he's had a lot of other great ones for us. He's an extraordinary player."

In his stirring moment of triumph, with writers and broadcasters flocking around him, Walton sat on the UCLA bench afterward and reacted sullenly.

"Was this your best game?" he was asked.

"I don't want to talk about it, man," he said.

"Will you turn pro?"

He shrugged without responding.

"How's the ankle?"

"I'll live."

Walton then got up and headed toward Larry (Dr. K) Kenon, the Tigers' six-foot-nine center who scored twenty points and was unable to contain Walton.

"I'll see you in the finals next year," he said to the grim-faced Kenon.

Kenon didn't reply, and Walton limped slowly to the UCLA dressing room.

Walton's teammates were slightly more animated, as they were thoroughly enjoying their big triumph, bounding giddily around the court, slapping hands, warmly embracing and shouting sounds of gladness.

Wooden's teams seldom display such emotion, but seldom do they face a team that posed such a serious threat in a game that was far closer than the final score indicates.

"I told you we'd do it," the reserve guard, Tommy Curtis, kept telling a smiling Wooden.

"It's beautiful—I love it," said Larry Hollyfield, laughing heartily. "I loved it out there. I kept telling those Memphis guys we'd beat them. And we did."

The happiest UCLA player was Greg Lee.

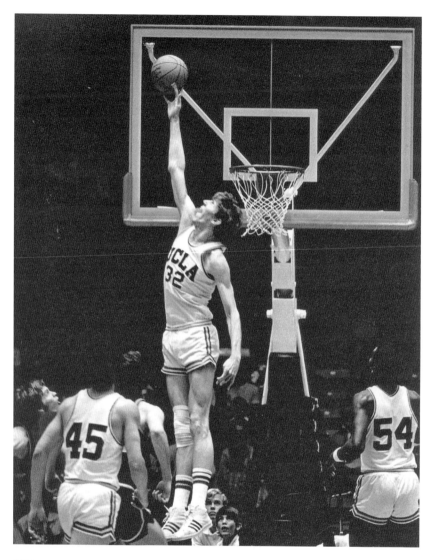

Bill Walton shows his defensive prowess as he soars to block a shot. *Courtesy of the University of California–Los Angeles.*

"This is the best I've ever felt," said Lee, who wound up with fourteen assists as a result of his deft passes to Walton. "Bill Walton was something special tonight. But he's always something special."

Bill Walton was slightly beyond being special on a memorable evening when all his vast skills were on graphic display—to the dismay of Memphis State.

Why Don't They Practice What They Preach About People? Bruins: Young Generation of Con

Los Angeles Herald Examiner, *February 21, 1974*

The young generation comes at you with love, peace and understanding. It likes to impress you with its sensitivity, compassion and feelings for impoverished people.

The young generation prides itself in its nonconformity, although it loathes short hair, coat and tie and obedience. It knows all the

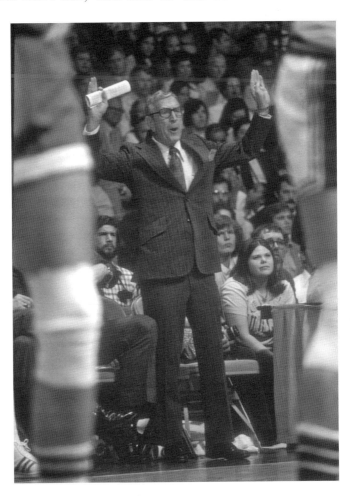

John Wooden instructing his players. *Courtesy of the University of California–Los Angeles.*

clichés, the live-and-let-live, let's-share-the wealth, peace-on-earth, et cetera.

The UCLA basketball team is made up of the young generation. It has players who are socialists, vegetarians, atheists, astrologists, transcendentalists and ecologists. It has players who eat yogurt for breakfast, read Mao before lunch and stand on their heads before dinner.

The Bruin players enjoy coming on as free-thinking, liberated youngsters with enlightened personalities, but I get a kick out of this image when I see them brush by reporters after a game refusing comment. Now that's promoting goodwill among your fellow man, isn't it?

I've also seen them brush rudely by kids seeking their autographs—innocent, hero-worshiping, googly-eyed kids. Now that's real nonconformity, isn't it?

And now I've been hearing the young-generation Bruins are saying that their coach, John Wooden, is responsible for their pratfall last weekend in Oregon. Hold it a moment while I recover from uncontrollable seizures of laughter.

They are saying that Wooden's point-guard offense doesn't allow for enough movement and is oriented mainly to the talents of two men, Bill Walton and Keith Wilkes. They are saying that this is why they managed to score only 107 points in their losing efforts against Oregon and Oregon State.

The Same Old Tricks

Of course, what these liberated thinkers failed to point out is that this is the same offense Wooden had used the past two seasons when they went 60-0 and the same offense he used during the 88-2 Alcindor era. They also failed to point out that they made thirty-six turnovers against the Ducks and the Beavers, that two guys named Bruce Coldren and Paul Miller made twenty of twenty-five shots against them and that they performed most of the time like they were in some kind of trance.

Funny how these evangelical youngsters remind you so much of their callous, old-fashioned counterparts of the past, how they also refuse to accept the blame for their own failures.

The young-generation Bruins may be made up of a lot of pseudo sociologists, but they are also made up of a lot of apologists—and that puts them in the same mold as the old-generation athletes.

Gas may be hard to find and facilities may be more modern and money may be more plentiful in sports today, but athletes remain the same as far as ego and self-esteem are concerned.

Tommy Prothro was greeted as another Moses by his players when he joined the Rams in 1971, but a year later, when these players started losing, they rebelled against Prothro, demanding his ouster.

It's always the fault of a manager or coach when a team loses. Either he's playing the wrong man, or he's lost communication with his players, or he's using the wrong strategy, or he's too nice, or he's too mean or he has a personality problem.

Wooden Isn't Bothered

John Wooden has heard the criticism that's been directed his way, and he knew it would be inevitable when his team went on its first two-game losing streak in eight years. But it's not keeping him awake at night.

"No one likes criticism," says Wooden. "But when it comes from immature people who don't know nearly as much as you do, you have to understand and not let it affect your feelings. I can't let it bother me—or I may react the same way as they do.

"Does the criticism hurt me? No. Do I like it? No. But I'm not bitter."

It has been learned from people close to the UCLA situation that Wooden admonished a couple of his players the other day at practice, telling them in no uncertain terms that he still ran the UCLA basketball program.

John Wooden is of the old generation. He doesn't affect any pretensions of intelligence. He doesn't wear jeans, sandals and T-shirts. He doesn't smoke, cuss or drink.

He's of the old generation. He's honest.

John Wooden in a stoic pose flanked by assistant coach Gary Cunningham. *Courtesy of the University of California–Los Angeles.*

West: Last Link to a Golden Past

Los Angeles Herald Examiner, *October 4, 1974*

The twenty-four-second clock ran out on Jerry West yesterday. And a memorable era in Los Angeles sports went out with him.

There were four athletes who dominated this city in the 1960s, four athletes whose skills and charisma elevated them to the dizzying heights of their professions.

There was Elgin Baylor and his dazzling repertoire of moves and shots, Sandy Koufax and his aristocratic perfection, Maury Wills and his revolutionary thievery and Jerry West and his grace and imperturbability under duress.

The ravages of age and injuries forced the retirement of Koufax, Wills and Baylor, leaving West the only one remaining from the *American Graffiti* age, from the age when people were more concerned with rock-and-roll and Elvis Presley than inflation and politicians.

Oh yes, Jerry West no longer a Laker, no longer gliding down court triggering the fast break and extending those long arms to make steals and floating in those picturesque jump shots that resulted in his scoring 25,192 points across fourteen NBA seasons.

Jerry West too old to play basketball with the Lakers? Sure, and smog has evaporated from the basin and the Santa Ana Freeway is an empty parking lot at 5:00 p.m. and Beverly Hills has streets brimming with filthy hovels on the threshold of being razed.

Jerry West is as much a part of Southern California as beaches, cars and movie stars, a glowing fixture since 1960, a nice guy never too distracted to sign autographs or answer reporters' question.

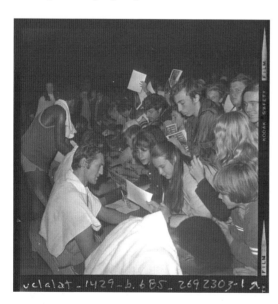

Jerry West signing autographs for adoring fans at an All-Star Game event. *Courtesy of Karen West.*

Tears welled up in his eyes when he made his announcement yesterday afternoon at the Forum, officially informing the world that he no longer would be playing basketball for a living. He had threatened to do it before, but now he said his decision was final and irrevocable.

Jerry West long has been the most human of all superstar athletes, a plain, unpretentious man who never took himself seriously and never affected an air of superiority.

He had his insecurities and his moments of moodiness, but he was sensitive and emotional and always civil and courteous with the adoring fans and the prying media.

As West told of his future plans, we reflected on some of the highlights of his career: the final-second steal of a Bob Cousy inbound pass and subsequent game-winning basket against the Boston Celtics in the 1962 NBA finals; the sixty-two points he scored off Oscar Robertson right in front of Robertson's Cincinnati Royals partisans; the year he averaged 40.2 points in eleven playoff games; the sixty-three-foot, final-second, game-tying shot he made against the New York Knicks in the 1970 NBA finals; the deft-passing point guard leader of the historic 1971–72 Lakers team that won a record sixty-nine games and had that incredible thirty-three-game winning streak...

And we also recalled the frustrations—all the injuries, all the championship losses to the Celtics, all the private frustration he felt constantly reading and hearing how Oscar Robertson was better than he was even though he usually outplayed Oscar when both were in their primes.

It makes me feel old to see Jerry West wave goodbye to a sport he has excelled in for parts of three decades. It makes me want to go to my doctor and have a physical and go to a mirror and check for lines and wrinkles and a five o'clock shadow.

It seemed like it was only a few sweet springs ago that I was an awed

A Jerry West press conference. *Karen West collection.*

freshman in college who traveled 230 miles from Fresno with a friend to see West and Baylor perform against the mighty Bill Russell/Bob Cousy–led Celtics at the Sports Arena, to see in person for the first time these sporting gods whom I had impersonated so often as a youngster while shooting baskets alone at a hoop attached to the garage behind our family home.

But that was in 1962, and a few things have transpired since then.

A few years later, I was covering the Lakers, West was averaging thirty points a game and I was always kidding him about how old he was even though he was just thirty at the time.

Jerry West is thirty-six now, but I don't kid him about birthdays anymore because I'm only five years behind him.

Ponce de Leon never found the fountain of eternal youth and neither has anyone else, and that's the reason Jerry West is an unemployed civilian today for the first time in his adult life.

"I really don't ever want to be an adult," West told his listeners yesterday. "I'm thirty-six and still feel like a kid. I've been playing a kid's game for the past twenty-five years. I always want to be a kid."

But Jerry West made his concession to the relentless procession of the years yesterday. It made a lot of people in these parts sad, including me.

A Magic Performance that Will Never Be Forgotten

Los Angeles Herald Examiner, *May 17, 1980*

PHILADELPHIA—It was an hour after the Los Angeles Lakers had become a team for the ages, and finally the mass of humanity had cleared out of their dressing room. But Magic Johnson still was making points—only now he was doing it with his teammates.

He went up to Jim Chones, warmly embraced him, planted a kiss on his cheek and said, "Chonie, you were sensational."

He repeated the poignant ritual with Jamaal Wilkes, Norman Nixon, Mark Landsberger, Brad Holland, Michael Cooper, Marty Byrnes and Butch Lee.

After Magic Johnson finally had finished his congratulatory rounds, Jim Chones turned to the Lakers prodigy and said, "Hey, Magic, we should all be kissing you. You're the greatest. You were the one who was sensational. We wouldn't have done it without you."

Indeed, the Lakers today are the world champions of basketball because of one super-cool, super-confident, super-talented twenty-year-old named Ervin Johnson.

Mr. Johnson may not be able to part the Red Sea, but I'm willing to bet he can walk on water as long as he has a basketball in his gifted hands.

Without Magic Johnson, the Lakers would have been a good team this season but would not have made it past Seattle in the playoffs.

Without Kareem Abdul-Jabbar last night, the Lakers were a great team because Magic Johnson rose to heights so staggering that it left cohorts in awe and Philadelphia in tears.

Considering the circumstances—unfriendly atmosphere, rough, desperate opponent, Kareem Abdul-Jabbar ailing in LA—Johnson dispensed one of the most heroic performances in all seasons of James Naismith's favorite sport.

It was more than just Johnson's magnificent numbers—forty-two points, fifteen rebounds, seven assists, three steals, one block—that triggered the 123–107 blowout over the 76ers. It was his charismatic presence that turned the Spectrum into his private showcase and turned the poor 76ers into ashes.

Always, he was in the right place, making just the right pass, the right steal, the right rebound, the right basket, the right hand slap, the right smile.

"No…no, not at all," Paul Westhead kept saying in the small, sweltering Lakers room. "No, believe me. I knew Magic was capable of such a performance. I knew he could take over. He could do anything. I bet he could run for president and even win."

Paul Westhead kept smiling, kept wiping champagne from his face and kept talking about how great Magic Johnson was, how sad it was Kareem Abdul-Jabbar wasn't around to celebrate, how gutty Jim Chones played, how gallant Jamaal Wilkes was in the clutch, how courageous Michael Cooper was after being belted by Darryl Dawkins and how tough it was for Norm Nixon to play with a dislocated finger.

"It's all just starting to sink in," he said. "I knew we could win. When you have a player like Magic, you're capable of doing anything. But I don't want it forgotten that we'd have never got here without Kareem Abdul-Jabbar."

A year ago, Paul Westhead was coaching LaSalle—and there was speculation around here that he might lose his job. Just seven months ago, Paul Westhead was an obscure assistant under Jack McKinney. And now he's coach of the premier basketball team on earth—and perhaps one of the best ever put together.

"It's unbelievable is all I can say," said the Shakespearean scholar as he hugged Lakers owner Jerry Buss.

Buss was proudly carrying the Podoloff Trophy, and he told Westhead, "We did it! Paul, we did it!"

Before Buss could utter another word, Brad Holland doused him with champagne.

"You know I like rum and coke," grinned Buss.

It was a chaotic scene.

Jamaal Wilkes was spraying everyone in sight with the bubbly stuff that was being consumed with hearty delight by the laughing, handshaking Lakers, and he also was talking about how he rediscovered his deadly jump shot during his sixteen-point outburst during the third quarter.

"The rhythm came back to me," he said. "No, I'm not surprised at all that we won. I think we showed in Game 5 what we could do with Kareem out. We played very well, and it just carried over."

Jim Chones kept talking about how fortunate he felt to have been rescued from the Cleveland Cavaliers.

"Nick Mileti [former Cleveland owner] didn't think I could play basketball anymore," said Chones. "Well, I think I've proved him wrong. I played as hard tonight as I've ever played in my life. I had to with the big guy back in LA."

Norm Nixon kept talking about how inspired he and his teammates had become because of all the media speculation about how the Lakers were destined to fall apart without Abdul-Jabbar.

"We all got tired about hearing how we had no chance to win," said Nixon. "Hey, we missed Kareem, definitely. But we're a pretty good team without him. I know we're quicker. And I think we showed tonight we're better than the 76ers."

Pat Riley, the assistant coach, was standing in a corner nervously sipping champagne.

"Look at me...I'm shaking," he said. "I feel bad that Kareem's not here to enjoy all this. We missed Kareem. But we had Magic."

Oh yes, the Lakers had Magic Johnson, and there he was afterward, engulfed by the reporters, telling them how his wondrous performance just came natural to him.

"I knew I had to take over, and I did," he said matter-of-factly, as though slaying Doctor J and Chocolate Thunder Dunk and the rest of those big, bad 76ers was just another night's work for the youngster who wasn't old enough to buy a drink in California.

"What are you doing to do for an encore next season?" someone wondered.

Magic Johnson smiled that pleasant, disarming smile.

"Just play basketball," he said simply.

This is just what Magic Johnson did last night, and those who witnessed his masterpiece won't soon forget it.

THE LONGEST SEASON OF JOHN WOODEN'S LIFE

Los Angeles Herald Examiner, *March 15, 1983*

For the first time since 1948, when he arrived in Westwood and began laying the foundation for what would turn out to be the greatest dynasty in college basketball history, John Wooden did not attend a UCLA game.

Since he retired as Bruins coach in 1975, Wooden had been a familiar figure at Pauley Pavilion, but this season his absence was conspicuous.

"This season my time has been taken up by something a lot more important than basketball," said Wooden solemnly.

Since last August, when his wife of fifty years, Nell, lapsed into a five-week coma from cardiac arrest during a hip replacement operation, Wooden has spent most of his time in hospital rooms.

In fact, during one 130-day span, Wooden spent twelve hours of each day at St. Vincent's Hospital, where many of his former basketball players would join in his vigil.

"So many of my old players came to the hospital, and it was such a big lift," said Wooden. "The ones who came most frequently were Pete Blackman and Eddie Sheldrake and Walt Hazzard. It was a very gratifying thing."

Nell Wooden had recovered enough by early January to return to the Encino condominium where she and her husband had lived since April 1972, and she soon improved to the point where she no longer required twenty-four-hour nursing care.

But John Wooden seldom left the side of a woman he married back in 1932, after they were high school sweethearts in Martinsville, Indiana.

In fact, when Wooden was in Atlanta on Sunday to present Ralph Sampson with the player-of-the-year trophy that is named in Wooden's honor, it was the first time he had been out of California since his wife got sick.

You may recall that Nell Wooden, who had one stretch when she didn't miss a UCLA game for seventeen straight years, herself became a part of the Bruins basketball tradition because of a hallowed ritual by her husband.

John and Nell Wooden were married in 1932 after John graduated from Purdue, but they began dating when both attended high school in Martinsville, Indiana. She passed away on March 21, 1985. *Courtesy of University of California–Los Angeles.*

Before the start of each UCLA game, John Wooden would look up into the stands and blow his wife a kiss.

"I guess it's something I started doing when I was playing basketball for Martinsville High and Nell was a cheerleader," said Wooden. "I'd

always look over to her before the tipoff and put my hands to my lips in acknowledgement. I never stopped doing it."

John Wooden also never stopped coaching winning basketball teams, establishing a legacy of success unrivaled on the collegiate scene, leading the Bruins to ten NCAA championships.

Wooden maintained a busy schedule during retirement—clinics, basketball camps, speaking engagements, television commentating, endorsement appearances, et cetera.

"I retired to go to work," he once quipped.

But all his activities ceased the moment Nell Wooden became ill except for one—his early morning five-mile walk.

"A few times it was really touch and go…one doctor said Nell visited heaven for a time," said Wooden. "But she is a fighter and never has given up. Luckily, she didn't suffer any brain damage. She's still pretty weak but getting stronger every day."

Wooden watched UCLA several times on television. "This Bruins team is as quick as a college team as I've seen," he said. "I'm not sure if it is under control as much as it should be, but it is a very talented team."

"Are the Bruins talented enough to win the NCAA title?" Wooden was asked.

"Sure, they have a chance to win it," he replied. "But I also think a lot of other teams do. You certainly can't count out North Carolina, or Louisville, or Houston or St. John's. And you certainly can't count out Virginia with Ralph Sampson."

Naturally, Wooden is impressed with Sampson, but he doesn't think Sampson is ahead of the two renowned centers he coached at UCLA, Kareem Abdul-Jabbar and Bill Walton, at a similar stage.

"I'm not sure Sampson has the physical maturity that Kareem and Bill had in college," he said. "But he sure does have good maneuverability. What I found strange about Sampson is that he made most of his shots from the outside.

"I remember a pro scout once asking me if Kareem could shoot from the outside. I told the scout, 'I don't know, and we'll never find out because that is not where he should be shooting from.' A seven-footer should stay inside for tip-ins, hooks and short jumpers."

As always, John Wooden offered strong views on the state of college basketball.

"The NCAA is going to have to establish some kind of uniformity in its rules," he said. "It's chaotic the way it is now—one conference has the clock, one doesn't; one conference has a three-point rule, one doesn't.

"The ACC championship game was a farce to me because of the short distance of its three-point shot—it's only seventeen feet, nine inches. That's

like shooting a free throw. It's ridiculous. North Carolina State made seven out of nine three-pointers in one half.

"I still advocate the use of a thirty-second clock that should start once a team gets by the center line. That should give a team more than enough time to set up its offense and get off a good shot.

"I still also think there are some coaches around who over-coach, who unnecessarily complicate a simple game. Basketball simply isn't as complicated as a lot of coaches make it out to be."

John Wooden claimed he doesn't miss coaching a sport that made him a legend.

"I don't miss coaching during games one bit," he said. "But I do miss the practices. This is when I was able to stress fundamentals and get the players prepared to play a game. I always said my teams won their games with the way they practiced Monday through Thursday."

The Bruins also won because they had the greatest coach in all the seasons of basketball coaching them.

IT'S TAKEN MANY YEARS AND POINTS, BUT KAREEM HAS HIM CONVINCED

Los Angeles Herald Examiner, *May 2, 1986*

Shhh—let's all keep this a secret from Wilt—but Kareem Abdul-Jabbar continues to prove he's the most amazing basketball player of all time.

Oh, I know Kareem is now a subpar rebounder, often lags back on defense and too frequently gives up as many points as he scores. But what he is still able to do at thirty-nine in a sport brimming with lightning-quick, high-leaping, boundless-energy athletes in their twenties is astounding.

I can think of only two other basketball players—Goose Tatum and Meadowlark Lemon—who were still making an impact at Abdul-Jabbar's advanced age, and both served as clowns in staged recitals for the Harlem Globetrotters.

Abdul-Jabbar seems to have spent his entire adult life making skyhooks and a mockery out of my usually flawless observations.

It was seven years ago that I wrote how the Lakers should make a major trade involving their then-thirty-two-year-old center before he lost his market value.

Fortunately, Lakers management ignored my advice—as it did a couple years ago when I predicted they would be making a serious mistake allowing Abdul-Jabbar to play basketball past his thirty-seventh birthday.

The joke, of course, has been on all of us who have failed to realize that Kareem Abdul-Jabbar long has been a phenomenon of human science.

The Lakers had their first honest-to-goodness playoff-crisis game on Wednesday night against the Dallas Mavericks—they trailed throughout against an inspired opponent—but there was Abdul-Jabbar, as usual, making one big play after another down the stretch to save his team from defeat.

He would score twelve of his twenty-six points in the fourth quarter, and he would make the game's key play—a block of a Derek Harper shot—in scandalous defiance of his ever-fading birth certificate that reads April 16, 1947.

It's incredible that Abdul-Jabbar still is a dominant performer at an age when all of his contemporaries are reduced to playing in neighborhood pickup games.

Because I'm Abdul-Jabbar's approximate age—give or take a year or three—I've taken particularly close interest in his work during the autumn of his career.

It has in recent years become almost a hallowed pre-Lakers game, Forum press lounge rite for me to seek counsel from Dr. Stephen Lombardo, the team physician, on suffering from my workout routines.

"Why did these injuries start happening to me when I reached my late thirties?" I asked Lombardo the other night.

"Because your muscles aren't as elastic as they once were," he replied as I grimaced.

"Then how can Abdul-Jabbar perform at such a strenuous endeavor and avoid even a minor hamstring pull?"

"He's just an amazing physical specimen."

The aging process is an inevitable curse to everyone, but the groups it often can be most painful to are beautiful women and professional athletes.

One it robs of vanity, the other it robs of the physical skills to continue employment in such a high-profile, high-paying line of work.

I sat at ringside in Las Vegas a couple weeks ago and watched with a sense of sadness as Larry Holmes—only a couple years ago so quick on his feet and possessor of remarkable reflexes—failed to avoid almost every left hook Michael Spinks threw.

Architects of the 1980s Showtime Lakers. *From left to right*: Jerry Buss, Magic Johnson, Kareem Abdul-Jabbar, Jerry West and Pat Riley. *Courtesy of Karen West.*

I recall seeing Willie Mays in his final days with the New York Mets stumbling under fly balls, a faint resemblance to the Willie Mays of the San Francisco Giants days when he caught everything in his vicinity with an effortless grace.

I can remember Elgin Baylor—a boyhood idol I still rate as the most spectacular of all basketball players—in his fading hours with the Lakers, the gravity-defying bounce gone from his ravaged knees.

Certainly, Kareem Abdul-Jabbar isn't what he was, say, ten years ago, but the fact that he still is able to take over a game at his age—and that's what he and Magic Johnson did during those final minutes against the Mavericks—makes him the most unique figure now gracing the sporting scene.

Abdul-Jabbar says he will retire at the end of next season when he will reach the oh-so-painful forty mark, but at least one observer, Jerry West, feels it might be a premature decision.

"I honestly think Kareem could play—and play effectively—for another five years," says West. "All he would have to have is some players up front who can take some of the workload off him."

In the past few years, Kareem Abdul-Jabbar seems to have specialized in making sportswriters, and not just me, eat our computer printouts.

After the first game of last year's championship Los Angeles–Boston series—the Lakers were beaten by thirty-four points—Abdul-Jabbar was crucified unmercifully by the national press.

You may recall what he did in the Lakers' emotional Game 2 victory—thirty points, seventeen rebounds, eight assists, three blocks— and what he did throughout the remainder of the series to earn the MVP trophy.

It seemed only a few weeks ago, during the final stages of the Lakers' regular season, that Abdul-Jabbar, finally, was showing dangerous decline as he dispensed one listless game after another.

But apparently this was another momentary mirage in the career of a man who has given great hope to those nearing, or enduring, the agonies of middle age.

KAREEM BREAKS SILENCE ON HIS BIGGEST CRITIC

Long Beach Press Telegram, *March 22, 1990*

At a press conference the other day at the Forum hyping his book, *Kareem,* Kareem Abdul-Jabbar didn't exactly disguise his dislike for longtime critic Wilt Chamberlain.

"Will you talk to Wilt if your paths happen to cross?" he was asked.

"Nope," he replied curtly.

"Would you appear on a television talk show with him?"

"Nope."

"Would you play him for a million dollars in a one-on-one charity game?"

"Nope."

The Kareem Abdul-Jabbar-Wilt Chamberlain feud long has been one of the most fascinating on the sporting landscape, considering the 7-foot-plus principals just happen to be the two most dominating centers in basketball history.

And at the fear of sounding immodest, your venerable correspondent has been a central part of it, inasmuch as 95 percent of Wilt's fulminations against Abdul-Jabbar across the seasons were conveyed through my column.

In fact, it was a hallowed annual event for me to call up Wilt about this time of the season when Abdul-Jabbar was still performing with the Lakers and seek a critique from him on Abdul-Jabbar's work.

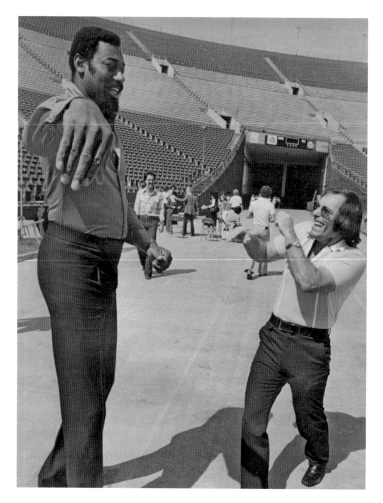

Wilt Chamberlain and Doug engage in a bit of frivolity before serving as judges at a Raiders cheerleading tryout at the Memorial Coliseum in Los Angeles. *Author's collection.*

Wilt being Wilt—i.e. outrageously candid, outlandishly quotable, characteristically controversial—it wasn't surprising that he often dispensed unflattering assessments of Abdul-Jabbar, underscoring most often Abdul-Jabbar's defensive laxities and rebounding deficiencies.

"How can a man seven-foot-two like Kareem wind up with three or four rebounds in a game?" Wilt used to ask derisively.

To Abdul-Jabbar's credit, he never reacted to Wilt's endless digs, a stance he has altered dramatically in *Kareem*, in which he writes a three-page italicized letter to "Wilt Chumberlame."

Among other things, Abdul-Jabbar mocks Wilt for always winding up a loser at the end to Bill Russell and the Boston Celtics.

"Bill Russell and the Celtics gave you a yearly lesson in real competitive competence and teamwork," he wrote. "All you could say is that your teammates stunk and that you had done all you could, and besides, the refs never gave you a break. Poor Wilt. You got all these rebounds and scored all these points and you were stuck with worthless teammates. What a shame!"

Abdul-Jabbar also scorches Wilt for winding up a loser to the New York Knicks in 1973. "That Knicks team didn't even have a center," he said. "Jerry Lucas, six-eight and 230, played high-post center that year. He was always considered a forward but he had enough guts and smarts to outplay you consistently.

"Yes, Wilt, we know you got umpteen rebounds per game, but no one really cares about those stats. The only significant stat is the New York Knicks' world championship. I guess that was the final straw for you, because true to form, you quit after that season and haven't been seen on the court since."

Abdul-Jabbar closes the derogatory missive by saying, "So, now that I have left, one thing will be part of my legacy: People will remember that I worked with my teammates and helped us win. You will be remembered as a whining crybaby and a quitter, stats and all."

"Did your publishing house inspire you to finally respond to Wilt Chamberlain?" Kareem Abdul-Jabbar was asked.

"No, not at all," he said. "It's just that Wilt for years has been taking shots at me, and I just decided to get in a few for myself."

Kareem Abdul-Jabbar thinks that Chamberlain's snippings against him were motivated by jealousy, but I disagree. I think it started years ago when Kareem Abdul-Jabbar was a youngster known as Lew Alcindor and when, asked by a reporter what center he respected most, he replied, "Bill Russell."

You must understand that Wilt Chamberlain, to this hour, is haunted by the specter of Bill Russell—the fact that he won only two world championships during his thirteen seasons in the NBA compared to Russell's eleven.

"Sure, it hurts when I always read how Bill Russell was such a great winner and I always found a way to lose," Wilt once told me. "It's so unfair. Except for about two seasons, Russell always was surrounded by better players than I was. Most of the players on those great Celtic teams are now in the Hall of Fame."

Wilt Chamberlain and I formed a close friendship that went back more than two decades to when I was covering the Lakers, and I used to pal around with him on road trips.

We had in those fun-filled days one passion in common: meeting ladies. And it was quite an experience for a youthful reporter to tag along with Wilt to the various big eastern city nightclubs where he was such a fixture.

Ironically, my long association with Chamberlain came to an end last year after I related his annual comments on Abdul-Jabbar.

Wilt insisted to mutual friends that our conversation was supposed to remain off the record, which, if true, would have been the first time in twenty-two years that this was the case.

"The irony of all ironies is that you and I talk to each other now, but Wilt and I don't," I said to Abdul-Jabbar as he got ready to do an interview with Jim Hill.

Kareem Abdul-Jabbar arched his brow in puzzlement, shook his head and said acidly, "Maybe that tells you something about Wilt Chamberlain."

BASKETBALL CHANGES BOTHER WOODEN

Long Beach Press Telegram, *March 25, 1990*

The voice still has the firmness of a man accustomed to being in command, and John Wooden is seated this quiet evening at his desk in the den of his Encino condominium reciting passages from such a learned gentleman as Abraham Lincoln.

The walls are covered with the memorabilia of his glorious past, and it's as though a quarter of a century of UCLA basketball is alive right there in your midst.

There is momentary silence as John Wooden pulls out another passage from his large collection, and moving across your mental screen is John Wooden on the Pauley Pavilion sidelines with a rolled-up program in his right hand, and suddenly you can see him blowing a kiss before the start of a game to his beloved wife, Nell, and you can see Walt Hazzard, Gail Goodrich, Lew Alcindor, Lucius Allen, Mike Warren, Sidney Wicks, Curtis Rowe, Bill Walton, Keith Wilkes, Marques Johnson, Henry Bibby and countless others romping up and down the court on the way to ten NCAA titles in twelve seasons for the Bruins.

He is six months away from his eightieth birthday, this greatest of all basketball coaches, maybe greatest of any athletic coach period, but he is as alert as he was when he was driving the Bruins to their epic achievements.

John Wooden and Lew Alcindor, who later changed his named to Kareem Abdul-Jabbar, celebrate UCLA's 79–4 win over Dayton for the school's third NCAA title—and first of what would be three during Alcindor's career with the Bruins. *Courtesy of the University of California–Los Angeles.*

The NCAA tournament is now in full bloom, and once upon a time it was the private domain of John Wooden and his teams who made such a mockery out of the event.

"Television is the worst thing to happen to intercollegiate basketball as far as I'm concerned," he says. "It forces games to be played at all hours of the day. It forces teams to play too many games. It also has made actors out of a lot of the players and even the coaches.

"I know the revenue schools make from television have helped defray the costs of non-income-producing sports. And that's good. But television has turned college basketball to a level only a notch below pro basketball."

John Wooden is in a melancholy mood because the following day he and his son and daughter and other family members will journey over to Forest Lawn Cemetery in the Hollywood Hills to visit the grave of Nell Wooden.

"It was five years ago tomorrow that we lost her," he says of the woman he had been married to for fifty-three years and had been childhood sweethearts in Martinsville, Indiana. "She was the only woman I ever dated, ever was with. Oh, do I miss her. Not a day goes by without me thinking of her."

He speaks about Nell Wooden often, and there is hurt in his voice because their relationship was so warm, tender and close, and he spent most of his time during the final year of her life staying with her in the hospital.

"If I didn't have any family left, I doubt I'd still be around," he says.

He thinks college basketball has changed dramatically since he departed in 1975, when he went out with still another UCLA title.

"No doubt about it, the players have greater individual skills now," he says. "But I'm not sure they play the game as smartly as they once did. There is a lot of unnecessary one-on-one stuff I see that I find disturbing.

"And I think the coaches have changed, too. They've made the game so much more complicated than it really is. Just look at them on the sidelines, storming around signaling to the players what to do on offense and defense.

"I never believed in that. At UCLA, we prepared for everything *before* a game, not during it. I think all you do by shouting instructions to your players during game is to confuse them."

The skeptics claim that John Wooden's accomplishments couldn't be repeated in this era of parity, that there simply are too many good teams around for one to emerge with a string of national championships.

"I've heard that argument, and I disagree with it," says Wooden. "You don't think there was parity when we played? Well, then how come in our ten championship games, we faced ten different schools?

"I'm sure before we won all of our titles that no one then thought such a feat was possible. And no one thinks it's possible now. But I do."

It is startling that Wooden never was asked to coach the U.S. Olympics basketball team.

"I was never a part of the 'in group' of the coaching fraternity," says Wooden. "Remember, I never drank, so I never went to those cocktail parties where everyone made their political contacts. When I went to a coaches' convention, I'd go with my wife, attend a meeting and then go back to my hotel room."

It is also startling that the most John Wooden earned from UCLA was the $32,500 he pulled down in his final season.

"I could have tripled my salary had I accepted coaching offers elsewhere," he says. "I got offers from Louisville, Purdue, Indiana and even the Lakers. Yes, Jack Kent Cooke wanted to hire me, but I never even considered it."

John Wooden recalls an incident with the former Lakers owner one evening when he was Cooke's dinner guest at a Kings game.

"It was right after we had beaten Houston by about sixty-five points in an NCAA game," relates Wooden. "Cooke came up to me and said, 'Can you believe how Elvin Hayes choked?' And I said, 'No, Mr. Cooke.' I don't think I would have lasted long working for Jack Kent Cooke."

"Do you have any regrets about your coaching career?" he is asked.

"None at all," he says. "I think the three most important things in life are health, happiness and peace. And these are things I've been blessed with for most of my years."

ONE MORE MAGIC MOMENT

Long Beach Press Telegram, *February 10, 1992*

ORLANDO, FL—It was as though Magic Johnson had never been away from the game that had been his stage across so many memorable seasons.

It was as though someone had played a cruel joke on the sporting multitudes and finally had decided that we had suffered enough from his

absence and that we should be given at least one more remarkable glimpse of this legendary basketball hero performing in his element.

It was as though somebody up there had arranged a storybook script for him that will be etched in athletic lore.

There was Magic Johnson once again on Sunday afternoon on the hardwoods giving a stirring recital of his unique skills among his high-priced peers in the NBA All-Star game.

There he was playing four positions and high-fiving teammates and slithering in for layups and raising his hands in triumph and making hook shots and warmly embracing Isiah Thomas and flipping no-look passes and converting three straight three-point shots in the final glorious moments and listening to the cheers from the 14,272 Orlando Arena fans throughout his twenty-nine minutes of duty.

The cynics dismissed his one-game return as being nothing more than a publicity stunt by a fallen idol desperate to regain lost glory, but there was Magic Johnson demonstrating that a person who has tested positive for the HIV virus can function effectively in the workplace by orchestrating the West to a 153–113 win over the East.

"I'm in a dream right now—and I really don't want to wake up," said Magic Johnson after his surrealistic twenty-five-point, nine-assist masterpiece that earned him the MVP trophy and rousing applause from everyone who witnessed it. "I got to be back in the NBA for one more time. What a feeling! This is something I'll cherish for the rest of my life."

Two hours before the game, Magic Johnson sat solemnly in his team's dressing room and insisted he wasn't nervous even though he hadn't faced any NBA competition since late last October when he played his final exhibition game for the Los Angeles Lakers.

"I'm going to be back in my world," he said. "All the pressure I've been under is going to be released. Playing basketball is what I'm all about."

Basketball was what Magic Johnson was all about in an emotional setting where he was the brightest star in a galaxy that included Michael Jordan and Charles Barkley and David Robinson and Patrick Ewing and Isiah Thomas and all the others.

Even before the opening tipoff, he was in the spotlight, as the fans stood and chanted his name when he was introduced. Isiah Thomas led the East team across the floor, and each player shook his hand and hugged him in what was a poignant scene.

When asked what the East players said to Magic, he replied, "It was mostly hugs and high fives...that's what I really loved. You know, this

is a game of passion. It's all for one, one for all, and it's the guys, the camaraderie, that I miss most."

All-Star games are not contested fiercely, and no one played Magic as though it were June and the NBA Finals.

"It was his show and his day, and we were playing a tribute to him basically," said Michael Jordan, who remained in the shadows and wound up with only eighteen points.

True, it was Magic Johnson's show, but wow, did you see that skyhook he lofted over Dennis Rodman, and omigod, how about that unbelievable pass to Dan Majerle, and ouch, look at the way he's banging bodies with Charles Barkley, Patrick Ewing and Kevin Willis, and do you believe in miracles—how 'bout that final three-point shot he somehow made over Isiah Thomas in what were the final points of the game and maybe of his career.

"Didn't surprise me one bit that he made that shot," said Isiah Thomas. "I've always said Magic Johnson is a special person put on this earth to do special things. And that was just one of the special things he did out there today."

Maybe the men facing Magic Johnson gave him leeway that wouldn't have been there under normal circumstances, but only Magic himself made those deft passes and array of shots so befitting of his nickname.

And only Magic Johnson—under intense media scrutiny—could somehow stay detached from all the controversy swirling in his midst and still manage to play exceptionally.

"If this is my last game—and it might be—this is the way I wanted to go out," said Magic. "Those last few minutes were great when I was going one on one with Isiah and forced him into an air ball and one on one with Michael and forced him to miss.

"The only one I didn't get was Larry Bird. But I'll see him on the blacktop someday, somewhere."

After his last three-pointer nestled through the net and the horn sounded, Magic Johnson suddenly was engulfed by his fellow players and broadcaster and photographers.

He kept smiling and shaking his head, and a few minutes later he was accepting the MVP trophy from NBA commissioner David Stern.

And with Natalie Cole's riveting "This Will Be" filling the air, Magic's wife and parents joined him in his moment of sterling triumph.

"I just wish I could bottle everything that happened out there and keep it for posterity," Magic Johnson would say later. "But the *real* importance of this game is that we got to educate everybody. First, it showed that people with the HIV virus can live on, lead productive lives, run and jump, whatever.

"Second, it showed that you can't get the virus from playing against someone, hugging or kissing them, high fiving them, whatever.

"And, third, it showed other people who don't have the HIV virus but have handicaps that they can continue to live and that life doesn't have to stop."

Magic Johnson realized the historic nature of his performance.

"I guess this is the perfect ending to the story," he said. "All week I've been trying to figure out if I was at a typewriter, what it would be. And I guess I came up with one."

Magic Johnson came up with a classic.

SWEET REPEAT:
LA LAKERS BEAT DREADED CELTICS IN DELIRIOUS VICTORY

Long Beach Press Telegram, *June 18, 2010*

With a perfectly distilled ferment of revenge, salvation, joy, retribution and redemption, the Los Angeles Lakers on Thursday night wound up tormenting their eternal tormentors, the Boston Celtics, in the climactic Game 7 of the NBA Finals at Staples Center.

Oh, it was ugly, as the Lakers and Kobe Bryant had a notably atrocious evening of shooting—Bryant wound up missing eighteen of twenty-four shots—but they managed to overcome a thirteen-point third-period (49–36) deficit to repulse an inspired challenge from the resilient Celtics.

While Bryant might not have been his usual effective self on offense, it was his toughness on defense, especially in the final period when he and Pau Gasol took control of the rebounds, that ignited the Lakers' dramatic 83–79 win witnessed by 18,897 jittery, nervous, delirious spectators happily blanketed by confetti at the final buzzer.

But this one was a lot more than a rousing triumph over a team that a mere two years ago had left the Lakers a battered, ignoble mess in the wake of a thirty-nine-point impalement in the elimination game at the TD Garden in Boston.

And this is a lot more than sustaining a dynastic Lakers epoch that has seen LA's most popular athletic entity now claim five world titles in eleven seasons, including the current back-to-back ones.

This one was for all those other Lakers across the decades who had suffered so much against the Celtics, who had a 9-2 record against the LA

team in these post-season test matches that so often turned out to be tortuous matches for those in the purple and gold and for their legion of followers.

This one was for Elgin Baylor, LA's first basketball superstar, who had accomplished so much in a Lakers career in which he suffered spring agony seven times against the Celtics, including once when the franchise still was ensconced in Minneapolis.

This one was for Jerry West, whose 0-6 playoff mark against the Celtics still irritates him and who to this day refuses to wear any apparel that has green in it.

This one was for Wilt Chamberlain, who lost only once as a member of the Lakers against the Celtics but did so on six other occasions when playing for San Francisco and Philadelphia and who forever had to endure taunts about his inability to beat Bill Russell.

This one was for Frank Selvy, the journeyman Lakers guard who in 1962 missed a final-second, Game 7 open jump shot at Boston Garden that would have given his team the NBA title that, instead, went to the Celtics once again when they dominated the overtime.

This one was for those—and that means every aging baby boomer, as well as West, Baylor, Mel Counts, Keith Erickson, Johnny Egan—who were present on that dark May 5, 1969 evening forty-one years ago when those victory balloons Lakers owner Jack Kent Cooke had so presumptuously stuck in the Forum rafters never were released because the Celtics emerged with their most stunning Game 7 victory.

But perhaps most of all, this one was for Kobe Bryant, who now has five NBA titles during his peerless Lakers incumbency and whose legacy as one of his sport's greatest performers is now firmly secure, as is his designation as the best basketball player on the planet.

LeBron James? Superb athletic skills, superb statistics, superb regular season record but still no world titles after seven seasons in the league.

Kobe Bryant got his first one in his fourth year, although he did have the benefit of O'Neal before ol' Shaq ate himself out of being a superstar and now has Gasol, who wound up with nineteen points and eighteen rebounds.

Bryant, naturally, earned the Bill Russell MVP Trophy for his stout work throughout the series, and despite his errant shooting on Thursday night, he had fifteen rebounds and twenty-three points, ten of them coming in the climactic final quarter.

"This title is the sweetest," said Bryant. "We had to work so hard for it. We had to win our final two games against Boston, and we managed to do that."

Kobe Bryant has been the face of the Lakers since being acquired by Jerry West. *Photo by Sergeant Joseph A. Lee.*

No one benefited more from the Lakers' victory than Jackson, who reportedly has a clause in his $12-million-a-year salary that would result in his receiving a $2 million bonus if his team won another championship.

Well, it did, and Jackson has to feel today like a guy who won the California State Lottery, although it's doubtful his Dunn & Bradstreet rating would have been negatively impacted had his team betrayed him.

With a record eleven NBA titles on his resume, Jackson has to be ranked now as the greatest coach in all the years of the NBA, although it's indisputable he's also the most fortunate. I mean, six of those crowns came with the Chicago Bulls with Michael Jordan and Scottie Pippen at his disposal, and five have come with the Lakers with Bryant, Gasol, Shaquille O'Neal, Lamar Odom, Derek Fisher, Robert Horry and a lot of other solid players on his roster.

Still, one must not minimize Jackson's achievements since one of the defining traits of his teams has been their ability to perform well in crisis times.

And that certainly was the case on a memorable evening when the Lakers gained a measure of revenge against the dreaded Celtics.

3

HOCKEY

ONE BIG MOVE MAKES THIS A HOCKEY TOWN

Los Angeles Herald Examiner, *August 11, 1988*

Wayne Gretzky already has made a historic impact with the Los Angeles Kings. He has sporting fans, even non-sporting fans, in Southern California actually discussing the Kings for the first time in the middle of the summer.

He has sporting fans around America actually discussing the Kings for the first time in the middle of the summer.

He has sporting fans around Canada for the first time actually believing that there is a legitimate National Hockey League franchise in Los Angeles—instead of some zany outfit that always has specialized in buffoonery.

With one daring, deft maneuver, the new Kings owner, Bruce McNall, accomplished something his predecessors, Jack Kent Cooke and Jerry Buss, never were able to do with a franchise that long has ranked right there in these parts on the nuisance scale with smog, freeway gridlock, brushfires, earthquakes and Benoit Benjamin's work habits.

Instantly, without so much as even winning one game—a rare event that too often has been occasion for great celebration—the Kings finally have gained credibility that has been noticeably absent since they came into existence in 1966.

There isn't much debate among hockey pundits that Mr. Gretzky is the best performer in all the seasons of his game—and for the Kings to land

such a unique commodity when he's still at the height of his skills at twenty-seven is mind-boggling.

There are those unenlightened souls, of course, who with obligatory indignation and dimwitted analysis will tell you how the Kings gave up too much to secure the legendary Great One who already holds so many NHL records.

These are the same kind of people with shallow insight and narrow perspective who in 1920 thought the New York Yankees were shameless spendthrifts in handing over a considerable sum of money—$100,000!—to the Boston Red Sox for a young outfielder named Babe Ruth; or who in 1975 thought the Lakers were forfeiting their future by acquiring Kareem Abdul-Jabbar for Elmore Smith, Dave Meyers, Junior Bridgeman and Brian Winters; or who as recently as last fall thought the Rams were pulling off an epic coup by detaching Eric Dickerson for a bunch of first-round draft picks that never will come close to matching Dickerson's production.

When a long-struggling team has a chance to get a superstar of Wayne Gretzky's staggering dimension, it would have to be practicing some diabolical form of self-destruction to pass up such an opportunity, even if it does mean relinquishing first-round draft picks in 1989, 1991 and 1993;

Wayne Gretzky took LA by storm, illuminating hockey for the California masses. *Courtesy of the Los Angeles Kings.*

giving up mediocrities Jimmy Carson and Martin Gelinas; and handing over $15 million to the Oilers.

Gretzky has been such a dominant player for so long that his reputation transcends his sport—and his mere presence in Los Angeles figures to result in a large new group of hockey converts, as already evidenced in the past forty-eight hours as 2,500 new season ticket holders have come aboard with the Kings.

You can be sure this winter that there will be people venturing to the Forum who otherwise never would be caught near a hockey rink to take a curious glimpse at this state-of-the-art practitioner whose wizardry on skates is a sight to behold.

Obviously, Wayne Gretzky alone won't turn the Kings into Stanley Cup champions—Abdul-Jabbar didn't win a world title with the Lakers until his fifth season, when Magic Johnson joined the team—but he certainly enhances their chances and strengthens their box-office appeal.

McNall, who made a mint from collecting ancient coins, figures to make a mint from his latest acquisition with the certain windfall that will come from increased season ticket sales and television revenue.

The transaction might have been a shocking development to most observers—Canadians still are in a state of national mourning—but your venerable correspondent first wrote about such a possibility in this newspaper after having a conversation with Gretzky at the Victor Award cocktail party on the evening of June 9 at the Las Vegas Hilton.

When I told Gretzky, who was with his then fiancée, Janet Jones, that it was unfortunate an athlete of his caliber never would be able to play in a media center the size of Los Angeles, he replied, "Never say never. You never know what might happen in the future."

Actually, Bruce McNall and long-suffering Kings fans in this vicinity owe Janet Jones, whom Gretzky recently married, a huge debt of gratitude.

I mean, if Wayne Gretzky had fallen in love with a woman from, say, Edmonton, he never would have approached the Oilers owner, Peter Pocklington, and requested a trade that he hopes will ensure lasting connubial bliss.

As luck would have it—and the Kings have had precious little in their time—Gretzky became smitten by a woman who resides in Sherman Oaks and works in the film industry, which is not exactly booming these days in Alberta.

It's known that the new Mrs. Gretzky preferred her hubby to reside permanently in LA.

A compassionate man who obviously didn't want to be blamed for causing matrimonial strife, Mr. Pocklington, bless him, acquiesced to Gretzky, thereby establishing what might become a revolutionary bargaining trend in athletics.

You just know, for instance, that Ol' Doc Buss is now keeping his fingers crossed that a bachelor like Michael Jordan falls madly in love with a Los Angeles–based actress and demands to be traded to the Lakers on grounds of maintaining marital harmony.

It's Hard to Feel Sorry for Bruce McNall

Long Beach Press Telegram, *May 12, 1994*

The Big Shot is a dreamer who loathes reality. He feels compelled to impress people with material goods even though he doesn't have the capital to buy them. He's a showoff who wears nothing but name-brand apparel and tools around in nothing but fancy cars and lives in nothing but huge multimillion-dollar dwellings.

But it's all an illusion that eventually will cause him anguish and embarrassment because it's an inevitability of the law of economics that a person who spends more than he has will wind up broke.

He blithely ignores such a fact because his vanity blindly blurs his perceptions, and he continues his excesses in the same self-destructive way that a crack addict keeps puffing on a pipe or a degenerate gambler keeps making those bets that keep him impoverished. He's hopelessly addicted to a lifestyle of fakery.

He's a pecking-order guy and stays clear of blue-collar types because he figures his image would be tarnished among his high-society friends if he were caught consorting with those from such a lowly caste.

He's a shameless name-dropper who enjoys being in the company of celebrities, and he'll subtly let you know about the immense donation he once made at a Sinatra fundraising event even though he never provides proof of it.

The Big Shot is a financial juggler who knows the wheedling techniques needed to coax banks out of money, and he has cost several loan officers high-paying jobs because of such sly manipulations.

He hangs out in upscale taverns, and his conversations with customers are often centered on his business deals and how well they're going, but the fact that no one ever can recall him picking up a tab would tend to belie such success.

He's an insomniac because his nights are filled with the restless anguish of coming up with exotic new flimflams to appease his disgruntled creditors, and he eventually drops out of sight in an effort to hide from them, as well as those many friends he bilked out of cash.

The Big Shot is a lamb in wolf's clothing, a movie set façade, a fake, a counterfeit, an illusionist, a David Copperfield able to float in midair because of some sleight of hand trickery.

But the taxman always is waiting at the gate to collect his due, and those who reside beyond their means eventually have their cruel comeuppance in the form of lawsuits, repossessions, bankruptcies, Chapter 11s, tarnished reputations, widespread social humiliation and even prison.

The one-time majority owner of the Los Angeles Kings, Bruce McNall, was a Big Shot who couldn't control his spending impulses, and now his once sprawling empire is in ashes.

McNall came at you with a big smile, an amiable handshake and charming words, and the media have treated his recent downfall as a tragic occurrence because he has evinced this good guy persona who went out and got Wayne Gretzky and got the Kings into the Stanley Cup.

Well, it is tragic—for those he swindled out of money.

I find it difficult to work up any sorrow for Mr. McNall when I think about all the bills he's skipped out on after he went on his spending spree for movie productions, Canadian Football League teams, Honus Wagner baseball cards, rare stamps, ancient coins and sundry other goodies.

McNall did owe $92 million to the Bank of America, and now his debt has been cut to a mere $32 million after he sold a good portion of the Kings to a couple of gentlemen named Joe Cohen and Jeff Sudikoff.

I asked a Bank of America official the other day if he thought McNall would make good on the money he owed the bank.

"I doubt it," he said. "We'll probably wind up absorbing the loss."

Thirty-two million?

I'd like to know the names of those gullible souls who were willing to give McNall such a vast loan in the first place, and one can only idly wonder how many other banks that he has conned will surface.

Obviously, Bruce McNall was a Big Shot who knew how to exploit the system, and now he's enveloped in a maze of lawsuits because of his financial indiscretions.

In gambling parlance, you're demeaned as a welsher when you don't pay what you owe.

The McNall apologists—and they abound in these parts—will tell you that he's just a victim of a depressed economy and that a lot of other high-profile investors have suffered similar plights in recent years.

So bleeping what?

I realize that this will be quite offensive to those politically correct bleeding heart yahoos who dot the landscape these days like a swarm of unctuous locusts, but human beings should be held accountable for their dark actions irrespective of the conditions that caused them.

Bruce McNall is responsible for his downfall because he liked playing the Big Shot role at the expense of a lot of people who now hold notes from him that never will be honored.

It always mystifies me how a guy like McNall in all good conscience can allegedly owe so many people so much money and still tool around in a Rolls Royce and live in a mansion.

But the Big Shot belongs to a different breed and lives by his own warped rules, rules I always have found repugnant.

(Bruce McNall eventually pleaded guilty to five counts of conspiracy and fraud and admitted to bilking six banks out of $236 million over a ten-year period. He was sentenced to seventy months in prison in 1997 and was released in 2001. He has been listed by the State of California as its largest delinquent taxpayer.)

"Ace" Bailey's Legacy Lives On

Long Beach Press Telegram, *September 10, 2007*

It began as another normal day for Kathy Bailey as she drove her husband, Garnet (Ace) Bailey, out to Logan International Airport so he could catch his 8:00 a.m. United Airlines Flight 175 to Los Angeles.

During the twenty-nine years of their marriage, Kathy Bailey had driven her husband to a lot of airports, not only the one in Boston but also ones in other places they had lived like Washington, D.C.; Detroit; St. Louis; and Edmonton.

These all were cities where Ace Bailey played hockey, including as a member of a couple of Boston Bruins teams that won Stanley Cups and also as a fierce protector of an eighteen-year-old rookie named Wayne Gretzky when Gretzky was breaking in with the Edmonton Oilers of the World Hockey Association during the 1978–79 season.

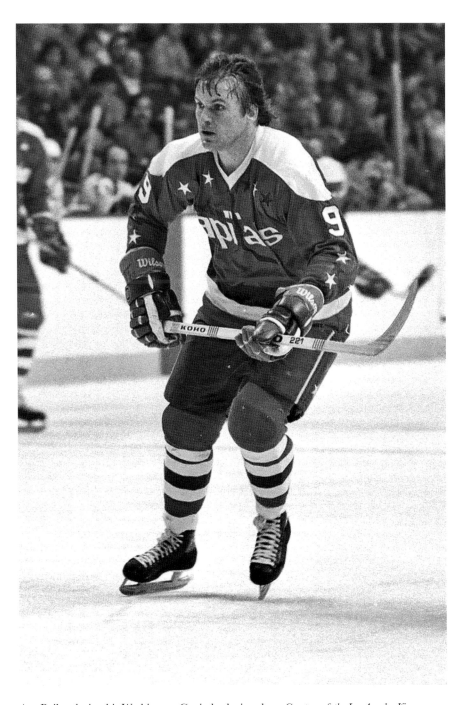

Ace Bailey during his Washington Capitals playing days. *Courtesy of the Los Angeles Kings.*

Ace Bailey was now fifty-three, and he was the director of professional scouting for the Los Angeles Kings, who were opening training camp that day at their El Segundo facility.

"Ace had me set an alarm clock, but he woke up before it went off, and I was the one who overslept," relates Kathy Bailey. "I remember Ace waking me and saying, 'We gotta get going.' I now wish it had been him who had overslept…"

Everything was uneventful for Kathy Bailey early on that September 11, 2001 morning as she dropped her husband off at the airport, kissed him goodbye and returned to her suburban home twenty minutes north of Boston in a hamlet called Lynnfield.

"I came home, made some coffee and turned on the TV to watch the *Today* show," she says. "But then it suddenly was interrupted by a news bulletin when that first airplane hit the north tower of the World Trade Center.

"Our son Todd came over, and we were watching in amazement as another plane crashed into the other World Trade Center tower."

At exactly 9:02:59, a 767-200 Boeing, Flight 175 from Boston carrying fifty-six passengers—including five terrorists with knives and box cutters—and a crew of nine tore into the south tower of the WTC.

"We had no idea that Dad was on that plane," says Kathy. "I had no thought he was in harm's way because his plane was headed toward LA. I soon would find out the awful truth."

Ace Bailey would be one of 2,974 people to die from the terrorists' suicide attacks that dark day that caused so much sorrow in this country and dramatically altered the international political landscape.

"At first I couldn't believe it," says Kathy Bailey. "It's just hard to accept your husband walking out the door and never returning. I kept expecting him to return home any moment, but it never happened.

"Ace was such a good man, and he was so full of life. Obviously, it was such a shock to lose someone in that manner that you love so much, and it was terribly difficult for a long time. After a while, you learn to live with it, and there are times when I can just hear Ace telling me, 'Get going. Start doing things. Life goes on.'

"And it has, but you have to make a concerted effort to bring happiness into your life. The suddenness of it all still defies comprehension. One moment you're saying bye to your husband at the airport, and the next moment you're watching a plane that he is on crash into a building. It was a little unreal. But something good has come out of the tragedy."

That something good is the Ace Bailey Children's Foundation, which has raised more than $1 million and refurbished a 6,500-square-foot room that

is now called Ace's Place at the Floating Hospital for Children at the Tufts New England Medical Center in Boston.

"It's a playroom for kids, and there is something there to do for kids of all ages," says Kathy proudly. "The older kids have air hockey, and the younger ones have toys and games and various other things. Ace always loved kids. We always said he was a kid who never grew up."

On the day of the 9/11 tragedy, Kathy Bailey's sister, Barbara Pothier, came over to console her—and wound up staying for a year.

"Barbara was all set to go to work at a new job, but she wound up becoming the executive director of Ace's foundation," she says. "Our family wanted to do something in Ace's memory, and we thought something that would help children would be what he wanted.

"And it's really worked out well. The foundation is now going to help refurbish the neonatal intensive care unit at the children's hospital. The Boston Bruins and LA Kings have been very supportive, as have so many people."

A native of Lloydminster, Saskatchewan, Ace Bailey played forward in the NHL for ten seasons, scoring 107 goals, collecting 171 assists and amassing 633 penalty minutes.

"Ace was a hard-nosed player who didn't back down to anyone," says Dave Taylor, the Kings' former general manager who is now the director of player personnel for the Dallas Stars.

"Ace was just a terrific guy, popular with everyone,'" says Bob Miller, the Kings' longtime announcer.

"Ace was a great big teddy bear, but he was no shrinking violet," says Kathy Bailey. "We don't have any information of what happened on that plane. But if Ace had sensed something was wrong, he would have tried to do something about it. He was a person who protected his turf. There's just no way he would have sat in his seat and done nothing."

Kathy Bailey was a flight attendant for Eastern Airlines in 1970, and she met Ace Bailey when the Bruins were returning after playing a game in New York.

"The Bruins won the Stanley Cup in May 1972, and we got married in June," she says.

"Ace wound up playing for several teams and became very good friends with Wayne Gretzky," says Kathy.

Ace Bailey served as a scout for the Oilers for thirteen seasons and wound up with five Stanley Cup rings.

Kathy Bailey today will attend a memorial service for the 9/11 victims at the statehouse in Boston and then will make an appearance, along with several members of the Bruins, at Ace's Place.

"When I walk into that playroom and see all the kids with smiles on their faces, it makes me really feel good," she says with emotion. "It's a place where good things can come out of sadness. It is a happy oasis, and Ace's spirit is all over that room. The terrorists might have taken away Ace, but they didn't take away his memory."

4
BASEBALL

FOR ANGELS, HEAVEN MUST WAIT: DID MAUCH OUTSMART HIMSELF?
Los Angeles Herald Examiner, *October 13, 1986*

He was one strike, one out, one breath away from exorcising all those demons that have haunted him since 1964, when he managed a Philadelphia Phillies team that blew a six-and-a-half-game lead with twelve remaining.

This finally was going to be Gene Mauch's glorious redemption, and all those years of not making it to the World Series and all those years of critics saying he never would because he over-managed would finally come to an end.

He had it all going his way with two outs in the ninth inning in the madhouse of high drama called Anaheim Stadium.

His team had a 5–4 lead over the Boston Red Sox, and his premier pitcher, Mike Witt, was on the mound, the bases were empty, and the 64,223 fans were standing and screaming and waiting anxiously for the California Angels to make their first American League pennant official.

It was the perfect setting for a man who so long has had to endure the ghosts of Jim Bunning and Chris Short and the charges that he panicked badly and overworked his star Phillies pitchers down that wicked stretch twenty-two years ago.

But then Gene William Mauch—instead of sitting in the dugout and allowing Witt the opportunity to finish out the proceedings, instead of

allowing his finest pitcher the opportunity to record that historic final out—made a dramatic decision.

He took out Mike Witt in a move that would set in motion a disastrous sequence for the Angels and would again have his critics afterward speaking harshly about his tactical wisdom.

Instead of allowing Witt to face Red Sox catcher Rich Gedman, who already had a single, double and home run, Mauch brought in Gary Lucas.

It was the percentage move, left-handed pitcher versus left-handed hitter, and Lucas had previous success against Gedman (he had struck him out on the two occasions he had faced him). Gene Mauch knew he would be lauded for such a stratagem if it worked.

But it didn't.

On his first pitch, Lucas hit Gedman, which was bad enough. But what made the errant pitch even worse is that it inspired Mauch to bring in the erratic Donnie Moore, the same Donnie Moore who had given up two runs and four hits to the Red Sox on Friday night, the same Donnie Moore who can look so overpowering in one game and so much like Tom Niedenfuer the next.

Well, Donnie Moore was Tom Niedenfuer now, yielding an unlikely two-run homerun to a journeyman outfielder named Dave Henderson, who is not to be confused with Jack Clark.

Suddenly, the Red Sox—set for the morgue slab only moments earlier—found themselves with unexpected life.

Suddenly, the Angels—set to douse themselves with champagne only moments earlier—found themselves having to catch another flight to Boston even though they did come close in their ninth-inning turn when both Doug DeCinces and Bobby Grich failed to drive in the deciding run with the bases loaded.

Suddenly, Gene Mauch—the Little General in his twenty-fifth season of major-league managing, the man often accused of making moves even when sound reasoning dictates they aren't needed—found himself again under scrutiny.

"I pulled Witt because Gedman had been hitting him all afternoon," explained Mauch softly in his locker room office. "And I knew that Lucas had handled Gedman in the past. Things just didn't work out the way we wanted.

"I can handle that. But what if I had left Witt in to pitch to Gedman and he had hit a rope? Well, I couldn't have lived with that."

Maybe so. Maybe Gedman was three for three against Witt. Maybe Gedman would have continued his assault on him.

But there is the other side to the argument, the human side that Gene Mauch blithely overlooked in turning to his bullpen.

The Angels fans had reached a shrieking crescendo after two outs in the ninth inning. Anaheim Stadium was rocking and rolling like never before—and maybe never again.

The great moment for Gene Autry had finally arrived, and the adrenaline in Mike Witt had to be pumping at a staggering level.

Since Gene Mauch favors percentages, he had to know the odds were overwhelmingly against Rich Gedman, a .278 lifetime hitter, getting still another hit off Witt.

Mauch also had to feel the great emotion pouring out of the stands from the long-suffering Angels fans who were set to burst on the field as soon as Witt got that final out.

But Mauch managed to mute this human tidal wave of momentum for several minutes when he made his pitching change.

Crowd noise, of course, doesn't strike out hitters, but it is known to be an intangible asset—as players themselves will attest.

If ever a baseball crowd could be a factor, it was that stomping, shouting, frenzied assemblage that went berserk with anticipation after Witt had induced Dwight Evans to pop up to DeCinces for the second out of the ninth.

But then Gene Mauch sent Rene Lachemann to lift Witt—and the crowd never again reached such staggering emotional heights.

And neither, coincidentally, did the Angels.

"I've always had very little success relieving Mike Witt," said Mauch. "This has happened to him several times this season."

Gene Mauch found it difficult to believe that DeCinces didn't decide matters in that ninth when teammates occupied every base and there was just one out.

All DeCinces had to do was hit a long fly ball, but instead he hit a short one to Evans in right field.

"I have no place to sleep tonight because I bet my house that DeCinces would win it for us," he said.

"Does this remind you of the Milwaukee series?" asked a writer, referring to the Angels' famed 1982 playoff fadeout against the Brewers when they squandered a 2–0 advantage.

"No, it doesn't...not at all," he replied. "Look, you guys are making a big deal out of nothing. Our time's going to come. We're going to win this. Believe me, we will."

For Gene Mauch's tranquility, the Angels better win it, or their manager will have to spend still another off-season explaining moves that came back to torment him and his team.

DODGERS WILL MISS FERVOR OF FERNANDO

Los Angeles Herald Examiner, *August 2, 1988*

It is late morning on a solemn Sunday for the Los Angeles Dodgers and Fernando Valenzuela, and the ailing pitcher suddenly ducks his head into the office of Tommy Lasorda.

"C'mon on in, Fernando," says the Dodgers' manager.

Fernando Valenzuela spots a couple of reporters and shakes his head shyly.

"C'mon Fernando, come here," pleads Lasorda, his voice rising a couple of octaves.

"Naah…I'll talk to you later," says Valenzuela.

Fernando Valenzuela departs, and a few minutes later the Dodgers officially will announce that the man who never missed a start will miss at least five during the next three weeks because he was being put on the disabled list.

"Oh, this one hurts," Tom Lasorda would say later. "You know, I've become very close with Fernando and his family. I love playing with his kids. Look, I have pictures of his two sons on the wall here. This has been tough enough of a season for Fernando with his father passing away.

"He's been under a lot of strain, and I know how much this is hurting him inside. I talked to him yesterday and earlier this morning, and both times he told me he wanted to keep pitching. But I told him he'd be better off taking a rest and making sure his shoulder healed properly."

After a year and a half of ceaseless conjecture, after optometrists were summoned, after palm readers were consulted, after psychiatrists were engaged, the mystery of Fernando Valenzuela's dramatic deterioration finally unraveled over the weekend.

It turned out that Valenzuela's decline can be traced to a bum left shoulder that turned the celebrated screwball-throwing artist into a wild-throwing, home run–allowing journeyman who seldom has been able to finish his games, once Valenzuela's trademark.

"I had a feeling all along that there was something wrong with Fernando," admits Lasorda. "I knew he wasn't the same pitcher he had been before. In the first spring training game last year, he pitched three strong innings. But after that game, he never was as dominating again.

"But what could I do? I couldn't bench Fernando because of what I thought. I'd ask Fernando if he was all right—and he always said he was. He said he wanted to pitch—so I had to pitch him.

"I guess I've been covering up for him. I wasn't going to tell you guys that he wasn't throwing as hard as he once did or with the same motion. I'm never going to say anything derogatory about one of my players—at least not for publication."

The pain threshold of most baseball players

Fernando Valenzuela flashing the form that made him a left-handed pitching star for eleven seasons with the Dodgers. *Courtesy of Los Angeles Dodgers.*

is laughable when you consider the injuries their football counterparts routinely endure. A bruised rib cage, or a pulled hamstring or a slight ankle sprain is often the lame excuse for too many to take a few days off or even to go on the DL.

With 255 consecutive starts across eight and a half seasons, Fernando Valenzuela was a shining rebuke to the faint-hearted of his profession. He felt it was his obligation to perform unless it was a physical impossibility to do so, even if he did have a multiyear, guaranteed contract.

"Fernando went out there and pitched the same way he did when he was a kid pitching in Etchohuaquilla, Mexico," says Lasorda. "Fernando always

has felt that if he didn't pitch, he would be taking the money the Dodgers gave him under false pretenses. He has been a throwback to another era, an era when a player almost had to break an arm, or leg, for him to come out of the lineup."

The Dodgers will miss Fernando Valenzuela even though he has a mere 5-8 record, has failed to complete eighteen of his twenty-one starts, has given up too many runs and allowed too many hits and walked too many batters and has been a counterfeit version of the gentleman Peter O'Malley made into a millionaire.

Orel Hershiser is now the Dodgers' most dominant pitcher, and certainly Tim Leary this summer has been more formidable, but there was something about Fernando Valenzuela's resilience that made him a special commodity out there on the mound even during his time of struggle.

It might ironically be Valenzuela's most astonishing achievement during a career of so many big-game victories that he somehow willed himself to keep pitching without complaint even though his shoulder long has been a hindrance.

"Fernando is one of the fiercest competitors I've ever seen," says Lasorda admiringly. "Look, I've played with some great ones with the Dodgers—Jackie Robinson, Don Hoak, Carl Furillo, Pee Wee Reese, Roy Campanella, Gil Hodges and many others. Fernando was like those guys. He'd never give an inch and welcomed a challenge in a crisis situation."

For a long time, there was an aura of invincibility about Fernando Valenzuela, but as he has shown on too many recent occasions, he has become quite mortal. His anatomy has betrayed him just as it has done to so many other athletes across the seasons, although he did remain healthy for an inordinately long period.

"When do you think Fernando will be returning?" Tommy Lasorda was asked.

"Oh, knowing Fernando, he'll be back pitching for us as soon as he comes off the disabled list," says Lasorda.

Fernando Valenzuela might be back this season, but he might not—a sad chapter in what has been the storybook life of a man who is only twenty-seven years old.

(Fernando Valenzuela would return to make one more start for the Dodgers during their 1988 world championship season—a no decision—and was released by the team in March 1991.)

BASEBALL

Just the Latest Victim of the Curse of Dodger Blue

Los Angeles Herald Examiner, *October 16, 1988*

It couldn't strike the mighty American League champion Oakland Athletics, recent four-game knockout winners over the Boston Red Sox.

It couldn't strike Dennis Eckersley, who saved all four against the Red Sox and yielded no runs and only one hit.

It couldn't strike the Athletics on an evening when Jose Canseco hit a grand slam, Tim Belcher lasted only two innings and Kirk Gibson wasn't even in the Dodger dugout for eight innings because of a serious knee injury.

There was just no way the dreaded Curse of Dodger Blue, not to be confused with the Curse of King Tut, would once again strike an unsuspecting opponent in the most unlikely manner imaginable.

But it did. Oh, did it ever!

In a season of incredible comebacks and heroic home runs and record-breaking pitching and one emotional how-do-those-guys-ever-win-that-game triumph after another, the Dodgers and Kirk Gibson somehow managed to upstage even their own patented routine last night before 55,983 of the most astonished, shocked, raucous witnesses you'll ever behold.

"It was an act of God…an act of God coming to our rescue," shouted the Dodgers second baseman, Steve Sax, after Mr. Gibson came out of ER and pulled off what certainly could be construed as a divine act with his pinch hit, two-out, two-run, game-deciding home run off the invincible Eckersley that left the Dodgers once again chanting their standard "What a (bleeping) team!" and left still another stunned victim reeling in disbelieving agony.

"You see that…you see that?" Tommy Lasorda kept saying in the afterglow of his team's 5–4 win in the World Series opener. "I knew he could do it. There's nothing Kirk Gibson does any longer that surprises me. There's nothing this team does any longer that surprises me."

Welcome to Dodger Stadium, Athletics, wicked chamber of darkness for visitors, where things that aren't supposed to happen do happen, as every National League foe of the Dodgers has discovered to its horror this madcap summer.

A handcuffed Houdini used to escape from a sealed barrel thrown into a river. Siegfried and Roy make elephants disappear on a stage. But the Dodgers and Gibson and Orel Hershiser have been even more astounding—they have been confounding everyone in baseball for the past six months.

119

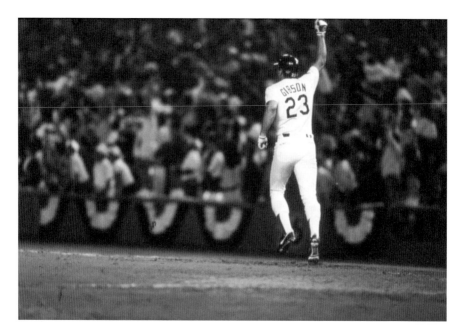

The Dodgers' Kirk Gibson celebrating his famous two-out, two-run, ninth-inning, game-winning home run against the Oakland A's in the 1988 World Series opener. *Courtesy of Los Angeles Dodgers.*

And they aren't doing it with mirrors or some other sleight-of-the-hand antic in continuing to dispense the most startling magic show now gracing the American scene.

The Dodgers are playing in the wrong venue. They should be operating out of the Magic Castle with their repertoire of illusion that turns out to be reality.

They slightly altered their trickery last night.

Why, they didn't even have Kirk Gibson in their lineup for eight and two-thirds innings, as he remained in the Dodgers' locker room receiving treatment on his bum knee.

Did the Dodgers perpetrate a cruel practical joke on the Athletics, leading them into a terminal case of overconfidence?

I mean, the Dodgers' starting pitcher, Tim Belcher, staked the A's to a 4–2 advantage when he surrendered that bases-filled, second-inning home run to Canseco.

The favored Athletics had to figure at this juncture that this one would be a breeze and that they would be destined to follow in the footsteps of their predecessors, who impaled the Dodgers in five games in the 1974 World Series.

Belcher might have performed well in the NLCS against the New York Mets, but he was ineffective on an evening destined to become a sacred part of baseball lore by actually setting up Canseco's blast by walking that renowned slugger Dave Stewart even after getting two strikes on the former Dodger pitcher.

It seemed, for the longest time, that the Dodgers were involved in the most one-sided 4–2 game you'll ever witness as the Athletics kept filling the bases with runners and the home team did nothing after Mickey Hatcher's two-run homer in the first inning.

But a strange thing happened, predictably.

None of those many Athletics base runners was able to score off Belcher's successors, Tim Leary, Brian Holton and Alejandro Pena.

Meanwhile, the Dodgers managed a run in the sixth to draw within one, but their future didn't look too bright when the most dominant reliever in the sport, Dennis Eckersley, who hadn't allowed a home run in two months, marched in from the bullpen in the ninth inning.

It looked especially bleak for the Dodgers after their first hitter, Mike Scioscia, popped out and their next one, Jeff Hamilton, struck out.

The patrons began repairing toward the exits, and it seemed the Curse of Dodger Blue would not wreak its usual havoc on this warm evening, especially with the left-handed-hitting Mike Davis, batting a mere .196, coming up to face a pitcher who only last week had easily handled another left-handed hitter of slightly greater renown, Wade Boggs.

Mike Davis never will be mistaken for Wade Boggs, but he avoided doing what Boggs did in his first appearance against Eckersley in the ALCS.

He didn't strike out.

"All I attempted to do was hit the ball up the middle and not try to over-swing," said Davis.

Davis worked Eckersley for a walk—and out of the Dodger dugout limped Gibson, whom Lasorda in desperation had summoned from the team's locker room.

This was a scenario right out of one of those cornball *Rocky* films—but this wasn't make-believe with a screenwriter around to save the hero in distress.

It was too far-fetched to expect Kirk Gibson, who hadn't even faced live pitching since last Wednesday against the Mets, to pull off still another miracle.

He fell behind 0–2 but somehow was able to work Eckersley to a full count.

"I remember our scouting report by Mel Didier on Eckersley, and he said when he goes to a full count he always goes with the backdoor slider,"

Gibson would say after the game. "And that was on my mind on the 3–2 pitch. I expected the backdoor slider, and I was fortunate to hit it out."

"When I saw the ball hit, I watched their right fielder [Jose Canseco] all the way, and when he didn't move, I knew it was gone," said Mickey Hatcher. "I wanted to run out on the field and kiss Kirk."

Those reflect the sentiments of all Dodger loyalists at this glad hour in the aftermath of the most dramatic home run in World Series history.

What in tarnation will these implausible Dodgers do for an encore?

TOMMY HAS A HUNCH, HIS TEAM HAS A TITLE

Los Angeles Herald Examiner, *October 21, 1988*

OAKLAND—Aristocracy took a berating. Royalty was mocked. Celebrated personages were humbled.

The Los Angeles Dodgers, a ragtag team that never stopped believing in its exalted destiny even though almost every learned observer did, soared to divine heights last night, becoming the brightest star in baseball's firmament.

They beat the supposedly unbeatable Oakland Athletics to win the world baseball championship in what was a stirring triumph for the nine-to-five working-class people of this land who go about their labors in silent oblivion.

This was a victory for the assembly line, lunch pail–toting folk against a team brimming with gilded sluggers—Mark McGwire, Jose Canseco, Dave Parker, et cetera—and renowned pitchers and skilled fielders.

This was a victory for the Mickey Hatchers and Rick Dempseys and Mike Shapersons of the athletic orbit, the lifetime journeymen who are unknown, unwanted and too often unneeded.

This was a victory for heart, courage, resourcefulness, camaraderie, unselfishness and all those other qualities that came so beautifully and miraculously together to make this Dodgers team one of the most unique in all the seasons of the national pastime.

But most of all, this was a victory for a pudgy, loquacious manager who never stopped believing in his players and never stopped pulling the right levers.

"This goes to show you what you can be achieved if you want something bad enough," said Tommy Lasorda, and this one day would serve as the epitaph of this Dodgers team that at least equals the 1969 New York Mets in the Cinderella category.

Orel Hershiser was given the MVP award for shutting down the Athletics after shutting them out the previous Sunday, but this might have been the first World Series in eighty-five years in which a manager deserved the award.

Tommy Lasorda might not have held Jose Canseco to just one hit in nineteen plate appearances, he might not have hit a dramatic home run like Kirk Gibson, he might not have hit a couple of important home runs like Mickey Hatcher and he might not have come in from the bullpen and stifled the Athletics like Jay Howell did in Game 4. But the Dodgers' fifth world title in Los Angeles certainly will be Tommy Lasorda's greatest legacy, the highlight of a career in which too often his gluttonous eating habits and hilarious spiels have upstaged his managerial acumen.

Dodgers Hall of Fame manager Tommy Lasorda. *Courtesy of Los Angeles Dodgers.*

Laugh at Tommy Lasorda's inflated midriff. Laugh at his obscenity-strewn eruptions. Laugh at his isn't-it-great-to-be-a-Dodger cornball rhetoric.

But take seriously Mr. Lasorda's leadership abilities, which proved to be so decisive to the Dodgers throughout the summer, then throughout the playoffs against the New York Mets and then throughout the World Series against the mighty Athletics.

He kept insisting to his underdog, injury-plagued team that it could overcome the gauntlet of adversities that kept muddling its path—and he somehow was able to cajole his players into believing in their invincibility.

The Mets' Gary Carter would beat the Dodgers with a two-out, ninth-inning, pop-fly single in the NLCS opener in what Lasorda said afterward was the most bitter defeat of his life, but he came to Dodger Stadium the next day in animated spirits.

"Hey, I'm dying inside, but I can't let my players know that," confided Lasorda, and the players came out of their gloom and went on to beat the Mets in a memorable seven-game series.

He would lose his top reliever, Jay Howell, for a game against the Mets because of a suspension—Howell was nabbed using pine tar—but he would dredge extraordinary efforts out of Alejandro Pena, Brian Holton, Ricky Horton and Jesse Orosco.

He would lose a Kirk Gibson with a bad leg, he would lose Mike Marshall and then he would lose Mike Scioscia, but he never would engage in any form of self-pity and always would build up their replacements as though they had been All-Star game participants in July.

But it would be more than Tommy Lasorda's inspirational words that meant so much to a team that never found itself in serious trouble against the Athletics after Kirk Gibson made his one—and only—World Series appearance.

His maneuverings from the dugout were also decisive as he made one deft move after another in a classic performance that vaults him to the top of his profession.

He made two dramatic decisions in last night's match, and both were vital to his team's 5–2 win that put the stunned Athletics out of their misery in this five-game Fall Classic that belonged thoroughly to the Dodgers from the moment Gibson dispensed his heroics in the dramatic opener.

In the fourth inning, Lasorda allowed his .196-hitting designated hitter, Mike Davis, to swing away on a 3–0 pitch—and Davis responded admirably by drilling a two-run homer.

And in the eighth with the Athletics having two runners on base, Lasorda allowed a struggling Orel Hershiser to face two dangerous batsmen, Canseco and Parker—and Hershiser also responded admirably by getting Canseco on a popup and getting Parker on a strikeout.

"I knew Orel was tiring, but he had pitched so well I decided to go with him," said Lasorda. "I had a hunch Orel would get those guys out."

Tommy Lasorda's hunches have been unerringly right from the first pitch of the season in April.

He had a hunch the Dodgers would rebound spectacularly from successive 73-89 seasons—and he was right.

He had a hunch the Dodgers would upend the heavily favored Mets and win the National League pennant—and he was right.

And he had a hunch the Dodgers would startle the heavily favored Athletics—winners of 104 regular-season games and 4–0 victors over the Boston Red Sox in the playoffs—and he was right on that one, too.

"I'd have to rate this achievement as very special because no one thought we could do it," said Lasorda, who now has two world titles and four NL pennants on his resume during his twelve seasons with the Dodgers. "This

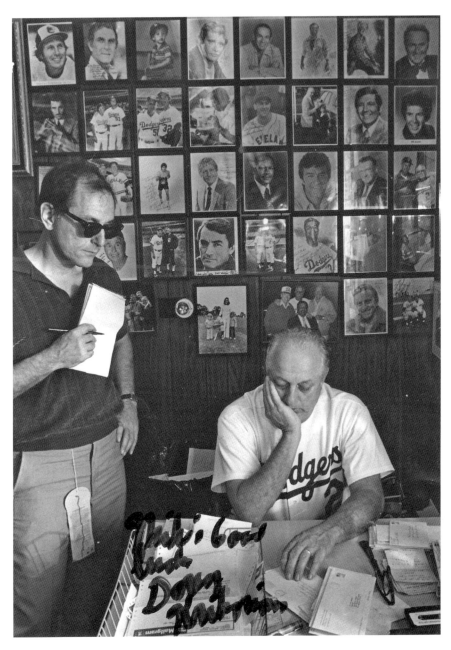

Doug interviewing Dodgers manager Tommy Lasorda moments after the St. Louis Cardinals' Jack Clark slammed his famous game-winning, eighth-inning, three home runs off Tom Niedenfeur that gave the Cardinals the 1985 National League pennant. Why, Doug asked Lasorda, did he pitch to the slugging Clark with first base open? *Author's collection.*

one proves that you never can give up in life, that good things can happen if you just keep persevering."

"How happy are you?" he was asked.

"There is no one in the world right now happier than I am," he replied. "Oh, there might be some guy in China somewhere. But I'd like to find him."

Indeed, Tommy Lasorda should be the happiest because his fascinating Dodgers team that continually defied reality has now become a sacred part of sporting lore, and it is he who is responsible for such a phenomenon.

It's a Joke of a Park No More

Los Angeles Herald Examiner, *October 17, 1989*

SAN FRANCISCO—It was a day baseball stood still—and Candlestick Park still stood. It was a day the old stadium shook violently and lost bits and pieces of its structure but withstood a savage assault by the San Andreas Fault in what could have been a tragic event for the sixty-two thousand fans had it not been so sturdy.

And what otherwise had been a dull, one-sided show, the eighty-sixth World Series between the Oakland Athletics and San Francisco Giants instantly etched its place on the sporting pantheon even though no game was played and even though the A's maintained their 2–0 advantage.

It won't matter if the Athletics wind up sweeping the Giants because this series will be remembered as the one shut down by the most ferocious earthquake to strike these parts since the famous one in 1906 that burned down the city.

The national pastime has endured gambling scandals, labor strikes, poor attendance and all sorts of other adversities during its existence. But never has it endured what happened to its showcase offering at 5:04 p.m. on a warm, windless afternoon as fans in the crowded stadium sat poised to watch the start of the first World Series game held here in twenty-seven years.

At that moment, the long-ridiculed structure began shaking and rumbling, and fans in the aisles began swaying crazily and tripping over one another; those sitting frantically held on to their seats to keep from falling out of them.

Parents with kids began cradling them solicitously, while some in the crowd panicked and headed for exits. Still others seemed to be in a state of

denial as they laughed and hooted and acted as though the whole shocking development was some sort of weird practical joke.

But it wasn't, and soon it would be revealed that a 7.1-magnitude earthquake was responsible for the sudden development that caused a weird mixture of anxiety, hilarity and ambiguity among the startled people.

"Will the fans in the field boxes please exit onto the field in case of an emergency," said the public address announcer a few moments later. "And those in the upper stands please proceed to the nearest exit."

Since its erection in 1960, Candlestick Park just might have had its finest hour.

After all, if this wind-blown, architectural dump lived up to the tawdry reputation that always has engulfed it, it would have feebly collapsed like Humpty Dumpty.

One shudders to consider what might have happened had the old stadium crumbled, although there still were enough cracks in it for the commissioner of baseball, Fay Vincent, to call off the game, which he would have had to do anyway because of a power outage

For sure, things would have been a lot worse than the massive parking lot congestion that ensued on the Candlestick premises after the earthquake, as well as the telephone and electrical malfunctions.

"I knew exactly what it was because I was involved in the Coalinga earthquake," said the Athletics centerfielder Dave Henderson, who grew up in the San Joaquin Valley town of Dos Palos, not that far from Coalinga. "I was in the clubhouse, and some guys got shook up, but I stayed calm. I knew nothing was going to happen."

I was walking up steep stairs to my press seat in the reserved section behind home plate when I suddenly lost my balance—my feet went out from under me—and I tumbled haplessly into the lap of a fan, who was seated.

It was a bizarre sensation, and my first thought was that I was having either a stroke or a heart attack. But I realized this wasn't the case when I remained conscious and felt physically well.

The guy I landed on calmly held me up and said, "We've just had an earthquake. Look."

He pointed to a set of light towers that looked as though they had been struck by a Category 5 hurricane as they swung crazily back and forth.

What I also remember was how the fans around me were cheering wildly—not realizing the severity of what just had transpired.

"Mother Nature is a Giants' fan," shrieked one.

But within thirty minutes, as players stood on the field and refused to go into the dugouts, as reports began surfacing of the widespread

severity of the quake, as a police car filled with officers drove in from the outfield and as the electric scoreboard remained unlit, the fans suddenly grew sullen.

It was a surrealistic scene out in the Candlestick parking lot.

There was Ricky Henderson still wearing his Oakland Athletics uniform, jumping into a friend's car as fans surrounded it and feverishly sought his autograph.

"Hey, I wish we could play and get the series over with," he could be heard saying.

There was old Giants hero Orlando Cepeda standing out in front saying, "I was in the IBM tent when it hit, and I ran like hell to get out of there. That's the first time I've run in ten years."

The beleaguered Giants, in desperate need of a win, lost again yesterday—even though the dark fates kept them from playing.

But their battered old stadium—the object of so much derision across the years—gave them and the fans that filled it a great victory by remaining upright against a devastating assault by nature.

DODGERS ROCKED BY ANOTHER LOSS

Long Beach Press Telegram, *July 4, 1993*

In the photo-bedecked office of Tom Lasorda at Dodger Stadium last Wednesday night, there was a most poignant scene as two old Dodgers Hall of Famers, Don Drysdale and Pee Wee Reese, warmly embraced.

"You look great, Big D," said Reese, referring to Drysdale by his nickname.

"I feel great, but I wish we didn't have to keep meeting under these circumstances," replied Drysdale, shaking his head sadly in reference to the fact that Reese was in town for the funeral of another Dodgers Hall of Famer, Roy Campanella.

Moments later, I asked Reese if he could spare a few minutes for an interview. "Oh, I wouldn't do it, Pee Wee," warned Drysdale. "You gotta watch that guy."

Don Drysdale, an old acquaintance of mine for the past twenty-five years, was smiling broadly.

I would interview Pee Wee Reese later, and he would talk about the death of so many of his Brooklyn Dodgers teammates and how he hated to travel

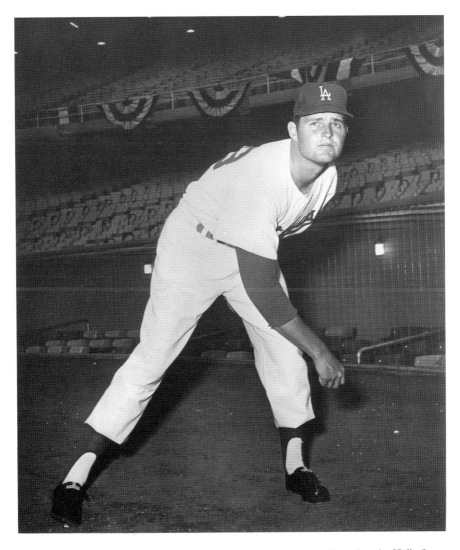

Don Drysdale won 205 games during his Dodgers career and was elected to the Hall of Fame in 1984. *Courtesy of Los Angeles Dodgers.*

and how he reluctantly decided to fly out here from his summer residence in Louisville because of Campanella's passing.

Sadly, Pee Wee Reese probably will be coming out to Los Angeles again this week in the wake of the unexpected death of Don Drysdale from a heart attack on Saturday in Montreal. Drysdale was a late-arriving member of the Boys of Summer, joining that legendary Dodgers bunch in 1956 just in time for its final National League pennant in Brooklyn.

He was a hot-tempered, flame-throwing, pugnacious kid in those days and remained that way for several seasons after the Dodgers moved to Los Angeles.

I remember once watching a Dodgers-Giants game at old Seals Stadium in San Francisco when Drysdale was getting belted around by the Giants.

When the then Dodgers manager, the late Walter Alston, went out and gave Drysdale the hook, the strapping six-foot-six right-hander trudged back to the Dodgers' dugout and angrily gave the Giants fans the middle-fingered salute.

"Yeah, I was a pretty crazy pitcher when I was young," Drysdale would recall. "But slowly I learned from my mistakes and grew up."

By 1962, he had his temper—and pitches—under tight control and wound up having his best season, with a 25-9 record that earned him the Cy Young Award.

He was a passionate competitor who was notorious for brushing people back like Willie Mays and Hank Aaron, and his side-wheeling delivery made him particularly difficult for right-handed hitters.

He wound up with a 209-167 record in his career, which ended in 1969, and his most celebrated achievement was his major-league-record fifty-eight and two-thirds consecutive scoreless inning streak in 1968. It was broken twenty years later by another Dodger pitcher, Orel Hershiser.

Drysdale was a keen student of baseball, and pitchers, writers and even managers delighted in listening to his always insightful monologues on the game.

He was privately critical of the modern players, tracing their lack of fundamentals, their penchant for the disabled list and their periods of laxity to the multiyear, multimillion-dollar contracts so many have been bestowed.

"Hey, I wish I could have made that kind of money," said Drysdale, who never made more than $130,000 in a season for the Dodgers and had a celebrated spring training contract holdout with Sandy Koufax in 1966.

When I once asked Drysdale what he thought he would have made had he played today, he replied with a smile, "Sandy Koufax would have owned half the Dodgers, and I would have owned several shares."

Big D always had a ready smile—except when he was on the mound firing pitches to batters.

He was a popular figure around baseball, well liked by everyone who came in contact with him. In recent years, he had been unhappy about his diminished role on the Dodgers broadcasting team, but he never publicly voiced his displeasure.

He graduated from the same Van Nuys High School class as actor Robert Redford.

"Bobby Redford went on to become world famous and make millions, and I went on to become a baseball player," he would say. But Don Drysdale was one extraordinary baseball player, one of the most adored ever to wear a Los Angeles Dodgers uniform.

He was a homegrown product who made it big, and he and Koufax formed the most feared one-two pitching punch in baseball throughout the first half of the 1960s.

Drysdale played on five Dodgers pennant winners and three World Series champion teams.

My final glimpse of Don Drysdale came after I concluded the interview with Reese last Wednesday in the Dodger press lounge, in the sixth inning of the Dodgers' game with the Giants.

Drysdale joined Reese at a table, and the two began talking about Campanella and grander times.

And now Don Drysdale is gone at only fifty-six, and the Dodgers' grieving is heightened by the loss of another storied performer.

HALL OF FAMER REFLECTS ON A GREAT CAREER

Long Beach Press Telegram, *June 14, 1998*

Wisps of smoke float hazily from the cigarette Bob Lemon is holding, and the weathered, craggy face and deep, sad voice serve as a road map to his glad life.

"How am I doing?" he says, echoing a reporter's question with wistful resignation. "Hey, I'm soon going to be seventy-eight. I'm an old man. I'm soon going to die. I got things wrong with me. But life's good for me. Been married to the same lady [Jane] for fifty-four years. Been living in the same house in Bixby Knolls since '49.

"I'm happy. Meet once a month with old baseball cronies at local restaurants. This weekend I'm going to attend a card show in Atlantic City. Joe DiMaggio will be there. Next weekend [June 20] I'll be in Cleveland, where they're going to honor me by retiring my number."

"What number did you wear?" Lemon is asked.

"Wore twenty-one," he replies. "A good number."

He puffs on his cigarette, and the people around him in the restaurant ignore his rebuke to the anti-smoking codes of this age.

Maybe they realize that he's a person from a time when such a pursuit was acceptable. Or maybe they realize you earn privileged exemptions when you make it to the Hall of Fame for winning 207 games for the Cleveland Indians and when you manage the New York Yankees to a World Series title and when you're a long-revered figure in your community.

"What do you think about the anti-smoking movement?" Lemon is asked.

He takes a deep drag on his Salem, and he flashes a bemused look.

"I'm sure it's good for some people," he says laconically. "But I've been smoking a pack or two a day since I can remember. I'm not about to change now."

Bob Lemon manages a soft smile, and the Wilson High graduate begins reflecting slowly on his life in major-league baseball that began in 1941, when he played a few games with the Indians as a third baseman, and ended in 1958 as a storied pitcher who had put together seven twenty-win seasons and recorded 188 complete games.

He talks about how he learned more about baseball in the club and dining cars of trains than on sporting fields, and you can hear the clanging railroad noises that he must have heard as he slept in his Pullman berth on road trips to St. Louis; Chicago; New York; Boston; Washington, D.C.; Philadelphia; and Detroit.

"All you did on those train rides was sleep, play cards and talk baseball," says Lemon.

He talks about that memorable 1948 Cleveland Indian season in which Lou Boudreau's team won the World Series and in which he, for the first time, won twenty games, and you can hear the shrieks of the more than two million fans who showed up at Cleveland Municipal Stadium that summer to watch their heroes wage a torrid battle for an American League pennant that wasn't secured until they beat the Boston Red Sox in a one-game playoff.

"There was a love affair in those days between the fans and the players," says Lemon. "And what a camaraderie there was among the players. Maybe it was because a lot of us had just come out of the service. But there was a closeness that I just don't see today."

He talks about how Willie Mays's famous eighth-inning catch in the 1954 World Series opener would ignite the New York Giants to their shocking four-game sweep of his Indians team that had won a record 111 regular season games, and you can see Willie Mays making his dramatic eighth-inning over-the-shoulder catch 440 feet away from the Polo Grounds home plate to deprive Vic Wertz of what would have been a game-winning extra base hit for the ill-starred Indians.

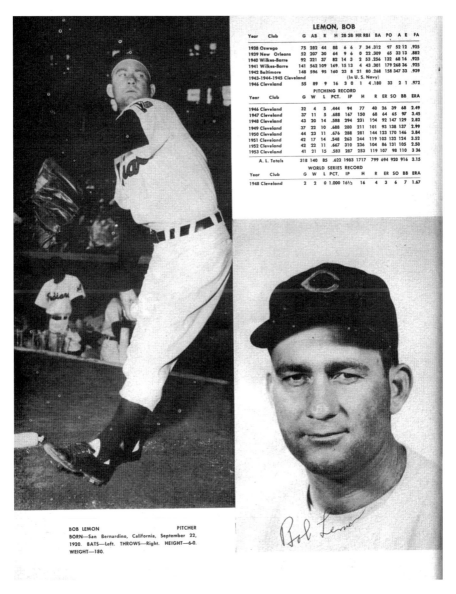

LEMON, BOB

Year Club	G	AB	R	H	2B	3B	HR	RBI	BA	PO	A	E	FA
1938 Oswego	75	282	44	88	6	6	7	34	.312	97	52	12	.925
1939 New Orleans	52	207	30	64	9	6	0	22	.309	65	33	13	.882
1940 Wilkes-Barre	92	321	37	82	14	3	2	53	.256	132	68	16	.925
1941 Wilkes-Barre	141	562	109	169	15	13	4	43	.301	179	268	36	.925
1942 Baltimore	148	596	95	160	23	8	21	80	.268	158	347	33	.939
1943-1944-1945 Cleveland						(In U. S. Navy)							
1946 Cleveland	55	89	9	16	3	0	1	4	.180	33	2	1	.972

PITCHING RECORD

Year Club	G	W	L	PCT.	IP	H	R	ER	SO	BB	ERA
1946 Cleveland	32	4	5	.444	94	77	40	26	39	68	2.49
1947 Cleveland	37	11	5	.688	167	150	68	64	65	97	3.45
1948 Cleveland	43	20	14	.588	294	231	104	92	147	129	2.82
1949 Cleveland	37	22	10	.688	280	211	101	93	138	137	2.99
1950 Cleveland	44	23	11	.676	288	281	144	123	170	146	3.84
1951 Cleveland	42	17	14	.548	263	244	119	103	132	124	3.52
1952 Cleveland	42	22	11	.667	310	236	104	86	131	105	2.50
1953 Cleveland	41	21	15	.583	287	283	119	107	98	110	3.36
A. L. Totals	318	140	85	.622	1983	1717	799	694	920	916	3.15

WORLD SERIES RECORD

Year Club	G	W	L	PCT.	IP	H	R	ER	SO	BB	ERA
1948 Cleveland	2	2	0	1.000	16½	16	4	3	6	7	1.67

BOB LEMON **PITCHER**
BORN—San Bernardino, California, September 22, 1920. BATS—Left. THROWS—Right. HEIGHT—6-0. WEIGHT—180.

The great Bob Lemon. *1954 Indian Sketch Book.*

"We lost that game in the tenth inning when Dusty Rhodes hit about a 280-foot home run into the right field bleachers off me," laments Lemon. "If Mays doesn't make that catch, we score at least two runs, and the game would have never gone into extra innings. We just never recovered from that catch."

He talks about the men he played with and competed against in the 1940s and 1950s, and you can see Joe DiMaggio gliding gracefully across the Yankee Stadium outfield grass to make a catch and you can see Ted Williams stroking a line drive with his picturesque swing and you can see Bob Feller ringing up a strikeout with his sweltering fast ball or knife-like curve and you can see ol' Casey Stengel shuffling out to the mound to give the hook to Allie Reynolds, or Eddie Lopat, or Vic Raschi or Tommy Byrne.

"Ted Williams definitely was the best hitter I ever faced," say Lemon. "He just knew all the time what you were going to throw. You couldn't fool him. Would have hit a lot more home runs had he played at Yankee Stadium instead of Fenway Park. The Yankees usually had the best teams because they had the best players. But we had some good teams in Cleveland."

He talks about taking over the Yankees from Billy Martin midway through the 1977 season and going on to guide the Bronx Bombers to their six-game World Series victory over the Dodgers.

"How can I ever forget those three home runs Reggie Jackson hit in the last game for us?" says Lemon. "We had a helluva team. Had no problems managing the players. And got along fine with George Steinbrenner."

He talks about how it became a post-game ritual for him and his teammates to go out for dinner and cocktails, and you can envision him and Bob Feller and Early Wynn and Mike Garcia and others walking into Toots Shoor's famed joint in New York after playing the Yankees.

"What times we had," he says. "Used to drink V-O and Seven. No more. Just an occasional screwdriver now."

The restaurateur, Phil Trani, suddenly brings over an autographed color photo of a young Bob Lemon in an Indians uniform that Trani had had in his possession since childhood.

"Wow, that picture had to be taken more than fifty years ago," says Lemon, inspecting it closely.

The photographer, Ken Kwok, gives Lemon a baseball to hold as a prop for a picture.

"You wanna know how to throw a curveball?" asks Lemon, and he then gives a quick demonstration as he holds his middle and index fingers across the seams of the ball.

"I guess my best pitch was the curveball, but I also had a good sinker. Mel Harder taught me how to throw the curveball."

He pauses a moment.

"Who was the best pitcher you ever saw?" he is asked.

"Bob Feller," he says. "Great fastball and great curve. Never saw anyone who could throw that hard with such a sharp-breaking curve. He could absolutely freeze hitters."

"Did you ever pitch a no-hitter?"

"Yeah. In Detroit against the Tigers. Had all my stuff that day, and one of our outfielders, Dale Mitchell, saved it with a good catch against George Kell."

"What's the most you made with the Indians?"

"Fifty-five thousand dollars."

"You always returned to Long Beach when you were playing and managing."

"Yeah. Love this town. Can't beat the weather. Ever been back east in the winter? Cold, rain, snow. Who needs that?"

Bob Lemon nonchalantly lights up another cigarette.

"Any regrets?" he is asked.

"Nah. Had a good life. It's been like a storybook. No regrets."

ANGELS WIN FIRST WORLD SERIES WITH GAME 7 TRIUMPH

Long Beach Press Telegram, *October 28, 2002*

They came out on Sunday evening decked out in their red apparel and equipped with their Thundersticks to cheer for their saintly team that had caused them so much torment across forty-one summers.

They pounded those inflated balloons with a rhythmic frenzy and strained their vocal cords with tireless shouting as they never wavered in their passionate support for their divine team in the grandest moment of its existence.

And the Angels—those winged heroes with surnames like Eckstein, Erstad, Salmon, Anderson, Glaus, Fullmer, Spiezio, Molina, Kennedy, Lackey, Donnelly, Rodriguez, Washburn and Percival—certainly didn't let their exuberant supporters down in their Game 7 World Series showdown with the San Francisco Giants.

The Happiest Place on Earth might be Disneyland, but it's doubtful any place on the planet could match the euphoric bliss that pervaded Edison Field on the evening that the Angels of Anaheim finally became rulers of their sport with a 4–1 win over the Giants before those 44,598 fanatics whose undying devotion was almost as riveting as the unyielding deportment of their gallant idols.

Oh yes, with a thrilling gladness, with a relentless deftness, with a blue-collar toughness, with a theatrical coolness, the Angels, at 8:18 p.m. on Sunday, made it official that they had overcome the odds, the Giants and their own troubled history to win their first word championship.

They did it on the strong pitching of John Lackey, Francisco Rodriguez, Brendan Donnelly and Troy Percival and a three-run, third-inning double by Garret Anderson, but this was almost a foreordained, anticlimactic triumph in light of their spectacular Saturday night, Game 6 triumph in which they came back from a seventh-inning, five-run deficit that gave them an aura of invincibility and left the Giants totally dispirited.

They did it with still another comeback—their eighth in eleven postseason victories—although this one was quite mild compared to others as they quickly made up a 1–0 second-inning disadvantage with Anderson's decisive hit down the right field line that kept the audience howling at an even higher pitch for the remainder of the proceedings.

They did it with their powerful young third baseman, Troy Glaus, upstaging the Giants' mighty Barry Bonds to win the Most Valuable Player award, even though Glaus would prefer to share the trophy with his teammates because there are no immense egos on this gracious Angels team that has engendered such widespread goodwill with its mannerly approach.

As exceptional as the Angels have been since recovering from a 6-14 April start, the vocal backing of their partisans also has been a vital part of this magical story that reached a successful conclusion against a Giants team that forfeited any change of emerging victorious before the game even commenced when Dusty Baker committed the folly of starting the incompetent Livan Hernandez instead of the steady Kirk Rueter.

Everyone except Baker knew Hernandez would be a foil for the Angels, and he was as Mike Scioscia's troops pounded him to the sidelines in that third inning.

Rueter would wind up indicting Baker's decision when he appeared in relief and threw four scoreless innings, but it's doubtful these Angels would have been prevented from their epic breakthrough even had Rueter started because they've had destiny imprinted on them throughout this wondrous October as they dismantled the proud New York Yankees with such insolence and then impaled the Minnesota Twins with similar audacity.

And now the Angels have brought down Barry Bonds and the Giants after falling behind 3–2 in this series that only a couple of days ago seemed securely in the corner of San Francisco.

They have been a quintessential team whose players have performed with a quiet composure without engaging in the cheap frills and shameless posturing

that so many engage in on the athletic scene these days, and they have forged a sacred bond with their loyalists because of such a reserved work ethic.

"No one guy on this has gotten us to this point or carried us through to this point," said Glaus, who wound up with a series-leading eight RBIs to go with a .385 average and three home runs. "It's been a team effort all the way through, twenty-five guys. Without everybody contributing, doing their job, understanding what they were supposed to do, we wouldn't be here and we wouldn't have won."

But everyone did do their job on the Angels, from Mike Scioscia, who kept making all the right moves like going with John Lackey on three days' rest in contrast to Dusty Baker's refusal to employ Kirk Rueter under similar circumstances, to Scioscia's terrific group of coaches to his resilient troupe of athletes that overcame every daunting challenge and always responded to adversity with a flourish.

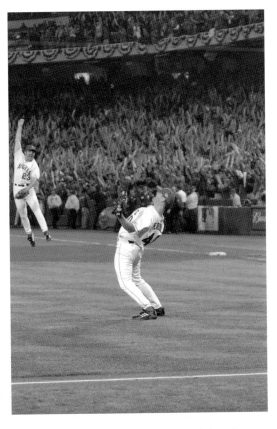

These Angels won't be remembered in baseball lore as a great team because they weren't even able to win their own division and were admitted into the playoffs as a wild card, but they forever will be remembered for winning the franchise's first American League title and World Series crown and for creating one of the most exciting athletic tales in Southern California sporting history.

These Angels have built an impassioned alliance with their patrons, and it's understandable because they never stop hustling and never stop attacking and never stop fouling pitches off and never stop diving

Angels reliever Troy Percival expresses his joy after nailing down last out of the series against the Giants, as first baseman Scott Spiezio leaps in exhilaration in the background. *Courtesy of the Los Angeles Angels.*

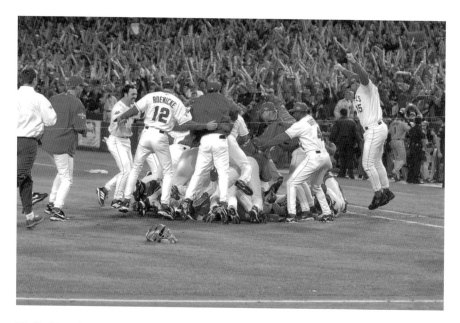

Thrilled Angels have a wild celebration on the Angel Stadium field after beating the San Francisco Giants in Game 7 of the 2002 World Series. It was the first—and so far only—world championship in the team's history. *Courtesy of the Los Angeles Angels.*

for balls as their spiritual leader, Darin Erstad, did in the fifth inning on Sunday night when he lunged his body through the air in left-center field to come up with a line drive struck by the Giants' third baseman, David Bell.

These Angels are young and entertaining and don't know about the frustrations that the team's late owner, Gene Autry, endured over the years; they don't know about Gene Mauch's miscalculations and don't care that not one baseball pundit expected to see them taking a victory lap around the ball diamond on Sunday evening waving exultantly at the appreciative crowd moments after Erstad caught Kenny Lofton's fly ball for the game's final out.

"For us to get to this level is very, very rewarding," said Mike Scioscia, whose team reflects his humility. "I think this is an incredible gift to the whole community. Our fan support has been incredible."

It has been.

But the Angels have been incredible, too, bringing the World Series title back to this area for the first time since 1988, when the team that once was the dominant force around here, the Los Angeles Dodgers, pulled off the feat.

The Angels are now the ones under the bright lights of adoration, receiving the loud applause for achievements that were as exciting as they were unexpected.

5

GOLF AND BOXING

THIS MUHAMMAD ALI WAS THE GREAT IMPOSTER

Los Angeles Herald Examiner, *October 3, 1980*

LAS VEGAS—He was an old man in a lost frontier, groveling hopelessly to find his way out of his own cruel senility.

The jab, the beautiful, stinging jab of rhythmic poetry, the jab that puffed up so many faces and slashed open so many eyes, was a soft handshake that caught only air.

The legs, the legs that turned a ring into a ballet recital, the legs that kept him on the move and out of danger, were broken-down wheels.

The flurries, the flurries that once created such a frenzy, the flurries that were thrown with such graceful precision, were a light jab and a feeble right once every other round.

The magic, the magic that carried him past the Listons, Foremans and Fraziers, the magic that made him the most special athlete of the twentieth century, was left in another decade.

Muhammad Ali, bigger than life for the past twenty years, was smaller than life last night before a hushed crowd of 24,970 in the Caesars Palace parking lot.

Larry Holmes beat him up savagely for ten rounds before referee Richard Green wisely stopped one of the more one-sided and boring heavyweight title fights in the history of the meanest science.

Doug interviewing Muhammad Ali. *Author's collection.*

But Larry Holmes didn't fight Muhammad Ali, the Louisville Lip and the float-like-a-butterfly-sting-like-a-bee slayer of evil forces who could overcome every challenge.

He fought an impostor of Muhammad Ali, a thirty-eight-year-old imposter, who displayed a sad parody of the former champ's skills.

This Muhammad Ali couldn't do anything right—couldn't move, couldn't punch, couldn't get out of the way of jabs, couldn't get out of the way of overhand rights, couldn't even outthink a man who once was his sparring partner.

All Muhammad Ali proved was that he, too, couldn't find what has eluded Ponce de Leon and every other human being across the ages: eternal youth.

Muhammad Ali is an earthling. He is quite mortal. Thirty-eight-year-old men should be worrying about facing the midlife crisis, thinking about taking out life insurance policies and concerned about how their kids are doing in school.

Muhammad Ali found out that thirty-eight-year-old men shouldn't use their fists to settle arguments with thirty-year-old men who are in condition.

Not if the guy's name happens to be Larry Holmes, who recorded his eighth-straight title defense knockout without much effort under the stars on a warm, picturesque Nevada night.

Holmes punished Ali unmercifully, stalking him from the opening bell, never allowing him to rest, bouncing punches off his bruised face with methodical accuracy.

This Muhammad Ali, this impersonator, this counterfeit of a fighter, looked like some of the victims of the other Muhammad Ali, the one who always could pull a rabbit out of a hat.

He looked like a Karl Mildenberger, an Al Lewis, a Rudi Lubbers, a Chuck Wepner, a Jean-Pierre Coopman, a foil, a painted clown who was supposed to elicit laughter with a pratfall.

But all Muhammad Ali elicited last night was sorrow and even a few boos from a turnout that paid a record $6 million to see a match that had less action in it than a sorority pillow fight.

Muhammad Ali knew what he had to do to beat an underrated champion who remains undefeated.

He knew he had to tire Holmes out. He knew he had to find Holmes's jaw with a right hand like Ernie Shavers once did. He knew he had to keep Holmes off balance with the jab. He knew he had to conserve his energy.

But nothing worked for Muhammad Ali.

His mind told him what to do, but his reflexes wouldn't react to it.

He was Joe Louis getting himself punched through the ropes by Rocky Marciano.

He was Willie Mays unable to get around on a fastball.

He was O.J. Simpson unable to get back to the line of scrimmage.

He was Muhammad Ali, a joyless, pathetic sight trying to regain the glories of his bright past.

He failed ignobly, although no one actually fails ignobly when he enriches his bank account by $8 million.

Even his taunting histrionics—the wide-eyed gesticulating, the funny faces, the nonstop prattle—failed miserably.

Larry Holmes didn't punch himself out—or even come close to it. All he did was punch Muhammad Ali out.

There was a cloying repetitiveness to this fight—Holmes throwing, Ali catching, round after dull round.

"Do something Ali!" ringside fans kept imploring, but this was one time that Muhammad Ali couldn't do anything for himself, nor could almighty Allah.

"Ali! Ali! Ali!" chanted the audience on one occasion after Ali reached Holmes with a flimsy right, but their chant went unnoticed by their fallen idol.

As always, Muhammad Ali showed heart, refusing to quit.

He took his punishment with a stoic dignity befitting a man who belongs to the ages.

The final three rounds had to be particularly rough on him as he wobbled helplessly around the ring with a pained expression, unable to escape Holmes's relentless attack.

Holmes pinned him against the ropes several times and would snap his head back with a variety of brutal punches.

It was an ugly scene, but Ali courageously endured it.

Fortunately, he didn't have to come out for the eleventh round. This Muhammad Ali—this thirty-eight-year-old relic with no resemblance to the original—wouldn't have lasted through it.

TESTIMONIAL TO A BOXING CHAMPION

Los Angeles Herald Examiner, *May 24, 1985*

It was late in the evening, and the old heavyweight champion had grown tired from the long plane trip from China earlier in the day. He stood at the podium to acknowledge the tributes that had flowed his way for more than two hours, an aging king addressing his court.

The words came out of Muhammad Ali in a slow, hoarse whisper, in sad contrast to the wisecracking staccato of his younger days.

"Champ, you the greatest...God bless you," shrieked Ali's old spiritual advisor, Drew (Bundini) Brown, as Ali droned on in his barely audible manner.

It was an ironic sight because the World Boxing Council threw the $500-a-plate dinner at the Beverly Wilshire Wednesday night in honor of Ali to raise proceeds for the sports medicine research foundation it had created at UCLA.

SPAR (Safety and Performance Advancement through Research) is a brainchild of Mr. Jose Sulaiman, longtime WBC president. And there is no bigger name around who can serve as Exhibit A for science than Muhammad Ali.

Ali still can turn a funny line, but no longer can he turn it as quickly as he did during his float-like-a-butterfly, sting-like-a-bee, rhyme-spouting youth.

Even Ali himself admits he boxed for too long—that his slurred speech can be traced to the steady barrage of punches he took during his declining years.

But there still is no one in athletics who can generate such an outpouring of affection as Ali.

Mayor Tom Bradley and others were slightly more restrained, although the speaker inspiring the loudest applause wasn't even present. In a taped message from the White House, President Ronald Reagan gave Ali a stirring salute.

Sulaiman has been under constant criticism in recent years for the WBC's twelve-round title limit and its mysterious fighter ratings system. But Sulaiman should be commended for his efforts to upgrade the safety standards of boxing.

The WBC already has raised several hundred thousand dollars for SPAR.

"I will go to my grave knowing I've done everything within my power to make boxing as safe as possible for the fighters," said Sulaiman proudly.

There was a large turnout of celebrities for Wednesday night's affair, including everyone from financier Kirk Kerkorian to football star Walter Payton to Bo Derek to Edwin Moses to Ernie Banks to everybody who's anybody in the boxing orbit.

Doug (right) with Muhammad Ali and Johnny Ortiz. *Author's collection.*

It is a reflection of boxing's great respect for Muhammad Ali that its multitude of warring factions showed up with peace offerings, actually choosing to lay down its arms—at least for the night.

"I wouldn't be up here talking and wearing all these rings if it weren't for Muhammad Ali giving me a chance to promote his fights," said Don King, who hates Bob Arum.

"Muhammad Ali gave me my start in boxing by allowing me to promote the first fight I ever saw in person—Ali versus George Chuvalo," said Bob Arum, who hates Don King.

"I tried to separate Ali's head from his shoulders three times, but I want to tell Ali right now I love him," said Ken Norton, who once hated Ali but now loves everyone.

A couple of local don't-invite-'em fight characters, Bill Caplan and Don Fraser (they've exchanged punches on three occasions over the years), were seen saying hello to each other without cocked fists—a first.

Holmes's former manager, Richie Giachetti, who hates King, was seen smiling—the first time that has happened in a long time with King in the vicinity.

Even the bitter adversaries of a month ago, Marvelous Marvin Hagler and Thomas Hearns, were seen exchanging pleasantries after both had risen to praise Ali.

The master of ceremonies was Roy Firestone, an impressionist who dabbles as a local sportscaster. His impersonations of Ali, Cosell, Keith Jackson, et cetera, were a scream. Firestone should leave the TV airways to peachy-faced optimists like Stu Nahan and become a full-time comedian.

But the undeniable star of the evening was Muhammad Ali, still a charismatic albeit heftier figure at forty-three years old.

Ali sat at a table flanked on one side by Sugar Ray Leonard and on the other by Sugar Ray Robinson. As usual, he was charming, politely posing for pictures and signing autographs for an endless parade of people.

The most poignant moment came when Ali asked Sugar Ray Robinson to join him on stage. The two men smiled and embraced and waved warmly to the crowd amid cheers.

They both have known healthier days, but their popularity still is as immense as it was during those memorable years when they routinely turned their fights into private recitals of their peerless skills.

Sorry Cooney Hasn't Paid His Dues:
Despite His Inactivity, He Gets Megabucks Fight with Spinks

Los Angeles Herald Examiner, *April 23, 1987*

The Great White Hoax, Gerry Cooney, made a rare Los Angeles appearance to participate in what turned out to be one of the more farcical boxing press conferences in the grand and glorious history of such dreary affairs.

For those of you who haven't paid attention—and you deserve high marks if this has been the case—Mr. Cooney has been disinterred from the fistic graveyard to fight Michael Spinks on June 15 at the Trump Plaza in Atlantic City.

The only reason this match is taking place is because Mr. Cooney happens to be of the Caucasian persuasion, which is a pathetic commentary on our society and doesn't exactly bolster a sport that forever is reeling from criticism.

Cooney has no business earning a possible $5.0 million—he's guaranteed $2.2 million—and facing a fighter the magnitude of Michael Spinks, a legitimate practitioner who has twice beaten Larry Holmes.

Since being knocked out in May 1982 in thirteen rounds by Larry Holmes, Cooney has a) retired, b) gone into a two-year funk over losing to Holmes, c) visited every disco in New York, d) unretired, e) injured his shoulder f) gotten into a disco beef in which one of his so-called bodyguards was beaten up, g) knocked out a setup named Philip Brown, h) knocked out a setup named George Chaplin, i) reinjured his shoulder, j) retired, k) resumed his disco visits, l) unretired, m) knocked out a setup named Eddie Gregg, n) retired, o) unretired and p) stayed cautiously away from anyone who vaguely resembled a professional fighter.

This has pretty well been the extent of Cooney's existence during the past five years, while other heavyweights such as Mike Tyson, Tony Tucker, Pinklon Thomas, Frank Bruno, Tony Tubbs, Carl Williams, Mike Weaver, Bone-crusher Smith, Tim Witherspoon, Trevor Berbick, David Bey and Tyrell Biggs have been winning, losing and battering one another in the ring.

Despite such inactivity, Gerry Cooney suddenly rises from his self-imposed exile and finds himself in a megabucks fight through the Machiavellian dealings of his manager, Dennis Rappaport, and the promoter Butch "I've Never Told a Lie" Lewis.

And the only viable reason for such a bizarre phenomenon even taking place is the pigmentation of Gerry Cooney's skin, despite all the inane statements to the contrary dispensed yesterday by the Lewis and Rappaport clown act.

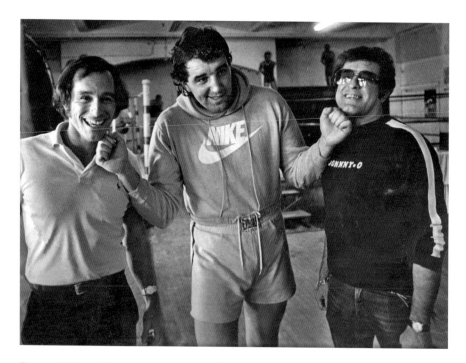

Doug with Gerry Cooney, who was stopped by Larry Holmes in a 1982 heavyweight title fight. Main Street Gym co-owner Johnny Ortiz is on the right. *Author's collection.*

Lewis, disbarred member of the Dynamic Duo (yes, there was a time when he and Don King were actually partners in what had to be the weirdest alliance since Nazi Germany and Soviet Russia got together for a brief time in the late 1930s), droned on and on and on about how HBO tried to keep this fight from happening and about how dark, subversive forces did everything to prevent the American public from the privilege of watching the War at the Shore.

Lewis rambled incoherently for ten of the most insufferable minutes imaginable during the late morning session at the Airport Park Hotel that was attended by former Lakers Rudy La Russo and Mitch Kupchak, both of whom snoozed soundly.

"Butch would make a million if he decides to market the tape of his speech," cracked Caesars World Sports president Bob Halloran, who looks like a young Robert Redford. "It would be a sure-fire remedy for the most hopeless insomniac."

Rappaport was more eloquent than Lewis and used fancier language, but the manure he slung was every bit as odorous.

After passionately berating all the sanctioning bodies in boxing—not one of which, by the sheerest coincidence, has given title recognition to Spinks-Cooney—Rappaport asked, "Why are these organizations getting away with murder?"

I idly wondered to myself how Dennis Rappaport has been allowed to get away with finagling Gerry Cooney into another big money match without having to fight any top ten–ranked contender—precisely what he pulled off when he had Cooney pick up $10 million for getting roughed up by Holmes.

"The career of Gerry Cooney has been an agony and ecstasy," said Rappaport. "He's been up and down. He's had a major shoulder injury. But he's back and healthy and grinding on his teeth to become the heavyweight champion. And that's his destiny."

Rappaport, who enjoys listening to his rhetoric far more than his audience does, then added, "This fight is making a statement—we don't need any of those sanctioning bodies behind us."

"The only statement this fight is making is that a white guy can make several million dollars without fighting anybody for five years," bristled Flip Speight, the legendary eighty-year-old local character who still attends every major sporting event usually accompanied by lady friends at least one-third his age.

Physically, the thirty-year-old Cooney looked great. He has a well-trimmed beard that he will shave off before the fight, and he weighs 245 pounds. He was in fine spirits until he became upset with questions from your warm-hearted reporter.

"Considering you've fought three nondescript fighters in five years, why do you think you're being given the opportunity to fight a Michael Spinks?" I wondered.

"Because I think I've shown in the past what I'm capable of doing," he answered. "I beat Eddie Gregg last year, and he was the number three–ranked contender."

Well, if Eddie Gregg, whom Cooney stopped in a matter of seconds, was the third-best heavyweight in the world last May, then I'm sure Eddie Murphy must be the best.

"Considering it took you more than two years to get over the depression of losing to Larry Holmes, how do you think you'll react if you lose to a guy as small as Michael Spinks?" I asked the six-foot-seven Cooney, who will tower over the six-foot-three, two-hundred-pound Spinks.

"I don't plan on losing," he retorted.

When I asked Spinks, a friendly fellow with a pleasing smile, why he was fighting Cooney instead of a more qualified, deserving opponent, he said, "Because the public wants this fight."

At that moment, Gerry Cooney yelled to me, "Are you trying to make this a black versus white issue?"

"Not at all…I am just trying to figure out how a guy who has fought a total of seven rounds in five years against guys no one has ever heard of suddenly can wind up in a multimillion-dollar fight with Michael Spinks," I said.

Afterward, Gerry Cooney came up to me and pleaded his case.

We argued back and forth and neither changed the other's mind about a farce of a fight that I think belongs on the WrestleMania circuit.

DON "ONLY IN AMERICA" KING: TAKES HIS ACT TO THE USSR

Los Angeles Herald Examiner, *March 17, 1988*

As a roving ambassador of good will for the United States of America, Don King has enriched countless countries around the globe with his magnetic presence and lush rhetoric, spreading the virtues of democracy and free enterprise with Jeffersonian eloquence.

"Only in America can there be such a creation as a Don King," Mr. King has told South Americans, Central Americans, Africans, Mexicans, Englishmen, Filipinos, Japanese and other nationalities during his worldly travels. "Only in America can there be a guy who comes from the ghetto like me, does time in prison and then gets out and becomes a respected multimillionaire."

Don King has reached such an exalted financial state because of his prowess at promoting conflicts, staging fistic shows in locales from the Philippines to Zaire to Venezuela.

As the years have gone by, as his coffers have swelled, as he has settled into middle age, King continually has aspired for loftier pursuits, coming to the recent conclusion that his private calling in life might be found on the international diplomacy scene.

A friend of Jesse Jackson, King has told intimates he might one day consider accepting a State Department job, and he might have even been boning up for such an assignment when he visited the Soviet Union for the first time on a trip that has been shrouded in secrecy.

"All I can tell you about it is that it was big, real big," King said the other day during a fight press conference at the Beverly Hilton as he lowered his voice in a conspiratorial manner.

"Do you mind elaborating?" I asked.

Don King grimaced, shook his head and uttered two words I never thought would emerge from his energetic vocal cords.

"No comment," he said.

"Why?"

"I'm going to have a press conference in a couple of weeks to explain the whole situation. All I can tell you is that I'm working on something gigantic. There's never been anything like this."

"In boxing?"

"In the history of mankind."

In the spirit of glasnost, one initially figured that Mikhail Gorbachev had enlisted Don King to introduce professional boxing to the Soviet Union, if not also to introduce his revolutionary hairstyle to a country conditioned to more conservative cuts.

But King left one with the distinct impression that he's working on something with great political magnitude and that he's on the threshold of a historic breakthrough.

"This is Nobel Peace Prize stuff I'm talking about," said King modestly.

Doug with one of his favorite characters, boxing promoter Don King. *Author's collection.*

One wonders if it was a case of the Soviets simply valuing King's expertise on bloody disputes—he has endured well-publicized ones with Bob Arum, Butch Lewis and the IRS—and seeking his sage counsel on such pressing national matters as Afghanistan and the ethnic unrest in Azerbaijan and Armenia.

"Did you talk to Gorbachev in Russia?" I asked King.

"I can't say," he replied.

"How did you like Russia?"

"Oh, it was great. The people treated me very well. You wouldn't believe how many people came up to me and said, 'Comrade Don King.' I signed more autographs there than I do in New York or Los Angeles."

"You mean they actually recognized you?"

"Are you kidding? I walked down their main streets and crowds surrounded me. They were fascinated, I think, by my hair. They had never seen anything like it before. I did find my hair to be an inconvenience. You know, they couldn't find one of their fur hats to fit on my head. Incredible!"

"How long did you stay?"

"Six days."

"How many people did you take with you?"

"I took the whole Don King Productions camera crew. Ten people. We were allowed to film right there at the Kremlin."

"What did you film?"

"I can't say."

Obviously, the Soviets didn't feel Don King had any CIA ties or they wouldn't have allowed his camera crew to visit such a high-security building.

"They let us film stuff no Americans have ever filmed before," revealed King.

"Any run-ins with the KGB?" King was asked.

"No, not really," he said. "Oh, when I went through airport security, one of the guards did a strange thing. He put his hand through my hair to see if I was hiding anything. Incredible!"

Don King is famed for his laugh-wrenching monologues replete with double-entendres, non sequiturs, fractured syntax, outrageous hyperbole and scandalous malapropos.

I think he's a natural comedian gifted with the ability to keep an audience in stitches, and you can imagine the severe culture shock the Soviet people must have felt while listening to one of his wild oratories.

"Actually, the biggest problem I had was with the Russian interpreter," said King. "He was unable to translate what I was saying."

Of course, American interpreters long have faced the same crisis.

GOLF AND BOXING

Sugar's Better at the Sweet Science

Long Beach Press Telegram, *June 18, 2000*

Oscar De La Hoya might be the Golden Boy and might be the most popular fighter in Los Angeles. But he's no longer the best one.

That title now belongs to Sugar Shane Mosley, a twenty-eight-year-old from Pomona who staged a fistic performance of exquisite artistry on Saturday night at Staples Center, where he methodically took apart De La Hoya across twelve rounds in a match that appeared to be one sided to everyone but the judges.

Mosley, so much quicker than De La Hoya, landed the heavier punches, especially during the fourth, eighth and twelfth rounds when he violated De La Hoya with disdainful impunity.

Mosley, so much slicker than De La Hoya, easily avoided his game opponent's most ominous weapon—the left hook—throughout the fight and never was hurt.

Oscar De La Hoya flashes his boxing stance, as promoter Bob Arum (left) and Doug stand beside him. *Author's collection.*

Mosley, so much better than De La Hoya, dominated the proceedings with a quick right hand that constantly found its mark, a bristling jab that did the same and superior footwork.

Yet despite Mosley's performance that was right out of a textbook authored by the likes of Sugar Ray Robinson and Jose Naples—he was that good to do what he did against a fighter of De La Hoya's caliber—the boxing orbit almost received another staggering blow afterward when Michael Buffer announced the decision.

He first revealed that Lou Filippo had Mosley winning by a 116–112 margin, which was only one point different from my scorecard, in which I had Mosley winning nine rounds for a 117–111 advantage.

But then Buffer said that a judge named Marty Sammon had De La Hoya a 115–113 victor, much to the distress of the Mosley corner, the shock of the De La Hoya corner and the outrage to anyone who had witnessed the punishment Mosley had just meted out to De La Hoya.

Fortunately, Buffer's final announcement spared the sweet science a most shameful development when he said that judge Pat Russell saw it 115–113 for the new WBC welterweight champion of the world.

Who could Marty Sammon have been looking at? Maybe he had his eye on WBC president Jose Sulaiman, a passionate De La Hoya advocate who just happens to assign officials to cushy WBC title fights at glamorous cities in foreign countries.

After all, it is known Sammon is a WBC official, as is Lou Filippo, an independent sort who was the one who voted for Marvelous Marvin Hagler against Sugar Ray Leonard in their famous 1987 fight.

What Sugar Shane Mosley, who a year ago was a lightweight and was expected by many observers to find the twelve-pound jump to the welterweight division to be too much against De La Hoya, on Saturday night defied all pre-fight expectations.

No one ever before had struck De La Hoya with so many punches—not Pernell Whitaker, not Ike Quartey, not Felix Trinidad, not anyone.

But the CompuBox punch stats revealed that Mosley connected 284 times against De La Hoya, with many of the punches being straight right hands thrown over De La Hoya's left.

"Oscar De La Hoya is a great fighter, but I showed tonight that I'm better," said Mosley, and who could argue with Mosley, except a myopic fellow named Marty Sammon?

The fight had its moments of drama, when both men would exchange brisk flurries that evoked cheers from a celebrity-laden crowd brimming with

Doug with his friend Sugar Ray Leonard. Doug covered all of Leonard's major fights, including the ones with Roberto Duran, Thomas Hearns, Marvelous Marvin Hagler and Wilfred Benitez. *Author's collection.*

athletes like Mark McGuire, Kobe Bryant and Shaquille O'Neal and actors like Sylvester Stallone, Denzel Washington and Mel Gibson.

This time there can be no excuses offered by De La Hoya, who whined that he was robbed against Trinidad even though he spent the final three rounds of that fight trying desperately to hitchhike a ride out of Las Vegas.

This time, De La Hoya was beaten fair, square and brutally by Mosley, a blur of a whirlwind who simply was too fast for De La Hoya, who throughout his career had always been too fast for every one of his opponents except Whitaker.

Not that Oscar De La Hoya didn't try.

He pursued Mosley relentlessly throughout the fight, but he kept getting beat to the punch in a fashion that had to be disheartening to so many in the crowd of 20,744, which cheered loudly for the two-to-one favorite.

Sugar Shane Mosley was supposed to be too small and too inexperienced for De La Hoya, who performed in several of these high-profile exercises and who was supposed to finally display his greatness.

But Mosley exposed De La Hoya for what he is—an exceptional fighter with a firm heart who simply isn't in the class of the Durans and Leonards.

As for Sugar Shane Mosley, he might be.

All he failed to do on Saturday night was to stop De La Hoya, and it seemed in that twelfth round, in which he whacked De La Hoya around the ring for most of the three minutes, that he might pull off such an unexpected accomplishment.

Besides De La Hoya, the biggest loser was Bob Arum, the Top Rank promoter whose organization is linked so closely with De La Hoya, whose sheen is now terribly tarnished.

Oscar De La Hoya might still be the Golden Boy to his legion of followers, but that nickname no longer fits in Southern California, where Sugar Shane Mosley now is the king.

TIGER'S LIFE NO LONGER HIS OWN

Long Beach Press Telegram, *April 17, 2001*

"All I do is hit a golf ball in a hole," said Tiger Woods on Saturday at El Dorado Park when someone asked him how it felt to be one of the most famous people on the planet.

Tiger Woods smiled sheepishly.

It was as though he were embarrassed by his exalted station, by the ceaseless adulation that has turned his life into a frenzied existence in which his every step is shadowed by an idolatrous public.

"Tiger's life really no longer is his own," says his father, Earl Woods. "He can't go anywhere without being mobbed. When he checks into hotels, he has to go in the back way. When he goes to restaurants, his people call ahead, and he usually eats in a private room or at a table where he isn't too noticeable. He no longer can just go out and walk around like a normal person."

Such is the penance one must endure for being so proficient at a particular art.

Tiger Woods employs a five-man security force that closely monitors his every step, much like the Secret Service does with an American president.

When a suite at the Long Beach Marriott was reserved for Woods a month ago, a member of his bodyguard contingent immediately visited the hotel and checked out the layout. And this despite the fact that Woods was scheduled to use the room only for a couple of hours after the completion of his foundation's clinic at El Dorado to freshen himself up for an evening banquet.

Tiger Woods figures out his putting options as Doug, in sunglasses, observes in the background. *Author's collection.*

As the phenomenon called Tiger Woods made a weekend cameo appearance in Long Beach, one idly reflected on his staggering celebrity in which his every public move is under intense scrutiny by not only the sporting patrons but also an intrusive media.

Oh, as far as can be determined, there isn't a standing $1 million bounty out for photographers to catch Tiger in the buff, as apparently there is among Japan's tabloids with the Seattle Mariners' new right fielder, Ichiro Suzuki.

But Woods is stalked relentlessly by the paparazzi, and they were out en masse at El Dorado on Saturday, snapping pictures of Tiger hitting golf balls, instructing young players, warmly embracing his father, accepting gifts from Long Beach mayor Beverly O'Neill ad nauseam. Not exactly stuff that would make the cover of the *National Enquirer*, although I'm sure that prized photo showing Ol' Bev handing the key to the city to Tiger will be a valued memento of the Long Beach Historical Society.

As the current champion of the four biggest tournaments in his sport—the Masters, the U.S. Open, the British Open and the PGA—Tiger Woods just might be at the peak of his powers.

He forever will be renowned for his accomplishments, but he will discover, as have all those who have reached his staggering plateau, that his fame eventually will subside.

There was no more mythical figure in baseball at one time than Willie Mays, and I remember how he was besieged by autograph-seekers—I was one of them—after San Francisco Giants' games at Candlestick Park during the 1960s.

In those days, Mays was treated like a rock star, but that would change as soon as he stepped away from baseball and stopped hitting home runs and making those basket catches out in center field.

I'll never forget attending one of those old American Airlines celebrity golf tournaments in Scottsdale, Arizona, in the spring of 1978 and how Mays was largely ignored by the galleries, who focused their attention instead on the recent World Series hero, Reggie Jackson.

There was a time in Los Angeles when Maury Wills couldn't go anywhere without drawing large crowds, especially in 1962, when he stole 104 bases and altered forever the landscape of baseball.

But now he can walk into a restaurant and only a few scattered old-timers will even recognize him, much less recall his heroics.

I once navigated the Caesar's Palace casino with Sugar Ray Leonard, and it took some aggressive work by his bodyguards to keep fans from engulfing him. Leonard now walks alone and is no longer under constant siege because he no longer beats up people in a boxing ring.

I'll never forget interviewing O.J. Simpson in the spring of 1974 at the Hilton Hotel in Las Vegas a few months after he had become the first player in NFL history to rush for more than two thousand yards. We were at the

Doug next to boxing champions Michael Nunn and Sugar Ray Leonard (right) and Lakers owner Jerry Buss. *Author's collection.*

hotel's swimming pool, and we couldn't sit in the lounge chairs, as we both preferred to do.

"I have to keep walking when I'm outside because I'll be mobbed if I stay in one place," said Simpson, who would become even more notorious two decades later for a non-football incident that would turn him into an international pariah.

There is, of course, a direct correlation between Tiger Woods's ability to make putts and his current preeminence.

Once he starts missing them—and one day he inevitably will—his fame will diminish, and so will that of his father, Earl Woods, now serving as a lively warmup act at the foundation's clinics.

Nothing in this fickle universe remains the same.

One day, Tiger Woods will be able to walk around quite comfortably and won't need the protection he now must have; he won't need to clandestinely slither through pantries on the way to his hotel rooms. But at the moment, as his star glows brightly, he does—much to his private discomfort and his bank account's enhancement.

REMEMBRANCES

WITH CARROLL, IT ALWAYS WAS EXCITING

Los Angeles Herald Examiner, *April 3, 1979*

You hear the stunning news of Carroll Rosenbloom and you are seized by a sense of emptiness and melancholy. You have reported on the Los Angeles Rams since Rosenbloom came out here from Baltimore in the summer of 1972, and memories begin flowing across your mental screen about the late Rams owner.

Always from the moment Carroll Rosenbloom took over the Rams, he created excitement and commotion, from firing Tommy Prothro to trading for John Hadl, from the Great Rams Coach Search to the Great Rams Stadium Search, from the O.J. Simpson Negotiations to the Joe Namath Signing, from the George Allen Hiring to the George Allen Firing.

But you think of Carroll Rosenbloom now, and for a moment you forget about what doubtless will be his football legacy: the winning teams he fielded year after year in both Baltimore and Los Angeles and the discovery of such coaches as Web Eubank, Don Shula and Chuck Knox.

You think of all those autumn Thursday afternoons he would loyally show up at Blair Field to watch his hirelings practice, exchange jokes with them, offer them counsel, listen to their gripes.

You think of how enjoyable Rams charter flights once were with him on them, making all the writers feel as though they were reincarnations of Hemingway, revealing some tasty, off-the-record tidbit to each one.

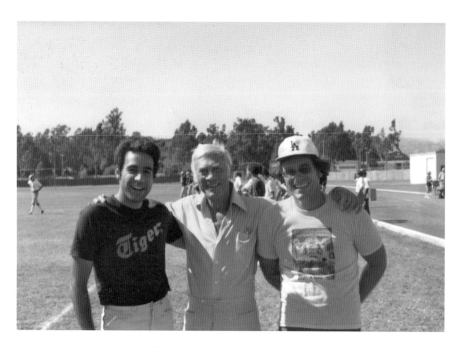

Doug (right) poses with Carroll Rosenbloom, owner of the Rams until his death on April 2, 1979, when he drowned at Golden Beach, Florida.

You think of the exhibition game at Oakland last year after Wendell Tyler scored a long touchdown and a peanut caromed off your shoulder, and you looked back and there was Carroll Rosenbloom, the practical joker who threw it, averting eye contact and looking straight ahead.

You think of how he would nervously pace the sidelines before a game and how during it he would sit in the press box and ride the roller coaster of emotion with his team, furiously pounding a table when it sagged and pounding Don Klosterman's shoulder when it soared.

You think of how at least once a week for six years you interviewed him over the phone about his team and how he would always conclude the conversation by saying, "You take care kid and say hello to your beautiful bride. By the way, how could a bum like you wind up with such a nice gal?"

This was a standard Carroll routine, one he playfully used on most occasions, no matter whom you happened to be with.

For instance, if you were with your father, Carroll would always say, "How could you have such a nice father and turn out the way you did?"

The "Great White Father," you nicknamed him shortly after his arrival here, an affectionate appellation inspired not only by his massive wealth and

power but also by his slow, deliberate manner of speaking and his white mane that gave him such patriarchal presence.

Like all power brokers whose moves affect the lives of hundreds of people, he was a mass of contradictions, a man given to moods of extreme hues.

He could be warm, charming and generous, the classic benevolent despot who often would stake players in business ventures or help them out of scrapes with the law.

He also could be unforgiving and vengeful, angrily unbraiding a critic with harsh language one moment or defiantly trading a stubborn holdout to a lowly team the next.

You once wrote that it was a status symbol for Carroll Rosenbloom to be mad at you, much like it is fashionable to be insulted by Don Rickles.

You wrote this at a time you and Carroll Rosenbloom were speaking, but this condition wasn't in effect the past year when you had differences over the move to Anaheim and George Allen.

It was long your view that Carroll enjoyed all the squabbles he had across the years with coaches, general managers, commissioners, owners, politicians, sportscasters, referees and writers. You felt bearing arms was his way of keeping young and vigorous.

Don (Duke) Klosterman (center) was Rams general manager during Carroll Rosenbloom's tenure. Fresno heavyweight boxer Don Srabian is on the left.

Actually, Carroll seldom stayed mad long. In fact, his ability to get mad at people was exceeded only by his ability to make up with them.

"I'm just a tolerant guy who wants to do well in the world," he once told you with an impish smile. "Some people say I have an obsession to win the Super Bowl. I wouldn't deny that. A guy shouldn't be in this game if he doesn't want to win the Super Bowl."

It's hard to comprehend the Rams now without Carroll Rosenbloom because his shadow covered the scene so completely in recent years.

His passing marks the end of an unrivaled era in Los Angeles sports history for controversies, excitement and stunning scenarios not even the most imaginative novelist could have envisioned.

COOKE'S LASTING LEGACY—THE FORUM

Los Angeles Herald Examiner, *May 29, 1979*

Like all power brokers who make expedient decisions with a callous disregard for people's feelings, Jack Kent Cooke has built up his share of detractors across the years.

To them, he has been a ruthless tyrant incapable of sensitivity, a posturing linguist given to using polysyllable words, a greedy curmudgeon who worshipped on the altar of money.

But even Jack Kent Cooke's most severe enemies will concede that since he came riding out of the Canadian sunset in the mid-'60s to purchase the Lakers, he has established a legacy on the Los Angeles sporting scene that puts him on historic par with the other franchise owners who descended on this celestial territory to cut a lasting swath.

The late Dan Reeves brought the Cleveland Rams here in 1946—giving the town its first major-league franchise. The ailing Walter O'Malley brought the Brooklyn Dodgers here in 1958—giving the town its first major-league baseball team and Dodger Stadium. The late Carroll Rosenbloom came here in 1972—giving the town an era unrivaled in controversies, intrigues and enough stunning scenarios to keep everyone on the edge of their seats 365 days of every year.

In retrospect, Jack Kent Cooke's biggest achievement has been the construction of the Forum, a colonnaded edifice that has served as a stage

for the Lakers and Kings, not to mention countless rock stars, gymnasts, bronco riders, boxers and even midget-car drivers.

Without it, the Sports Arena would be a viable concern today instead of a white elephant immersed in red ink.

Without it, we still would be driving to downtown LA to watch the Lakers and the Kings instead of to Inglewood.

The Forum—or the Fabulous Forum, or the House That Jack Built or whatever you want to call it—has inalterably changed the landscape of professional sports in Southern California.

It never would have been built had Jack Kent Cooke and the Coliseum Commission not had a memorable falling out in 1965.

To condense a long story, the Coliseum Commission was strongly behind Dan Reeves's attempt to secure an expansion franchise from the National Hockey League. After Cooke was granted it, he and the Coliseum Commission immediately began feuding over game dates, and he warned commission members he would leave the Sports Arena if his terms weren't met.

The Coliseum Commission arrogantly told Cooke to go out and build his own arena—and this proved to be a disastrous threat against an enterprising man who had started his climb to riches by selling encyclopedias door to door.

In December 1967, the Forum opened for business—and for years, Jack Kent Cooke was its most visible patron.

There was a time when Cooke would loyally attend every Lakers and Kings game, sitting in his sky box in the Forum rafters with friends, a king holding court over his domain.

It used to be a ritual for Cooke to have a pre-game dinner with a carefully selected list of guests, who usually included an entertainment figure, a business associate and a journalist.

It also used to be a ritual for Cooke to have lunch once a week in his Forum office with various sportswriters and sportscasters.

During these sessions, he would probe each person on a wide range of subjects, everything from the virtues of Kareem Abdul-Jabbar to the bathing habits of Bill Walton to the dedication of George Allen to the writing skills of John Cheevers.

It was obvious he used these informal, off-the-record discussions to get a bead of public opinion—and that some of his most dramatic moves resulted from them.

A self-educated man with a William Buckley proclivity for using language that would have bewildered Daniel Webster, Cooke probably is as proud

of his massive vocabulary as he is of all the shrewd transactions he's made during his life.

I recall the time he phoned me frantically a few minutes after I had interviewed him and he had talked about the "perceptiveness" of Wilt Chamberlain.

"Can you change perceptiveness to 'perspicuousness'?" he pleaded. "That gives a more exact meaning of what I want to say…"

Because of his divorce, Jack Kent Cooke in recent years has spent most of his time in Las Vegas—and it's more than just a coincidence that the Kings, Lakers and Forum attendance have sagged during his absence.

The Forum operation probably will improve with the imminent takeover by real estate magnate Jerry Buss. But the flair and style of Jack Kent Cooke won't soon be forgotten. Nor will his panache, élan and sententiousness.

(Jack Kent Cooke would become sole owner of the Washington Redskins in 1985 and also bought the Chrysler Building in New York. He died on April 6, 1997.)

OUR ATHLETES ARE PLAYING A NEW RUSSIAN ROULETTE

Los Angeles Herald Examiner, *July 1, 1986*

Oh no, please, not again, not another young athlete of great skill losing his life because of cocaine.

One week Len Bias, the next week Don Rogers and, step right up folks, win yourself a guided tour of Forest Lawn if you are able to guess the name of the next jock to fall under the fatal powers of the prince of darkness cloaked in poisonous white powder.

It's an appalling fact that the ancient parlor game Russian roulette has become the newest rage among some American athletes, replacing hearts, gin rummy backgammon and dominos.

But there has been a slight alteration made in this deadly ritual of chance.

It used to be one bullet in the cylinder—and, *bang!*, there went your brains splattered across the floor if your spin was unlucky. But now it's a line or a pipe full of coke—and, *bang!*, there go the arteries in the heart if you're unlucky and your system reacts adversely.

There was a haunting sense of déjà vu when the death report of Rogers first came out of Sacramento—the unbearable grief of family members, the denials by friends that drugs could have caused Rogers's death, the denials by

friends that drugs had ever been a part of his past, the glowing testimonials by teammates and coaches and then the numbing truth: the autopsy findings.

It was a repeat of what had happened eight days earlier in Maryland, where Len Bias also had gone out with friends and partied to celebrate an epic event in his life.

Len Bias had just been drafted by the Boston Celtics. Don Rogers was only one day away from marriage. And both, sadly, wound up as obituaries because both engaged in cocaine usage—their dreams, their hopes, their futures forever gone.

"I wish," said Thomas "Hollywood" Henderson to me several times during the many hours I interviewed him for a book about his well-publicized cocaine addiction, "I had never touched the stuff. It's brought me nothing but agony. For every minute it's made me feel good, I've spent months paying for it. It's ruined my life."

Henderson first made me aware of how deeply cocaine has permeated athletics, revealing the names of several nationally known athletes who used it.

One in particular—not a Dallas Cowboy—was a stunner to me because of his wholesome image, but Henderson solemnly swore the guy dabbled in it.

"I personally did a few lines with him in a hotel room in Hawaii," said Henderson.

Don Rogers's death has been felt deeply in Southern California because Rogers had been such a visible part of the terrain here, an All-American safety at UCLA.

I think of Don Rogers and I think of him doing the impossible—making people forget Kenny Easley with his crunching tackles and his interceptions and his Rose Bowl heroics. And now I think of Don Rogers and I think of an ill-fated figure who died too young for reason too frivolous to accept.

And so the macabre death wait continues; who will be the next athlete to ignore the tragedy of Don Rogers, to ignore the tragedy of Len Bias, to ignore the tragedy of countless other people destroyed by coke?

The cocaine plague long has been polluting every segment of society, but the death of two prominent athletes in such a brief span has brought into glaring focus its murderous tentacles.

The resultant furor has been inevitable—the hallowed oh-we-have-to-do-something-about-these-tragedies posturing by self-serving politicians; the empty moralizing of college educators, athletic coaches and the like; and the dreary cliché-ridden rhetoric of the drug counselors and sociological types the press always props up to explain these morbid spectacles.

But what we need desperately now is drastic action, not meaningless words.

Since athletics are such an integral part of American life—and since their participants do serve as role models to youngsters—I think mandatory drug testing should become an integral part of athletics.

And mandatory drug testing can work—or at least it can in some instances. I personally know of a few people who stopped their recreational use of drugs once their employers began periodic testing.

The human rights fraternity will bray that such tests violate one's personal freedoms—and they certainly do.

But so what?

So what if we are deprived of the freedom that we no longer can hide the fact we snort coke? So what if the dopers are flushed out and forced to either go straight or go unemployed?

Go ask the kin of Len Bias and Don Rogers today if they're in favor of mandatory drug testing—and listen to what they say. They'll tell you that if it can save the life of one person, then the invasion of one's hallowed rights will be well worth it.

Mandatory drug testing certainly won't be a magic cure-all, but it might abate the Russian roulette madness of cocaine usage that has caused such misery and has at least two loving families on opposite sides of America in deep mourning.

AILEEN'S PLACE WAS SOMETHING TO SEE

Los Angeles Herald Examiner, *November 12, 1987*

It was the late 1960s and early 1970s, and the Olympic Auditorium near downtown Los Angeles was a thrilling place to be on Thursday nights for a young reporter.

It was Sonny Liston making his comeback start from his one-round Ali disgrace against one Billy Joiner, it was Mando Ramos and Sugar Ramos cutting each other up in a blood-smeared fury, it was some unknown from Japan named Shozo Saijyo upsetting Raul Rojas and it was Hedgemon Lewis and Ernie (Indian Red) Lopez waging passionate combat three times before screaming crowds that would have made all these modern-day, hankie-waving assemblages seem tame in comparison.

It was Howie Steindler fainting when his beloved Indian Fred dramatically rallied to stop Lewis in their first fight, it was Steindler's old buddies Willie

Ketchum and Tedd Bentham fuming about a decision, it was Robert Conrad and Ryan O'Neal seated at ringside and it was curvaceous ladies in miniskirts causing near riots during their promenades to the snack bar.

It was the brawling, beer-throwing, penny-heaving, "Mex-ee-co"-chanting fans roaring with delight or displeasure at the action, it was Gene LeBell rushing to put headlocks or sleeper holds on anyone engaging in unsanctioned fights and it was the great newspaperman Bud Furillo walking in theatrically just before the main event with his Downey entourage that was even larger than what tailed Sinatra or Presley.

It was the gamblers shouting out their propositions and exchanging their Ben Franklins, and it was a sad old figure, the notorious mobster Mickey Cohen, cane in hand, being assisted to his seat by an aide in what had to be a painful experience for a man who once commanded reverential attention at such gatherings.

And sitting in seat 2, row B, section 17, it was the overseer of all these proceedings, Aileen Eaton, who passed away the other day but left behind a flood of colorful memories and a legacy of being the most powerful female promoter in boxing history.

It is all different now.

Aileen's old, brick, dank shrine at the corner of Eighteenth and Grand is now dark and has an uncertain future.

Howie Steindler, Willie Ketchum and Teddy Bentham long have been gone, and the big money fights now are held in Las Vegas and Atlantic City.

The fight clubs in the area now stage their journeyman-marred matches monthly, and there is no one left in the game here who comes faintly close to matching the charisma and influence of Aileen Eaton.

Despite the fact that she was in a mean business forever dominated by men, Aileen managed to flourish across the decades, staging weekly fight shows at the Olympic that were aired on local television and also staging world championship matches at larger venues like the Sports Arena and the Los Angeles Memorial Coliseum.

Although she was a small, slight person, she had an intimidating presence about her, and not even the most inebriated Olympic patron would dare cross her.

Aileen was a sight to behold on fight night, constantly screaming into a phone to dressing room handlers to make sure the fighters would be in the ring on schedule, constantly conferring with her matchmaker, Don Chargin, constantly making sure the TV interviews went well for Jim Healy, constantly dashing around ringside to say her hellos to friends, foes and media members.

Doug is seen at ringside at the legendary Olympic Auditorium pointing jokingly at former professional fighter Dave Centi, who became a well-known bouncer at various taverns in the Los Angeles area. *Author's collection.*

She could be gruff one moment and charming the next, and her motherly instincts could surface when she met what she construed as a misguided soul.

"Young man, you gotta do something about your hair," she once told a young reporter the first time she met him in April 1968.

The young reporter, who in those days had thick hair he wore almost to his shoulders, smiled sheepishly.

"I knew the Olympic never would be the same when she left it in 1981—and it wasn't," says Chargin, who worked for Eaton for eighteen years. "I stayed on for another year and a half, but it wasn't the same. Aileen was the heartbeat of the Olympic. When she left, it for all practical purposes died."

Don Chargin can recite countless Aileen Eaton stories about her toughness, shrewdness and generosity, but his favorite one concerns Sonny Liston.

"We had signed Liston to a fight, but when he came to town, he claimed he had lost the contract," relates Chargin. "It was an obvious ploy. Liston figured he'd stick us up for more money with a new contract.

"So, he came down to the Olympic and met with Aileen. And as she talked to him, he gave her that famous stare of his. You might recall that Liston had a stare that could petrify people—and he liked intimidating people with it.

"Well, after a while, Aileen stopped talking about the contract terms, looked Liston straight in the eyes and said quite loudly, 'Look, Sonny, that

look of yours has been pulled on me by a lot of other guys. It doesn't scare me one bit. So either sign the contract, or get the hell out of town.'

"Sonny started laughing so hard he actually began crying. When we went outside the office, he told me, 'Everyone warned me I wouldn't get the best of her. And they were right.'"

And when it was perceived that someone had gotten the best of her, well, hell had no fury like an upset Aileen Eaton.

"She wanted to burn me at the stake when I made the Bobby Chacon–Ruben Olivares featherweight title match at the Forum in 1975," says Don Fraser, longtime promoter who served as the Olympic publicist for Eaton between 1959 and 1967. "Chacon had won the title at the Olympic, made one defense there and had a falling out with his manager, Joe Ponce.

"I was able to get Chacon to agree to fight at the Forum, and this enraged Aileen. She threatened a lawsuit because she said she had a contract from Chacon that gave her two options on his services. But the contract wasn't recorded with the State Athletic Commission—and it wasn't binding. I was public enemy number one with her for a long time."

But Aileen Eaton's capacity for getting mad at people was exceeded only by her capacity for making up with them.

"She and I became friends a few years later, and I was talking to her an average of once a week before she got sick," says Fraser.

Aileen once had a security cop remove the fight publicist Bill (Bozo) Caplan from a ringside seat at a Coliseum show—she was upset with Caplan because he had been working for a rival promoter—but all was forgotten a few weeks later when she hired Caplan to assist with PR at the Olympic.

After a couple years of prodding by Aileen Eaton, the young reporter finally consented to do something about his hair and agreed to have it styled by Aileen's personal Hancock Park hairdresser.

"You finally look civilized," said Aileen in a voice and manner that won't soon be forgotten by the reporter who now has become middle aged.

PRO FOOTBALL IN LA: THANKS FOR THE MEMORIES

Long Beach Press Telegram, *June 25, 1995*

With the Rams and their daffy owner, Georgia Frontiere, now safely tucked away in St. Louis and the Raiders returning to Oakland, I started reflecting

Farewell rally held at the Los Angeles Memorial Coliseum in support of the Rams moving back to Southern California. *Photo by CASportsFan.*

on how different life would have been for me the past quarter of a century had these teams not been in Southern California.

For one thing, the hundreds of columns I have written on their games, players, ownership and legal entanglements would have been done on other subjects.

For another, I would have had a less harried, if not more humdrum existence, detached from the endless controversies that have constantly swirled around the two franchises. I wouldn't have met so many unique individuals who left a lasting impression on me.

It's mind-boggling to think how drastically altered my existence would have been had the Rams and Raiders not been a part of the local landscape:

I never would had the daylights scared out of me when I was chased by Isiah Robertson one late December afternoon in 1978 at Blair Field. The late Rams coach Ray Malavasi and one of his players, Larry Marshall, both tackled Robertson, thereby preventing the star Rams linebacker from wreaking havoc on my anatomy. "The worst decision I ever made," Malavasi would crack years later.

I never would have worn Gucci loafers. When I commented to Rams owner Carroll Rosenbloom during a Rams practice one day in the fall of 1972 how much I liked his shoes, he responded a week later by sending me a pair of Guccis. But such a gift didn't exactly influence my coverage of the team or affect the way I analyzed Rosenbloom's constant mischief. At his death seven years later, we hadn't spoken for six months, and he even had come down to the *Los Angeles Herald Examiner* office to complain bitterly to the newspaper's publisher about my coverage of his team.

I never would have had lunch with Georgia Frontiere at her Bel Air mansion and listened to her relate how the night before she'd had a séance

with her late hubby, Carroll. She revealed he was in good spirits, and I told her to say hello to Carroll next time. She said she would.

I never would have formed a close relationship with George Allen, who was savagely fired by Rosenbloom after two exhibition games in the summer of 1978 in the worst move Rosenbloom made during his ownership of the Rams.

I never would have gotten to known Al Davis, who once liked my work so much that he was set to offer me a job with the team and who now treats me with a silent disdain because I had the temerity to violate sacred Raiders decorum when I kept writing that Art Shell was a lousy coach and that Davis had made a terrible mistake in hiring him.

I never would have become a pal of ol' Hunter himself, Fred Dryer, whose zany living-out-of-his-van persona was pure hyperbole. When he was with the Rams, Dryer was always taking acting lessons and preparing for his future beyond football, while teammates who would wind up broke weren't.

I never would have had the opportunity to decipher the thrilling quotes of Rams coach Chuck Knox, whose speeches now are being marketed on CDs and being peddled to insomniacs in lieu of sedatives.

I never would have those endless who-can-kick-whose-butt, who's-the-toughest-dude-around machismo conversations with the late Lyle Alzado that I always found entertaining.

I never would have had the opportunity to meet one of the classiest people I ever have met during my years as a journalist, the late Rams guard Joe Scibelli.

I never would have experienced the exhilaration of being cussed out for four straight weeks during the Rams training camp in 1978 by the lovable Isiah Robertson. It was so enlightening for me at Fullerton that warm summer. Sticks and stones will break my bones, but Isiah's hyphenated curses only soothed me.

I never would have met the wacky linebacker Jack (Hacksaw) Reynolds, a character if there ever was one. When I once told Reynolds I'd fight him if he'd lose seventy-five pounds, he roared, "I'd lose seventy-five pounds and still kick your butt!" I'm glad he didn't lose those seventy-five pounds.

I never would have known Merlin Olsen, who was not exactly a passionate admirer of mine and who once came up to me at the conclusion of a Rams season and said: "See, even though I've been mad at you for your unfair comments in the paper, I never beat you up." How considerate Merlin was of my feelings and health!

I never would have taken an active role in the finances of Eric Dickerson, who was being horribly underpaid during his prime seasons with the Rams.

When I kept writing about this injustice, it caused Dickerson to become so agitated that he eventually forced the Rams into trading him to the Indianapolis Colts in an ill-fated transaction that heralded the start of the downfall of the franchise.

I never would have been a Rams coaching candidate. Honestly, I was—in a 1978 *Los Angeles Herald Examiner* poll. I was listed right alongside George Allen and others in the newspaper for a month as Rosenbloom searched for someone to succeed Chuck Knox, whom he had fired. Believe it or not, I received thirty-five votes.

I never would have had the privilege to view in person such sterling quarterbacks as Dieter Brock, Marc Wilson, Rusty Hilger and the worst of the lot, Joe Namath, the pathetic 1977 version who thoroughly embarrassed himself during his brief and forgettable time as a starter with the Rams.

I never would have been involved in the infamous one-day salary dispute walkout of Rams quarterback Vince Ferragamo, an incident that Ferragmo's attorney, Paul Caruso, and I concocted to a) give me a rousing scoop and b) give Ferragamo more money. I did get the scoop, but alas, Ferragamo didn't get the money. He returned without a raise—and was in the Canadian Football League by the next season.

I never would have had the opportunity to write such nice things about Georgia Frontiere's Hubby VII, Dominic Frontiere, who would wind up doing prison time on a Super Bowl ticket scalping beef and who once told a fellow reporter about me: "I'm going to urinate on his grave." To know Hubby VII plans one day to do such a dastardly deed still causes me nightmares.

I never would have dealt with such memorable people as Harold (Squeezer) Guiver, E. Gregory (I've Never Told a Lie) Hookstratten, Don (The Duke of Dining Out) Klosterman, Heckle Lynn, Steve Rosenboom and, well, space limitations prevent me from listing them all.

I never would have had so much fun.

HEARN'S PLACE IN HISTORY A SLAM DUNK

Long Beach Press Telegram, *August 6, 2002*

Death will prevent Chick Hearn from calling any more Los Angeles Lakers games, but we all know better.

Chick Hearn statue. *Photo by prayitno on eveverystockphoto.com.*

It's a "slam-dunk" he forever will be part of the team's broadcasts because his "words-eye view" will be carried on by successors who will describe a marginal call on Shaquille O'Neal as a "tricky-tack foul" or will equate a gravity-defying move by Kobe Bryant to "being faked into the popcorn machine" or dub a misguided shot attempt by Mark Madsen "an air ball."

Chick Hearn, the franchise's most enduring superstar, a man whose tenure with the Lakers spanned nine U.S. presidential administrations, a person who emerged as the most popular play-by-play voice in LA history even with the peerless Vin Scully in the same vicinity, no longer around entertaining us with his magical vocal cords?

I don't believe it.

I can't even envision it.

I simply can't fathom "yo-yoing" through an entire Lakers season without the presence of Chicky Baby, who always was there through Elgin, Jerry, Wilt, Gail and Happy, through Magic, Kareem, James, Byron, Michael and Norman, through Shaq, Kobe, Robert, Derek and Rick, through Robert Short and Jack Kent Cooke and Ol' Doc Buss, through memorable games and games not so memorable but that Hearn somehow still would make interesting.

Maybe Chick Hearn won't be with us any longer physically, but he will spiritually be part of those of us who thrilled to his ability to turn even the most

banal regular season games into re-creations of World War II by spewing out colorful descriptions in his rapid-fire narrative that kept us all transfixed.

Why So Popular?

"Why is Chick Hearn so popular with LA fans?" a media inquisitor asked me over the weekend.

That's an easy one.

Chick Hearn, more than any other play-by-play announcer, was one of us.

Unlike a Vin Scully, a lyrical poet who steadfastly maintains a sense of detachment during his work, Hearn always was a roller coaster of emotions, routinely engaging in hyperbolic utterances, meting out criticism and praise in equal shares much like garden variety patrons do when watching Lakers proceedings at taverns.

Hearn was able to encapsulate our feelings in his descriptions of the team, and you always felt like you were getting an honest portrayal from a man you knew had a passionate fondness for the Lakers.

You knew that Chick Hearn's timeless reign would have to come to a finish as everything in life inevitably does. But it's a difficult reality to accept because Chick Hearn has become such a sacred part of the Southern California ambiance that you just figured he'd last into infinity.

I first met Hearn in 1966, when I was fresh out of college, and I always will be appreciative of his kindness toward me when I took my first Lakers road trip in November 1968 and he introduced me to all the members of the team, including Elgin Baylor, Wilt Chamberlain and Jerry West.

I was the only writer from Los Angeles who regularly traveled with the team in those days during the regular season, and Hearn knew I often was alone and continually invited me to have lunch and dinner with him.

Natural Wit

He had a natural wit, and his one-liners on the bus rides to the arenas and in the waiting areas at the airports always inspired loud laughter among the players.

He's one of the funniest men I've ever been around, and I always thought he could have made it big as a standup comic had he not chosen sports casting as his destiny.

My first appearance on Los Angeles radio came on a Lakers pre-game show in 1968, and Hearn skillfully chaperoned me through it even though I was tongue-tied with fear.

I sat four seats down from him at mid-court at Staples Center throughout the entire playoffs, and we always exchanged pleasantries before the tipoff.

"You're the greatest, Chick" was my standard opening line to Hearn, and I meant it.

He has been the greatest broadcaster LA ever had—one who built a fanatical cult following that deified him.

There never will be another Chick Hearn.

Maybe death has put his broadcasting career into the refrigerator. And maybe the door's closed. And the lights are out. And the eggs are cooling. And the butter is getting hard. And the Jell-O is jiggling.

But for those of us who knew him and listened to him and clung to his every frantic word, Chick Hearn will remain forever.

THE FORGOTTEN BALLPLAYER

Long Beach Press Telegram, *September 14, 2005*

Vern Stephens has been dead now for almost thirty-seven years and has lapsed into obscurity despite numbers that dwarf the achievements of some men enshrined in Cooperstown who also played shortstop.

He once formed, with Ted Williams, baseball's most imposing one-two punch that for a time dispensed the kind of RBI production surpassed only by Babe Ruth and Lou Gehrig during their legendary time with the New York Yankees.

He is one of only three players in major-league history—Art Shamsky and Willie Kirkland are the others—to hit two home runs in extra innings, and he tied a major-league record for double plays by a shortstop in 1948, when he had five in one game.

He was a six-time All-Star, and during his fifteen seasons in the Major Leagues he wound up with 1,859 hits, 247 home runs, 1,174 RBIs and a .286 average, and yet he's been consigned to the dustbin of history while others who played his position like the Yankees' Phil Rizzuto (1,588 hits, 38 home runs, 563 RBIs, .273 average) and the Chicago Cubs' Joe Tinker (1,690 hits, 31 home runs, 783 RIBs, .262 average) have been honored with Hall of Fame acclamation.

Vern Stephens. *1951 Bowman Baseball Card.*

Even in his hometown of Long Beach he has been overlooked and overshadowed by other local men who played in the Major Leagues over the summers like his old friend Bob Lemon, or Tony Gwynn, or Bobby Grich, or Jeff Burrough or Bob Bailey.

Indeed, Vern Stephens is the "Forgotten Man of Baseball," not only in this city, where he first etched his athletic legacy in the late 1930s at Poly High, but also even in Boston, where during one storied three-season span he had 440 RBIs and ninety-eight home runs.

"What's incredible is that Vern Stephens is not even in the Boston Red Sox Hall of Fame, when a strong case can be made for him to be in the Cooperstown Hall of Fame," says former Los Angeles Dodgers general manager Fred Claire, who has been leading a movement with his MLB.com column to gain Stephens's belated recognition. "The guy was an incredible player and was actually my favorite player as a kid growing up in Ohio."

"No doubt in my mind that Vern Stephens belongs in the Hall of Fame," says Chuck Stevens, eighty-seven, the old Hollywood Stars first baseman who was a Poly teammate of Stephens and even came up with him to the big leagues in 1941 with the St. Louis Browns. "The guy's stats were astounding. He had a great baseball mind, and he could do it all as a player. He could run, field and hit, and he also had a good arm. There are men in the Hall of Fame who don't measure up to Vern Stephens."

"Vernie was definitely a Hall of Fame–caliber player," says Hall of Fame second baseman Bobby Doerr, eighty-seven, from his home in Junction

City, Oregon. "He was my roommate when he was in Boston and was a tremendous clutch hitter. He also was a solid fielder who fed me well on the double play at second base. You look at his numbers, and they stack up with anybody who played his position."

But Vern Stephens, a 1938 Poly graduate, remains an unnoticed, enigmatic performer, even though those 159 RBIs he had in 1949 with the Red Sox are the most ever collected by a shortstop, as are the 144 he produced the following season.

Why?

Why has a man who had such overwhelming statistics and who led the Browns to their only World Series appearance in 1944 and who was such a feared batsman in the American League for so many seasons been so thoroughly ignored by so many on the sporting scene?

Danelo's Death Is a Cruel Reminder: Fragility of Life Illustrated in Tragedy

Long Beach Press Telegram, *January 11, 2007*

Up against the wall that guards against the danger that lurks darkly beyond it are the rites of death—flowers, wreathes, bottled candles, signed mementos and the poignant missives of the grieving.

"He was a good kid," says a big man of middle age, shaking his head sadly. "Just don't understand how this could have happened."

A young lady in designer jeans leans over and gently lays down some long-stemmed roses as her eyes fill with tears.

"I graduated from USC in 1998, and I'm a huge football fan and just wanted to pay my respects," she says. "I didn't know him, but he played for my favorite team, and I just feel so bad that his life was cut short so prematurely. He was only twenty-one…"

It is near noon on a clear, gentle, warm, glistening day in which Catalina Island looms picturesquely on the horizon and Point Fermin in San Pedro is an idyllic park of quiet tranquility.

But it is a façade because so many people over the years have lost their lives in this area from falling off the sheer bluffs that drop down into heaps of rocks that clutter the small shoreline, which often is pounded by the unrelenting waves of the Pacific Ocean.

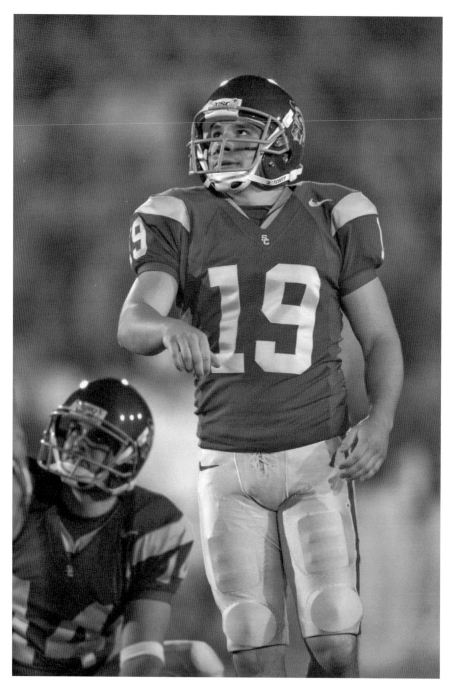

USC kicker Mario Danelo. *Courtesy of University of Southern California.*

It was down there, beyond that wall of commemoration, where the body of USC kicker Mario Danelo was found last weekend only a few hundred yards away from the home where he grew up in a tragic development that has left the close-knit San Pedro community, as well as the Trojans' football team, in a state of shock.

How could this happen? Why did this happen? How could a popular, affable, healthy, normal kid with such a bright future come to such an end under clouded circumstances?

What occurred late last Friday evening when Mario Danelo decided to visit Point Fermin? There are myriad theories being tendered at the site by some of the spectators, and none makes one feel too comfortable. Perhaps the winds that are known to become so fierce in that region somehow dislodged him from wherever he was perched. But why would he position himself in such a perilous spot?

Or perhaps. Or perhaps. Or perhaps…

Since the police have ruled that there was no foul play involved in Danelo's death, the reason for it may be shrouded forever in the unknown and should be eclipsed anyway by the glowing rhetoric of those reciting the virtues of an outgoing young man who was an All-City linebacker at San Pedro and who went on to become the most accurate field goal kicker in USC history.

Still, his death does once again reflect the horrible uncertainties of this existence, its ephemeral fickleness in which being at the wrong place at the wrong time in the wrong circumstance can be instantly fatal for a human being.

Indeed, one is always one bad diagnosis, or one bad turn away from having his life shattered, and one always wonders what could have prevented Mario Danelo from making his late night trek.

Oh yes, it's the if-only syndrome that always surfaces in these ill-starred incidents that too often are unexplainable.

If only USC had beaten UCLA, then the Trojans would have been in Phoenix last Friday practicing for a BCS title match against Ohio State, and Mario Danelo wouldn't have been near Point Fermin.

But one never can go back and alter the script after it's been played out.

Sure, if only Archduke Ferdinand of Austria hadn't visited Sarajevo on June 28, 1914, and been assassinated with his wife, Sophie, World War I might never have started, and ten million soldiers might never have lost their lives.

Sure, if only Mike Tyson had continued the fierce dedication he had displayed when he became the youngest heavyweight champion in the history of his sport at age twenty, he might have become legendary for his

fists rather than for his many unsavory escapades that have led to countless legal entanglements and a couple prison stays.

Sure, if only President John F. Kennedy had not decided to visit Dallas on November 22, 1963.

We live in a world that can perhaps be defined as a place of suffering, with so much anguish, anxiety, pain and fear. We live in a world where people routinely die from horrible car, plane, boat and train accidents, from drive-by shootings, from floods, famine, disease, earthquakes, hurricanes, tsunamis and fires. We live in a world where people battle one another with awful weapons to whose effects not even nightmares can do justice, where men terrify and torture one another with a regularity that is an appalling commentary on human nature.

It's a world that Mario Danelo, who had so much to live for, who was liked by everyone who knew him, who was living a dream playing for USC, has departed prematurely and tragically, as have so many others across the years with no logical explanation.

"I don't understand how this can happen," says the lady in the designer jeans who reveals she is a film editor and lives in West Hollywood.

She peers down at the makeshift memorial, daubing her eyes.

"He was too young," she says. "He had so much to live for. I don't understand…"

Who understands?

Perhaps those with divine powers do, but we mortals certainly don't.

Buss Is Deft Businessman as Well as True Bon Vivant

Long Beach Press Telegram, *April 25, 2010*

If ever an owner of an athletic franchise deserved to be enshrined in the Hall of Fame of his sport, it would have to be the Los Angeles Lakers' Jerry Buss.

Buss recently was bestowed such an honor, as he was named to the Naismith Memorial Basketball Hall of Fame for the astounding success the Lakers have had during his thirty-one-year proprietorship, in which they have won nine world championships and appeared in fifteen NBA Finals.

The Lakers, during this span, have become one of the most glamorous sporting brands on the planet, and such immense prosperity is a reflection of the smart, stable, patient and daring leadership of Buss.

At the premier of the 1980 James Caan film *Hide in Plain Sight* at the Fox Village Theatre in Westwood, Doug shakes hands with Los Angeles Lakers owner Jerry Buss. Doug and *Variety* columnist Army Archerd, seen in the background, emceed the event. *Author's collection.*

Indeed, it's now indisputable that Buss is not only the best athletic owner in LA history—the Dodgers won a mere five world championships under the forty-year aegis of the O'Malleys—but also one of the best ever to grace the American scene.

And what makes Buss's achievements even more impressive is that he has accomplished them despite living a hedonistic existence that has often drawn comparisons to Hugh Hefner and that too often causes irreparable disruptions for most others who embrace such a lifestyle.

There's no doubt the seventy-six-year-old Buss—who long has dated women young enough to be his granddaughters, who regularly engages in high-stakes poker games, who enjoys liquid refreshments slightly stronger than Coca-Cola, who has been a passionate habitant of the late night—has an ability to compartmentalize.

If he didn't, well, the Lakers might have turned out to be like the LA Clippers have been under Donald Sterling or like the LA Rams were under Georgia Frontiere.

There are those in the business orbit who might not know Voltaire from Venice. They might not know table etiquette or have proper command of

the English language. But when it comes to administrating a company, they have an unmatched deftness that sets them apart from others in their field. They are endowed with a special knack for inevitably making shrewd moves.

Jerry Buss has been such a person, and he has displayed that special knack by becoming a multimillionaire early in life through his real estate investments; through his purchase of the Lakers, Kings, Forum and a large ranch from Jack Kent Cooke for $67.5 million in 1979 and through his stewardship of a Lakers franchise that has become the most popular in Southern California.

He is a fascinating individual, and not just because he's a Wyoming native who came out here in his early twenties to pick up a PhD in physical chemistry at USC, where he worked for a time on the faculty of that school's Chemistry Department.

He is a gentleman who has gone through dramatic incarnations across the decades.

There was the Book Worm Buss—it took him only two and a half years to obtain a degree from the University of Wyoming before getting his doctorate at a mere twenty-four.

There was the Family Man Buss—he was married and had four children, two of whom, Jeannie and Jimmy, are now heavily involved in the Lakers operation.

And there has been the Female-Squiring, Card-Playing, Fun-Seeking Bachelor Buss—his persona throughout his incumbency with the Lakers.

This is the Jerry Buss I came to know particularly well during the Magic Johnson/Kareem Abdul Jabbar Showtime era of the 1980s, having observed Buss up close many times at his old Pickfair estate in Beverly Hills and at West LA nightclubs and at his private box at the old Forum, as well, of course, as at numerous press conferences.

I've never known anyone savor the joys of his riches more than Buss, who somehow has been able to artfully juggle his workload with his sybaritic nocturnal pursuits.

He once had a colorful entourage that I dubbed the "Seven Dwarfs," and they included such characters as Beverly Hills restaurateur John Rockwell, actor Miguel Nunez, mysterious entrepreneur Lance Davis, investment consultant Mark Fulton and the Wilder brothers, Dave and Ron.

The Seven Dwarfs long have gone their separate ways, although most plan to be present for Buss's Hall of Fame induction on August 13 in Springfield, Massachusetts.

While the years have conspired to diminish somewhat Buss's extracurricular activities, his Staples Center suite still routinely overflows with a bevy of attractive ladies.

And his team once again is favored to make it to the NBA championship round, which has become almost an annual occurrence since Jerry Buss took command of what has become LA's longest-running athletic dynasty.

(Jerry Buss passed away on February 13, 2013.)

WE'RE OUTTA HERE! AND THANKS FOR THE MEMORIES, SPORTS FANS

Los Angeles Herald Examiner, *November 2, 1989*

They tore a part of my heart out yesterday. It was announced that my newspaper, where I've laughed and played and cried and worked for my entire adult life, would be ceasing publication.

When sports editor Rick Arthur relayed the sad news to me, I felt the kind of emptiness that knifes through your anatomy when you lose a dear family member.

No *Herald Examiner*? No more going down to the grand old edifice at the corner of Eleventh and Broadway, where gangster Mickey Cohen once made regular appearances, where so many movies have been shot, where so many lively stories have been manufactured to the delight of millions of readers.

This just can't happen to a newspaper that has been a part of the community throughout the twentieth century—and a part of me since I got out of college.

But it did, and suddenly I'm seized by a state of melancholy as I reflect on all the glad memories connected with this newspaper across the past two decades.

I think of Bud Furillo, a newspaper master, driving, cajoling, screaming and, ultimately, perfecting the skills of youngsters named Allan Malamud, Steve Bisheff, Rich Levin, Jim Perry, Tom Singer, Bob Keisser, Larry Stewart and countless others.

I think of Melvin Durslag, whose elegant prose graced these pages for forty-nine years, counseling me to show more restraint when I wrote opinions and giving me advice with patriarchal care.

I think of Allan Malamud, the best notes columnist this town ever has had, telling me at so many eating sessions how he was starting another diet while ordering another chocolate cake.

I think of Gordon Jones, "the Professor," explaining to me how he could beat the horses even though he—and everyone else who has ever attempted—failed to do so on a regular basis.

I think of the late Rams owner Carroll Rosenbloom, among the most unforgettable characters I've ever met, and his son, Steve, coming down to the paper to meet with me, Durslag and then publisher Frances Dale to discuss our coverage of the Rams, which Carroll at the time detested.

I think of a young bodybuilder named Arnold Schwarzenegger meeting with me across the street at the long-gone Case Deli, pleading for a column that I wrote and that led to an immediate friendship.

I think of James Bacon, the old Hollywood gossip columnist, enlightening me at his desk with titillating stories of the legendary movie stars of yesteryear.

I think of Rick Arthur, my last boss and an editing wizard, gallantly keeping the ship afloat in the face of mass defection in the final days.

I think of those lively sports sections that for so many years were so unique to this paper and that might have made Chuck Knox less conservative, and that might have made Kareem Abdul-Jabbar expend more energy, and that just might have given Al Davis the push needed to take on the NFL in what turned out to be a legal fight of epic dimension.

I think of the days when I was a wide-eyed newcomer romping around the country with the Lakers and running around with Wilt Chamberlain, but nothing stays the same in this unpredictable life, and Uncle Wilt no longer acknowledges my existence.

I think of the moment Allan Malamud informed me, in January 1979, that he wanted me to become a full-time columnist and that I no longer had to cover the Rams, and I remember thinking how nice life would be now that I no longer had to spend my summer and autumn days worrying about getting beat up by Isiah Robertson.

I think of the most memorable assignment I ever had for this paper, and ironically it came only a couple weeks before its demise—at 5:04 p.m. on October 17, before the start of Game 3 of the World Series at Candlestick Park. That harrowing evening will live with me for the remainder of my hours.

I think of the time I was sweating at my desk pounding a typewriter—yes, there *were* typewriters in this business once upon a time—when someone in the office informed me that John Wooden was on the phone and wanted to talk to me. An hour before, Wooden had erupted at me at a basketball luncheon, but now he was uttering apologetic words, and this greatest of coaches made me feel embarrassed.

I think of another grand old downtown place that had better times, the Olympic Auditorium, and I suddenly realize just how much I do miss those wonderful Thursday evening fights. Oh, Aileen Eaton, wherever you are, it's just not the same any longer in LA.

I think of how proud I would be of our sports section on those days when we would scoop the mighty *Times* on a big story.

I think of all the characters I've come across because of my involvement with this paper—Clean Gene Kilroy and Leon (The Bartender) Bartolino and Bill (Bozo) Caplan and Norm (The Plunger) Gray and Satellite Mike Economou and all the others who brought laughter into my life on so many occasions.

And I think of all the fun I've had reporting sports for a paper that allowed me so much editorial freedom—and it grieves me to think it has been forever silenced.

ABOUT THE AUTHOR

Doug Krikorian chronicled the Los Angeles sporting scene for forty-four years—twenty-two at the *Los Angeles Herald Examiner* and twenty-two at the *Long Beach Press Telegram*. He covered all the major football, basketball, baseball, boxing and hockey events during that time and was known for his pungent views on a variety of subjects. He resides in the Long Beach enclave of Naples.